DRONESCAPES

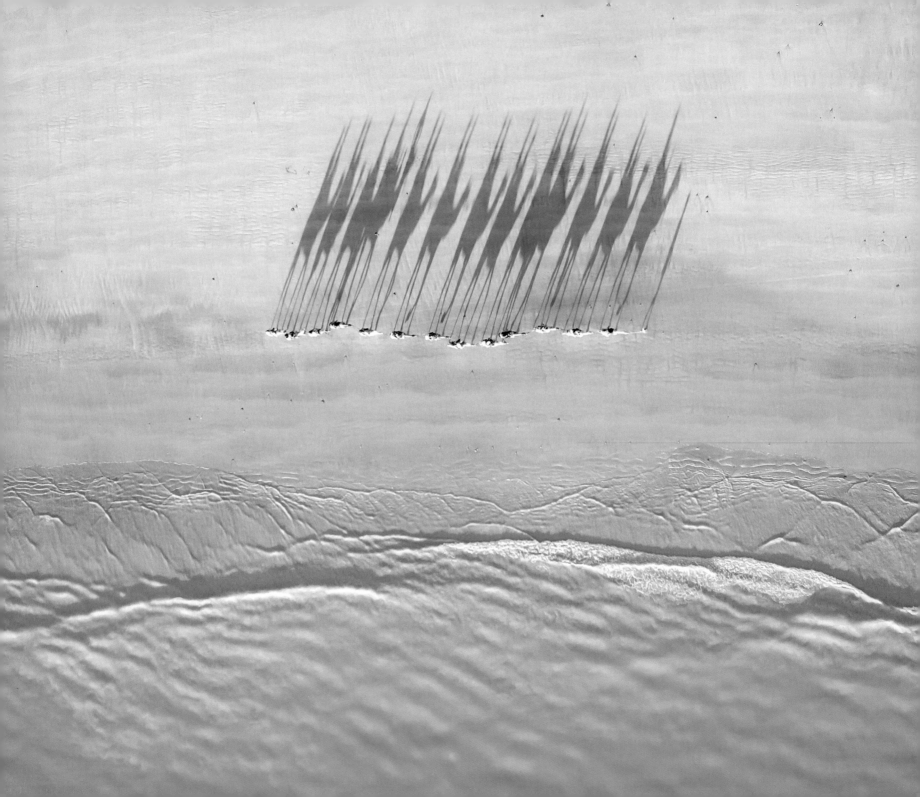

DRONESCAPES

THE NEW AERIAL PHOTOGRAPHY FROM DRONESTAGRAM

EDITED BY
Ayperi Karabuda Ecer

Thames & Hudson

With over 250 illustrations

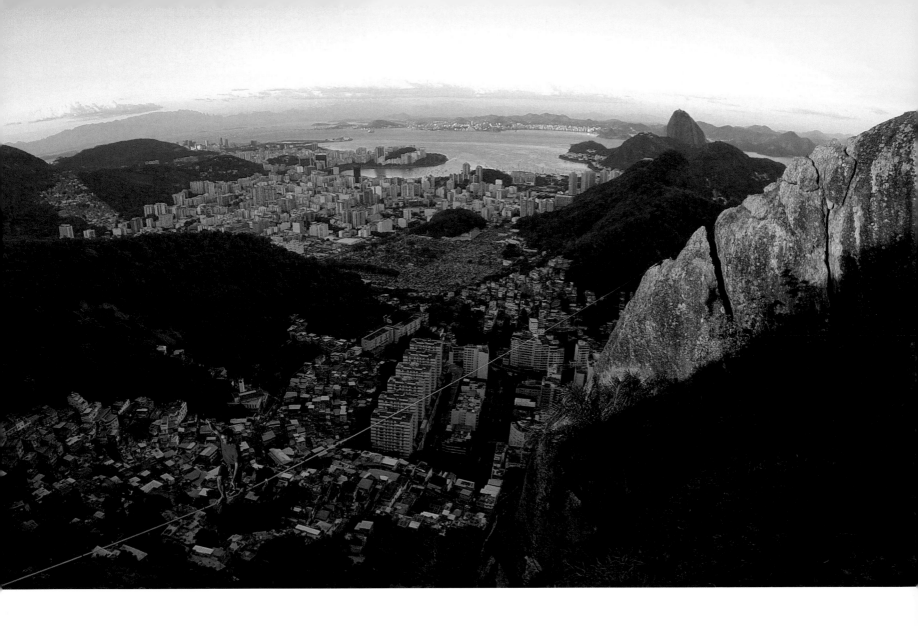

Rio de Janeiro, Brazil
By hanower

⊖ -22.9673

◑ -43.1968

⊕ 20m (65½ft)

FOREWORD

Launched in July 2013, Dronestagram is the first online platform to bring together aerial photography enthusiasts from around the world. Created in response to the lack of a dedicated website where I could share my photographs and videos, Dronestagram emerged just as the drone market was about to explode. Its purpose is not only to show amazing pictures taken from astonishing perspectives, but also to bring together a community who previously had no online presence or resource.

Drones are revolutionizing photography. These small and lightweight quadcopters can take pictures in places where no other device is able to fly: monolithic buildings; moving vehicles; sports arenas; inaccessible landscapes. They allow you to see the world from dizzying new heights, providing the ultimate bird's-eye view. They also signal a new 'layer' to traditional aerial photography, sitting somewhere in-between satellite, aircraft and street views. Dronestagram showcases a wide range of work by photographers, all of whom embrace the unique possibilities offered by drone photography, and in so doing invite us to see the world with new eyes.

Drones have become an increasingly popular device used by photography hobbyists and professionals alike, providing new opportunities for small startups that specialize in aerial photography. That's why Dronestagram has achieved the success and the tens of thousands of users it has today – it is accessible rather than exclusive and the ultimate resource for people to publish, share and discover stunning pictures taken from above.

Eric Dupin, founder of Dronestagram

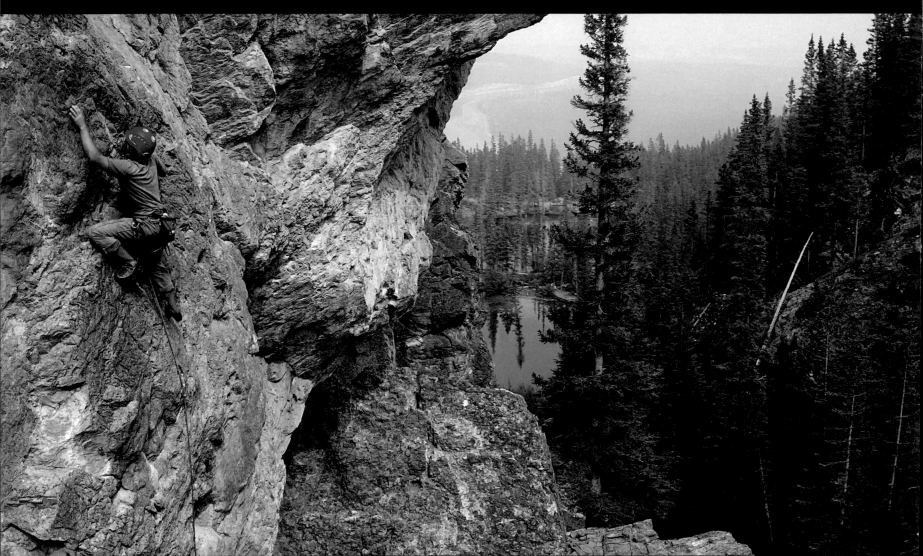

CONTENTS

LOOK UP!

Moscow, Russia
By Petr Jan Juračka

⊖ 55.7558
⊡ 37.6173
⊛ 1m (3ft)

Take a moment to remember the photographs of your parents and grandparents, staring happily at you from out of the frame; displayed on your wall, on top of the family piano, the fireplace, your desk. Now envisage a future where family members look 'up above' rather than at 'you', as they are immortalized by a drone that has been programmed to fly overhead.

Ever since the invention of photography there has been a desire to capture the world from above. The first aerial photographs were created in 1858 by 'Nadar' (Gaspard-Félix Tournachon) and documented the rooflines of the French village of Petit-Bicêtre. These images were shot from a balloon tethered at a height of 80m (260ft) and were precursors to other aerial works by Nadar, including his iconic views of the Arc de Triomphe in Paris in 1868.

Since these early experiments, aerial photography has evolved, always with the aim of 'putting together the pieces', of presenting all-encompassing views of the environments we inhabit, with ever increasing clarity and detail. These vistas, all the time seeking to provide new visual perspectives, show not only the grandeur of our urban and natural habitats but also highlight our responsibility to preserve them.

Aerial photography used to be expensive and exclusive. It involved having sophisticated and costly equipment and a wide range of professional skills aimed at documenting the unknown, the exotic. Today, however, the increasing democratization of image technology has opened up the sky to just about everyone. The drone photography revolution is a game changer, with an ever growing and diverse range of users now having access to this technology and the new perspectives of the world that it offers.

Unlike traditional aerial photography, drones do so much more than just going 'higher' and 'wider'. They get closer to, and more immersed in, their subject; they seek to trace, to follow. In this aim, however, they carry some major contradictions. Like the Internet, they offer unprecedented opportunities for discovery, access and liberation, but also a powerful means for surveillance and destruction.

Hand in hand with the very quick evolution of drone warfare, the strategic use of military and governmental drone imagery is constantly broadening, often with the aim of planning or documenting ruination. Recently a Russian crew launched a quadcopter that surveyed Palmyra, which had been brutally wrecked by IS forces since they took over the ancient city in 2015 – the footage itself was stunning, and looked more like a high-end tourist promotion than a document of obliteration.

New professional practices are also developing – in news reporting, sports photography, real estate and tourism, event photography, underwater photography,

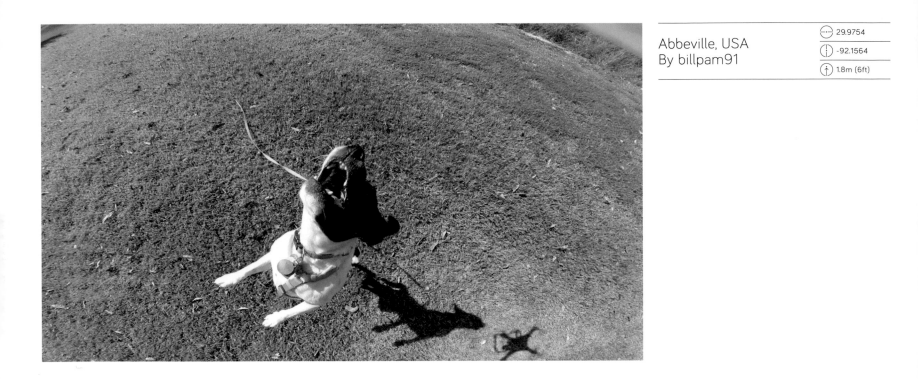

Abbeville, USA
By billpam91

⊖ 29.9754
⌀ -92.1564
⬆ 1.8m (6ft)

Salles-Arbuissonnas-
en-Beaujolais, France
By Thierry Eyraud

⊖ 46.0221
⌀ 4.3733
⬆ 4m (13ft)

ecological exploration, natural disaster interventions by non-governmental organizatios (NGOs) and much more. This aerial technology also taps into the increasingly narcissistic elements of photography, offering us the possibility to shoot 'dronies' – the aerial equivalent of the 'selfie' – but on a wholly different scale. It is the context, the environment, which often takes centre-stage in such images, though the photographer is still very much in charge and present.

Dronestagram is the first forum to offer hobbyists and professionals the opportunity to share with their peers the photographs and videos they have taken using their drones. Its members are from the world over, and the number of viewable photographs amount to the thousands, with new works being added every day.

Founded in 2013 by hobbyist Eric Dupin, in partnership with Guillaume Jarret, with the aim of providing an online resource for drone photographers where previously there had been none, Dronestagram is now quickly evolving as the go-to visual reference for drone photography. It even hosts various photograph competitions, among them the prestigious National Geographic/Dronestagram International Drone Photography Contest.

Dronescapes: The New Aerial Photography from Dronestagram, made in collaboration with the photographers of Dronestagram, showcases this unique community's wide range of work, and will be the first time, for many, that their photographs will be seen in print. Whether amateur or professional, these 'dronesters' have all adopted the sky to celebrate and explore visual perspectives. It has been a true adventure to dig into the wealth of images that they have produced to create a comprehensive selection of what the label 'popular drone photography' might encompass.

With this in mind, the photographs have been grouped into loose thematic chapters. In the first, **Drones Are Us**,

we look at the way in which drones are used for playful and humorous effect. The photographs highlight particularly the popularity of the 'dronie', and range from large group shots with hundreds of individuals to spectacular vistas in which lone figures are only just visible. The images are fun and celebratory, with people, and how they perceive the quadcopters they own, being the focus – the drone featuring almost as a treasured object: at home; on vacation; as a 'member' of the family.

In **Close**, the challenge of access is brought to the fore, with drones being seemingly able to transcend any limits and provide unprecedented angles of some of the world's most emblematic monuments. These breathtaking shots, such as those of Rio de Janeiro's Christ the Redeemer (pages 40–41), the Statue of Liberty (page 42) or Gaudí's Sagrada Família (page 43), benefit from the current legal void around drone access. Such images might very soon become a rarity.

Urban encapsulates unrivalled details of urban jungles and views of landmark buildings and other spaces. Some of these scenes show how drones imply a new level of surveillance at a time when urban privacy is already scarce. The capacity of drones to apparently fly anywhere and to follow anyone or anything raises again the question of just how private our places of work, and by extension our homes, streets and gardens, really are. If, today, you can connect a drone to your smartphone, so it can monitor your every move, might you, tomorrow, be able to programme someone else's to monitor theirs, and what would the moral and social implications of doing so be?

Almost as an antidote to some of the more troubling questions raised by the capability of drones for surveillance, **Fauna** presents a joyful survey of the animal kingdom, with drones flying alongside or hovering above their subjects, capturing the sheer remoteness of their habitats. Intrigued by these objects, the animals often interact with them, as

shown in capungaero's image of an eagle in flight (page 94), a shot that only became possible after the bird started to chase the drone.

Probe shows how drones are used to document and report on environmental issues and natural catastrophes, and is testament to their use for the good – as opposed to some of the technology's more negative connotations. Floods, the preservation of the natural environment, pollution and giant fires are all documented.

Space is the largest category of images. It reflects how photographers not only tend to follow in the tradition of classical aerial photography, taking awe-inspiring shots in which the landscape dominates and overshadows all else, but also how the capacity of drones to fly lower and closer to their subject enables the viewer to be more 'involved' within the scene. This can be seen in one of the most-viewed images on Dronestagram (page 173), in which the viewer comes face to face with a truck balancing on a terrifyingly narrow road in the French Vercors mountains. While many of the images in this section align themselves with the classical tradition, there are an increasing number that offer something different and whose makers aim to include, rather than exclude, the viewer from the vistas they have created.

Pattern/Shadow demonstrates the immense possibilities for imagining drone photographs as 'art', with shapes, shadows, colours and lines becoming the essence of the composition. Many amateur photographers dedicate themselves entirely to 'painting' with their drones and use the technology for their visual experiments and artistic statements. There are even nude 'portraits' shot by drones, such as those by alleyoops, who, in series such as 'Flat & Fall', creates 'visual puzzles' in which flesh and earth appear to seamlessly merge (page 16).

Drones, with their unrivalled views from above, play a vital role in the development of professional sports reporting. In **Move** we focus on amateur sports and leisure, showing the energy and dynamism of all kinds of sports and playful activities from above. An impressive example is the cliff divers at Mazatlán in Mexico (page 245), who, jumping from heights of 15m (50ft) into the shallow waters below, appear almost to be flying!

I Do shows how drones are more frequently becoming the 'photographer' of choice at weddings, producing unique, humorous and touching shots that would not be achievable at ground level. This chapter is an appropriate bookend to complement **Drones Are Us**, reinforcing the joyful and 'human' aspects of drone photography.

Throughout the chapters, various images have been highlighted, supplemented by short texts that explain how and where they were made. Indicated also are the coordinates and altitude for each work, to provide a sense of the sheer breadth of locations that drones can reach.

Interspersed within the chapters are profiles of leading drone photographers from the Dronestagram community. These include 2DroneGals – the mother/daughter duo who are making a name for themselves in a male-dominated field – whose environmental surveys make them stand out as some of the best, or Alexandre Salem, whose significant works include the documentation of natural disasters such as the 2014 mudslides in Brazil.

More abstract offerings are presented by Karolis Janulis, a Lithuanian photographer who has long been obsessed with shooting from above and, since acquiring his first drone in 2015, has become a master of shadows, creating works that are beautiful and playful in equal measure. Ludovic Moulou, formerly an Internet security engineer based in Paris, is dedicated to documenting the breathtaking beauty of Tahiti and to highlight the dangers of climate change, while Russian photographer Maksim Tarasov is equally inspired by nature, having lived in remote locations since childhood. Finally, there is Romeo

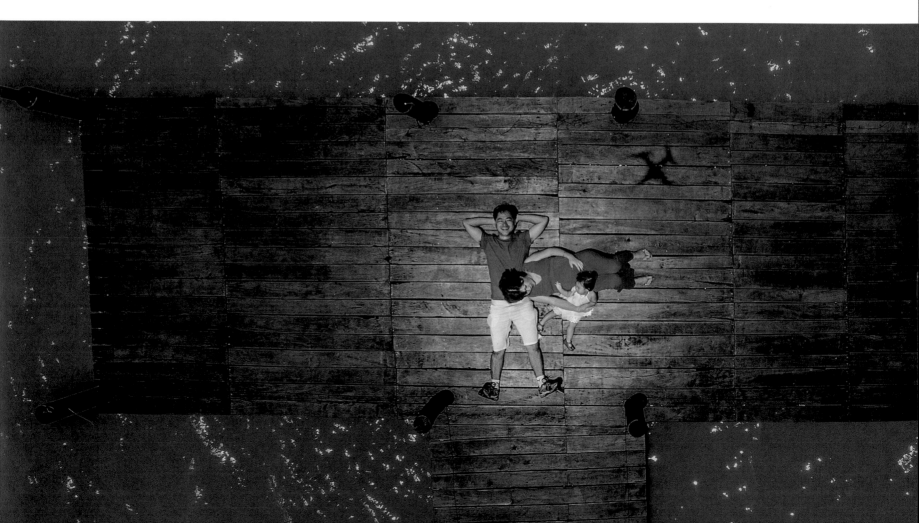

Guararapes, Brazil
By Marcio Ogura

-21.2134
-50.6417
7.1m (23½ft)

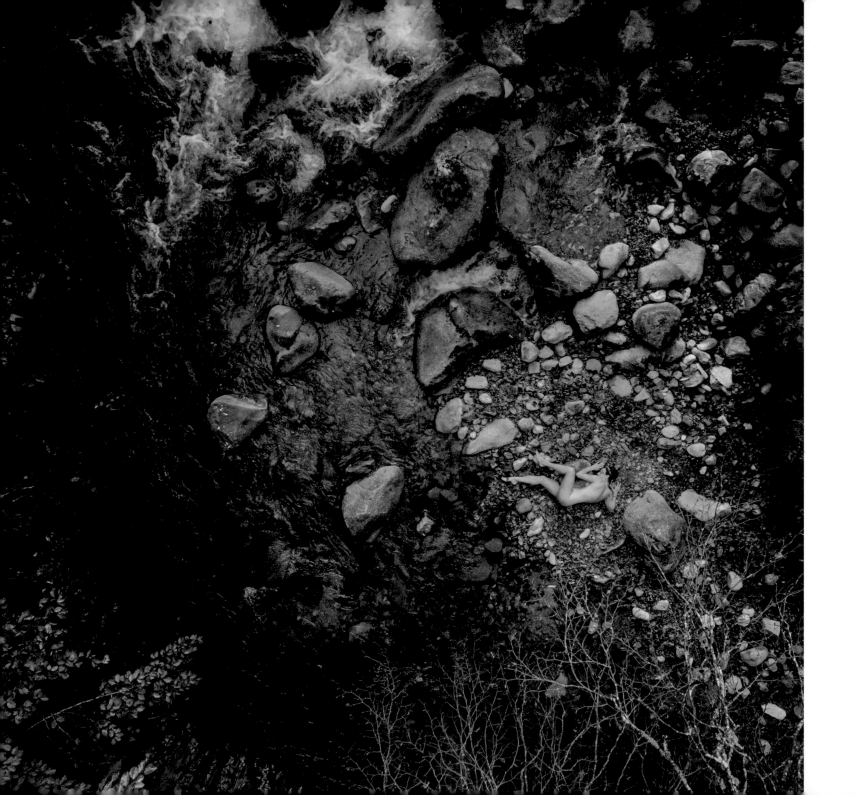

Durscher, perhaps best known for his spectacular aerial panoramas and his passion for light. Between them, these photographers demonstrate the sheer diversity of the images that can be made using drones.

However, in spite of how limitless the possibilities appear to be from the examples shown here, the Wild West of drone photography is slowly diminishing. The fear of terrorist attacks, of paparazzi invading the sky and drones crashing into aeroplanes are just a few examples that have led to new jurisdictions to restrict their use. Following campaigns by several lawmakers and complaints from celebrities, in 2015 a law was passed in California prohibiting paparazzi from using drones to survey private property. Through the new ban, 'physical invasion of privacy' has been redefined to include flying drones over private land for the purpose of taking pictures or filming.

Similarly, in April 2016, when a packed British Airways passenger jet was hit by a suspected drone as it came in to land at London's Heathrow airport – just weeks after the UK government had warned that drones could be used by ISIS to drop a dirty bomb – there were moves from the government towards restricting the use of drones.

A report by the Thomson Reuters Foundation in May 2016 has shown how drones are increasingly being used by NGOs in their search and rescue missions: with drones now having the capacity to produce 3D maps that outpace satellite images in terms of detail, they have become invaluable tools to map out isolated areas and the humanitarian needs of the people still living there.

However, their usefulness in this respect is under scrutiny, resulting in a widespread reassessment of flying regulations. In 2015, for example, quadcopters were widely deployed to document the effects of the devastating earthquake that hit Nepal. With no control over where the drones were flying and how they were feeding back information; the country's civil aviation authority banned operators from using their quadcopters without its permission. It introduced no-fly zones in specific areas and restricted flying times to just 15 minutes. The distance of the drone from the pilot was capped at 300m (980ft) and the maximum height restricted to 100m (328ft).

In spite of the concerns around secrecy, privacy and safety, and the changes in regulations, it is safe to say that drones are here to stay and will continue to integrate themselves into our daily lives. Today, photography is so much more than documentation: it is an essential form of communication, and drones play an integral role in this. Digital photography has invaded the Internet: becoming a never-ending conversation that is being shared and fed into, and which has now expanded into the sky.

The drone photography community will continue to grow. As technology develops, new usages will emerge and the possibilities for sharing will increase. The bird's-eye view will soon become standard and the drone practically a household object. The Federal Aviation Authority predicts that, in the US alone, up to 7.5 million drones will be operated across the county by 2020 and research suggests that sales rates will increase by 32 per cent every year!

In this book we celebrate the passion of those who are exploring these new ways of expression, adding perspectives and embracing drones as true companions.

Ayperi Karabuda Ecer

Bagnères-de-Bigorre, France By alleyoops	⊖ 42.9498
	⊕ 0.2705
	⬆ 12m (40ft)

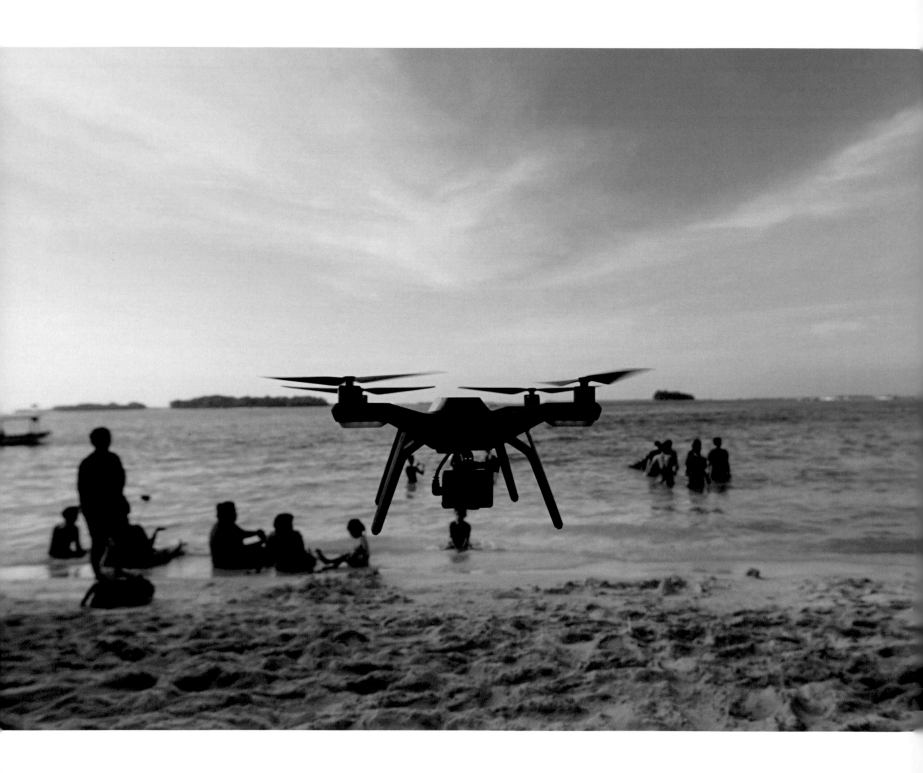

DRONES ARE US

Sviland, Norway
By r_audrius

⊖	58.8368
⊕	5.8456
⊕	5.2m (17ft)

Originally from Lithuania, this dronester has been living and working in Norway for more than ten years, and finds the beauty of the Norwegian landscape continuously inspiring.

This image, titled *King of the Mountain*, was taken near the small town of Sviland in Rogaland, using a DJI Phantom 3 Professional. The photographer had to wait at least an hour before he could take the perfect shot: a dronie from the highest part of the mountain.

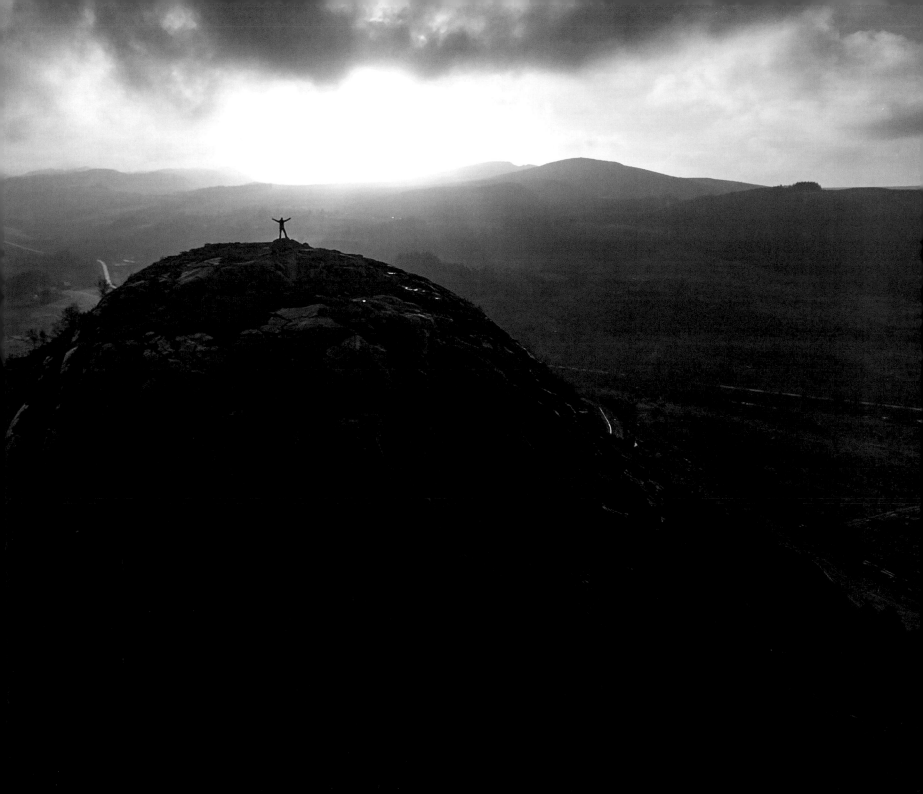

Czajowice, Poland
By Wniebowzieci

50.1960
19.7917
3.5m (11½ft)

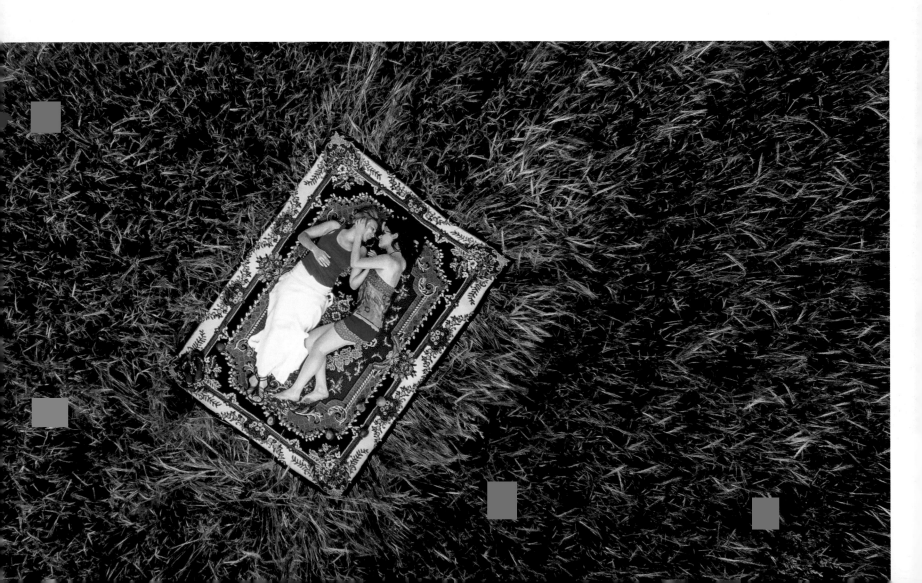

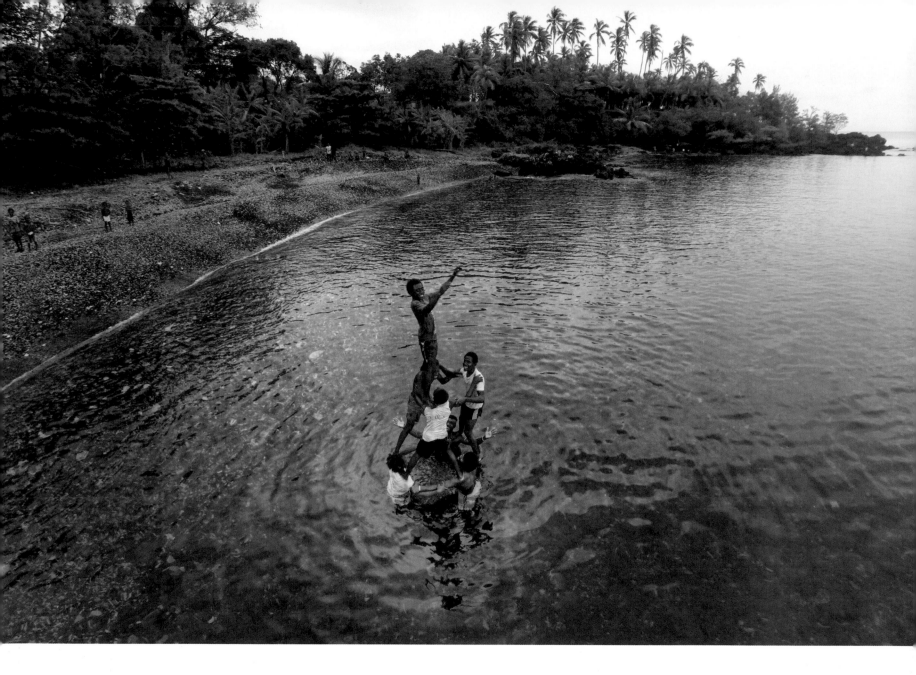

Fali Village,
Ambrym, Vanuatu
By Marama Photo Video

⊖ -16.2526

⌀ 167.8882

↥ 4m (13ft)

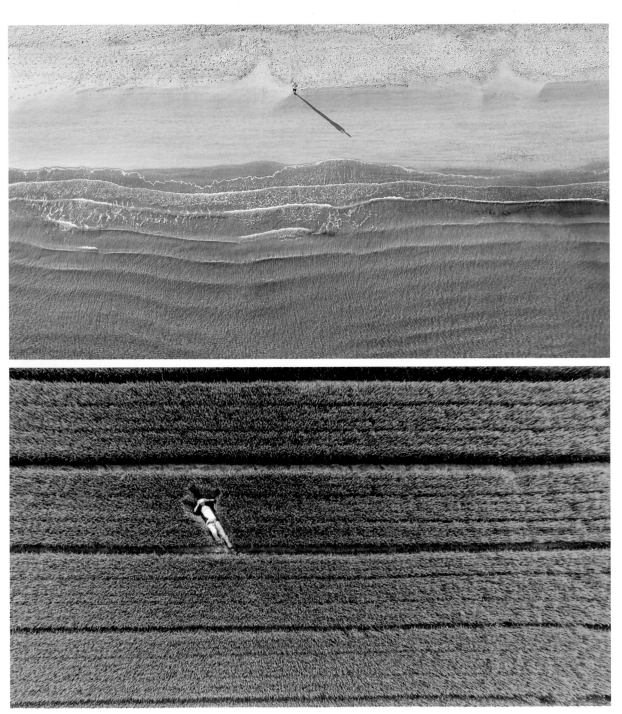

Tamarin, Mauritius
By Christopher_Barry

⊖ -20.3378
⌀ 57.3751
↥ 100m (328ft)

Zoucheng, China
By Ambroselune

⊖ 35.4096
⌀ 117.0385
↥ 20m (65½ft)

Shah Alam, Malaysia
By ari7474

⊖ 3.0905
⊕ 101.3765
↥ 7.3m (24ft)

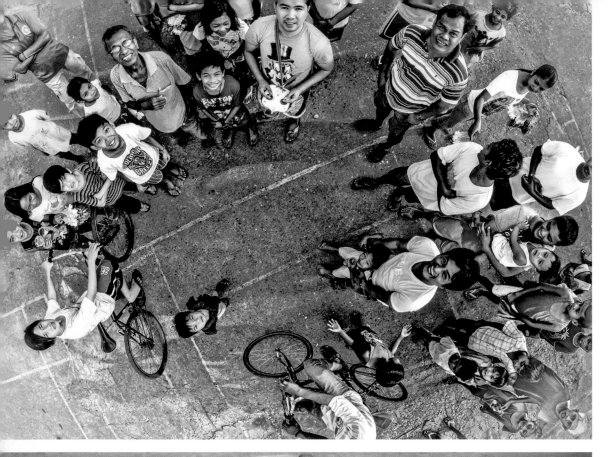

Manila, Philippines
By jericsaniel

⊖ 14.7679
⌀ 121.0596
↑ 6m (20ft)

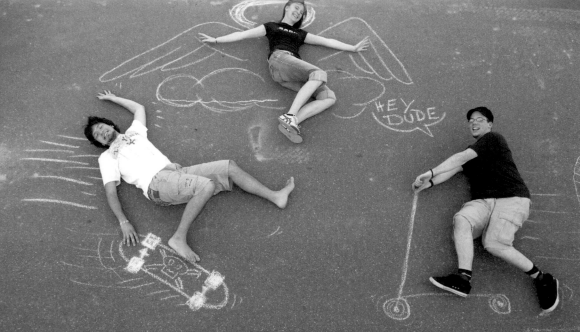

Bickenbach, Germany
By Lightning-Rocket

⊖ 49.7473
⌀ 8.6139
↑ 4m (13ft)

Titled *Chalk it up!* this picture was taken using a custom-made drone, which the photographer constructed from an old quadframe from one of the first APM modules ever produced. Lightning-Rocket joined Dronestagram in 2013.

Santa Fe, USA
By romeoch

⊖ 36.2358
⊘ -106.4252
↑ 7.5m (25ft)

A dronie of the Santa Fe Photographic
Workshop, shot with a DJI Inspire 1 and
a Zenmuse X5 camera with 15mm lens.
See also pages 87, 186–87 and 189–91.

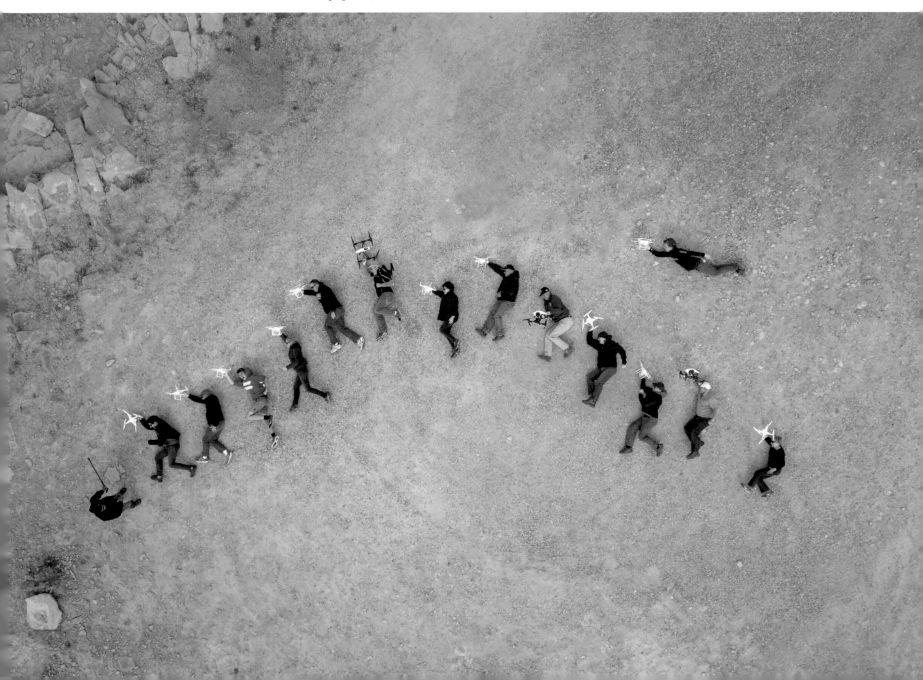

Limassol, Cyprus
By FlyoverMediaCy

⊖ 34.7587

⌀ 32.9907

⌕ 3.5m (11½ft)

Taken at the 2015 Limassol Carnival in Cyprus, a ten-day annual event that takes place before Lent, the 'Where's Wally' group pictured here was one of the largest to join the parade, with there being hundreds of 'Wallys' to spot. As the Wallys saw the drone flying above, they all started jumping up and down and chanting, and it was at this moment that they were captured by the photographer.

FlyoverMediaCy is a Cyprus-based dronester whose day job includes working as a Computer Systems Engineer and Satellite Communications Engineer. He was previously an Aircraft Simulation Engineer for the Australian RAAF.

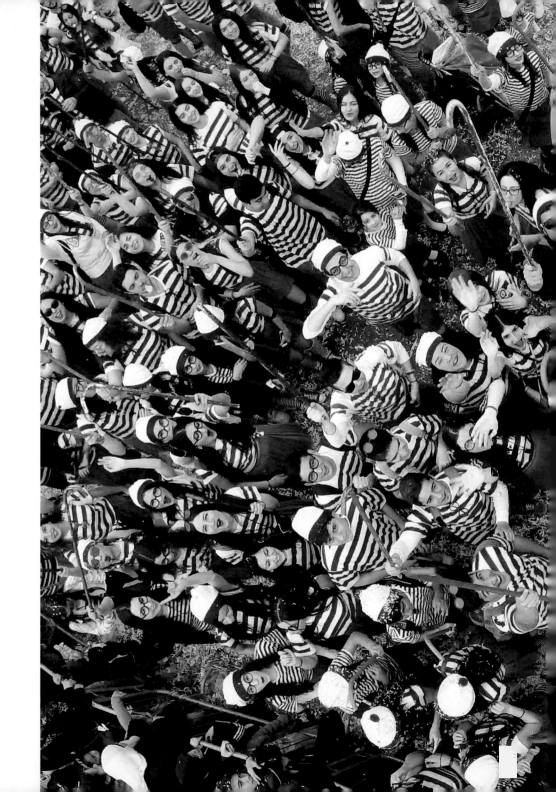

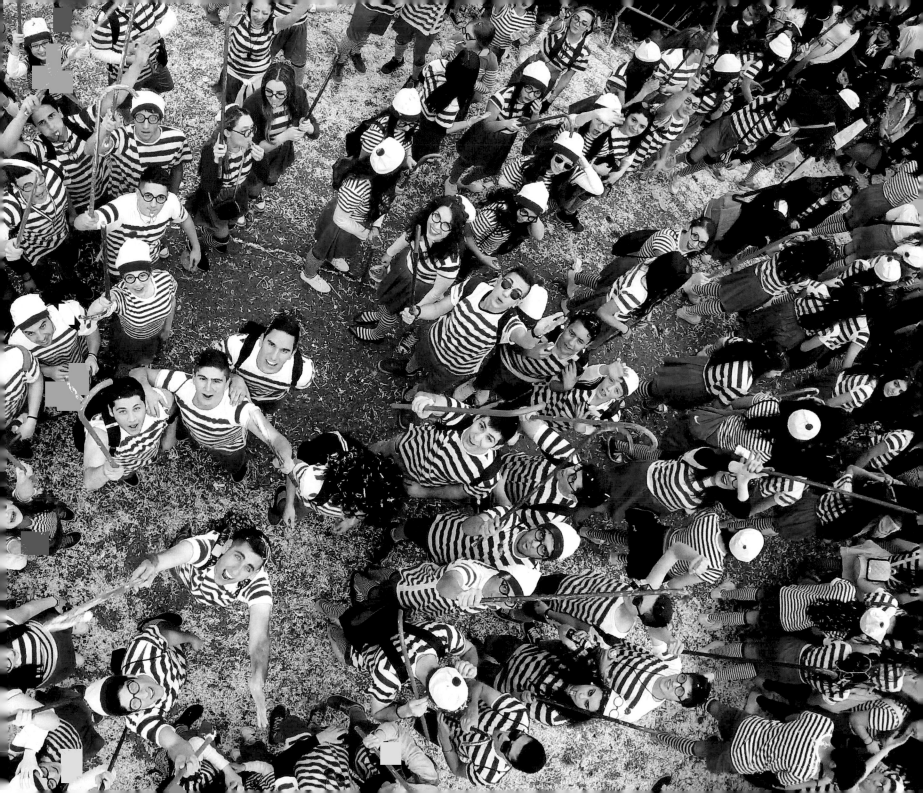

Kolkata, India
By dulaladhikary

22.6754

88.0883

1.4m (4½ft)

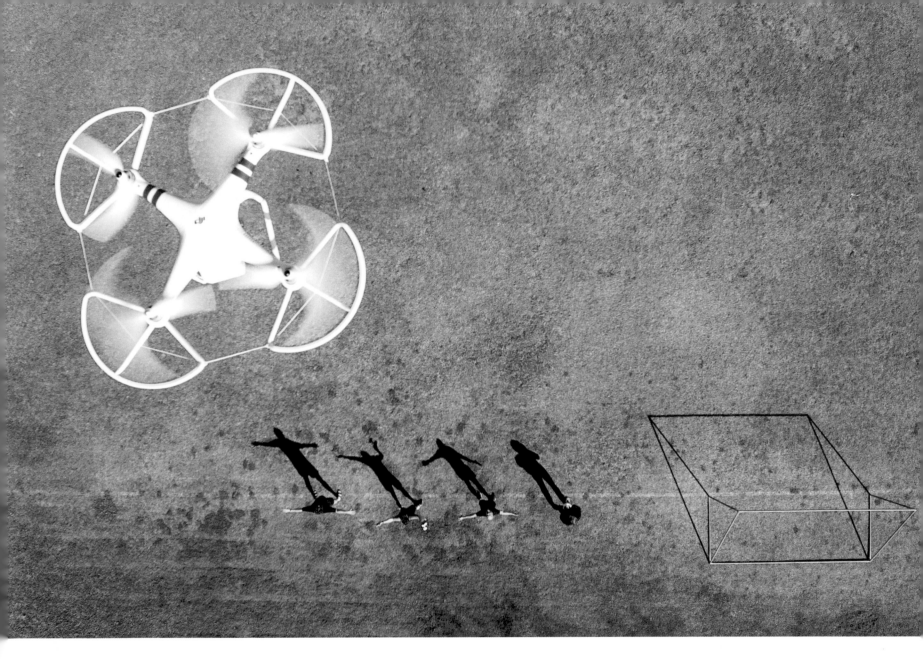

Brisbane, Australia
By Todd Kennedy

-27.4222

153.0319

16m (52½ft)

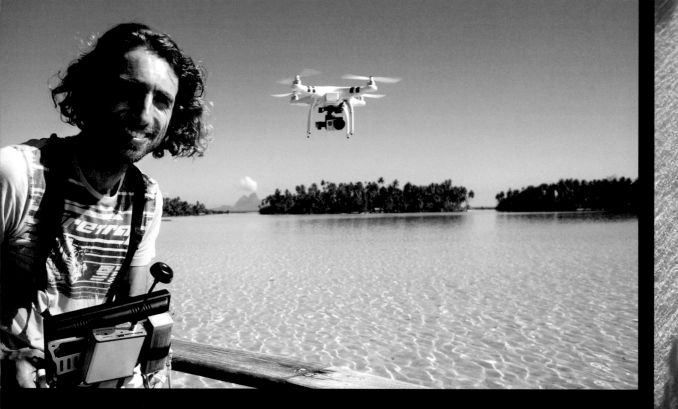

Ludovic
Moulou

Tahaa, Tahiti

⊖ -16.6167
⊕ -151.5000
↑ 100m (328ft)

AGE	36
PROFESSION	Internet security engineer, video maker and photographer for Marama Photo Video
NATIONALITY	French
BASED IN	Tahaa, Tahiti, and Aix-en-Provence, France
USES DRONES SINCE	August 2010
DRONE PIX TAKEN	500
EQUIPMENT	DJI Phantom 1 and ParrotBebop / GoPro HERO3 Black and Sony Nex5

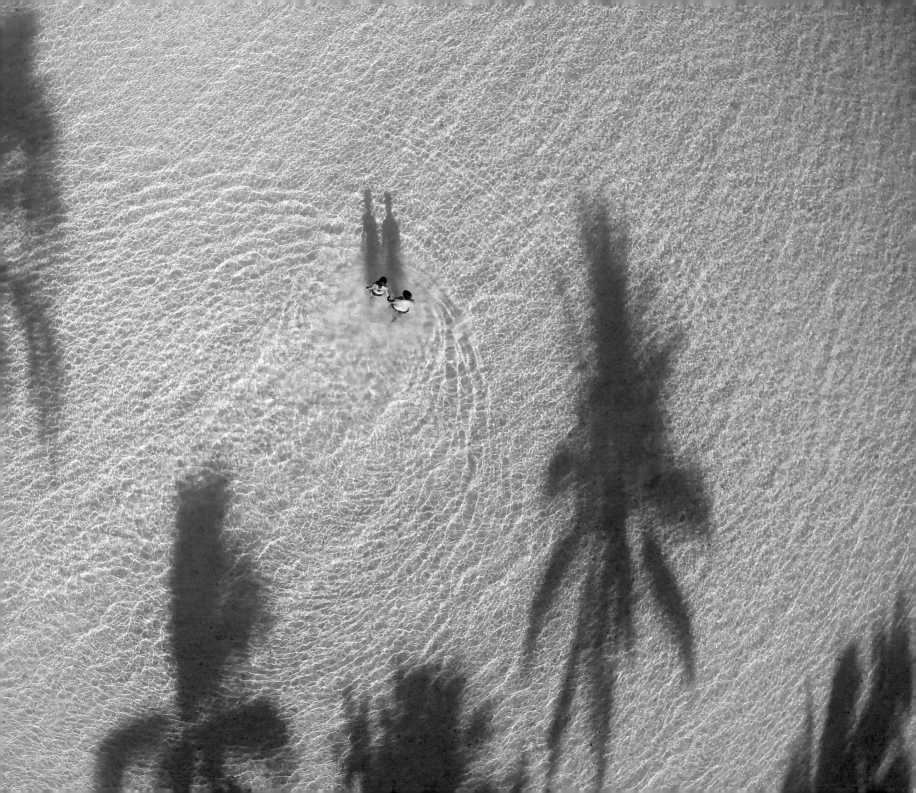

'As technology advances – with the rise of the 360-degree camera, Virtual Reality, more sensitive sensors and much more – the future of drone photography will become even more incredible.'

In 2013 Ludovic Moulou moved from Marseille to the Tahaa lagoon, an area of outstanding natural beauty located in-between the French Polynesian islands of Tahaa and Raiatea, in the middle of the Pacific Ocean. It was here that he set up a new office from which he would operate his drones – his very own motorboat – under the name of Marama Photo Video (the title by which he is known on Dronestagram; see also page 23).

Moulou works predominantly on and in the areas around the islands, capturing idyllic scenes of the natural world that most people might only dream of visiting. 'For many,' he says, 'Tahiti symbolizes paradise on Earth. If you have ever travelled to the islands by aeroplane, you would certainly remember the hypnotic beauty of the lagoon just beneath.'

Moulou is one of the only drone operators working in the area and is always busy producing photographs for tourists and local companies. Although his images provide a sense of the remoteness of the islands they are always populated with people. These individuals gently punctuate his seascapes, neither being entirely consumed by their environment, nor encroaching upon it; Moulou capturing here perhaps an ideal of the relationship between humans and the natural world. The area, he explains, provides a multitude of subjects for shooting, and he is always striving to discover them anew: 'One of my goals is to photograph from the air the humpback whales that enter the lagoon during seasonal migration...or the group of dolphins that I often encounter when I'm moving from one island to another.'

Moulou is not just an observer. He has a committed interest in the area, lecturing about drone photography in schools in the nearby Vanuatu Islands, and inviting locals to watch him work and view the scenes in his control monitor.

When Cyclone Pam hit the Vanuatu Islands in 2015, Moulou began photographing the islands' communities in the aftermath, and also played a role in bringing aid to the area. However, rather than portraying the people in these communities as victims, his photos show instead their resilience as they sought to rebuild their lives.

It is his concern for the preservation of the natural world that inspires him to work: 'most important for me is communicating that, in order to keep these fabulous landscapes, we have to fight against climate change before they disappear altogether'. The evolution of drone technology is another guiding factor: 'As technology advances – with the rise of the 360-degree camera, Virtual Reality, more sensitive sensors and much more – the future of drone photography will become even more incredible.'

In spite of working in such a glorious location, Moulou says there are challenges to the job, which include monitoring the safe return of his drone when shooting from the ocean, and preventing rust from forming on the metal elements, as well as navigating more difficult weather conditions. He finds that travelling with equipment can offer up other challenges: 'when I travel by aeroplane to other islands I often have to explain to airport staff why I carry so many lithium-polymer batteries with me. On many occasions I have had to abandon my batteries before boarding!'

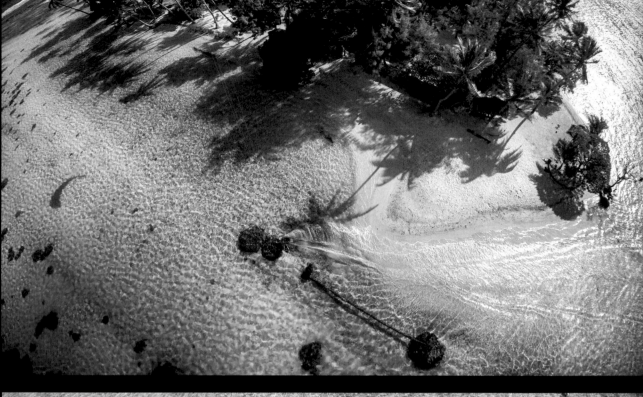

-16.6167
-151.5000
100m (328ft)

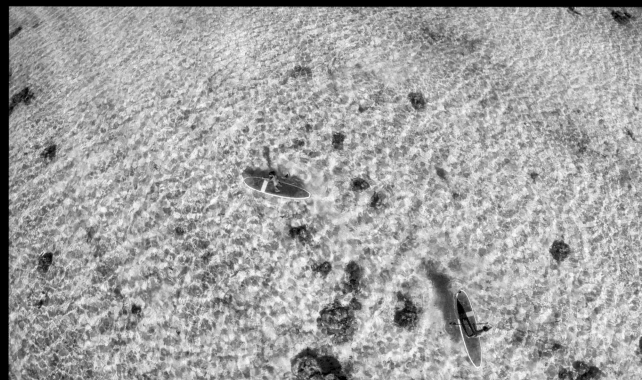

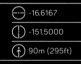

-16.6167
-151.5000
90m (295ft)

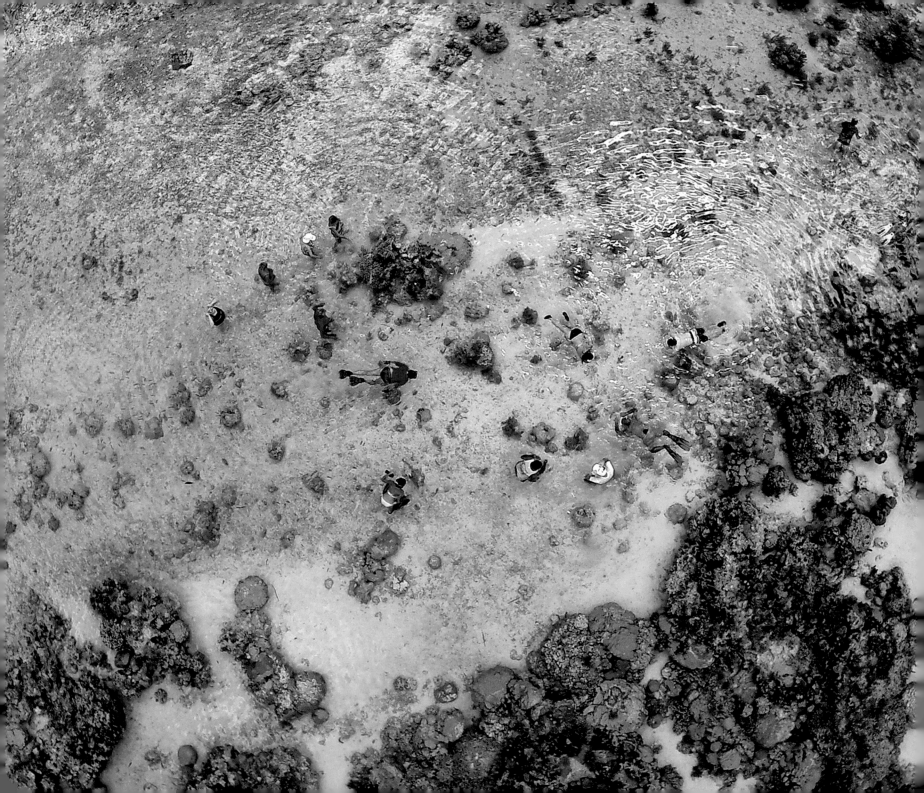

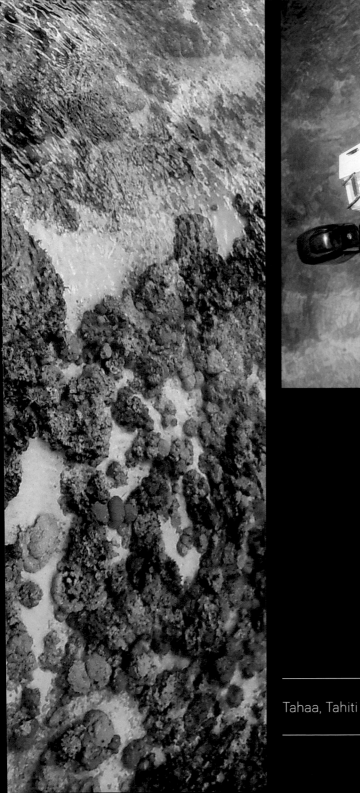

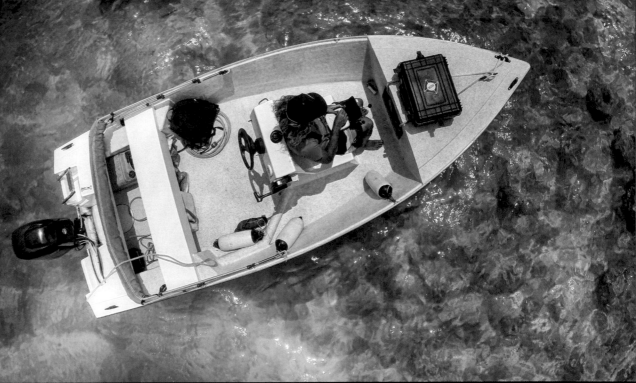

Tahaa, Tahiti

⊖ -16.6167
⌀ -151.5000
⊕ 15m (50ft)

Tahaa, Tahiti

⊖ -16.6167
⌀ -151.5000
⊕ 70m (229½ft)

'...most important for me is communicating that, in order to keep these fabulous landscapes, we have to fight against climate change before they disappear altogether.'

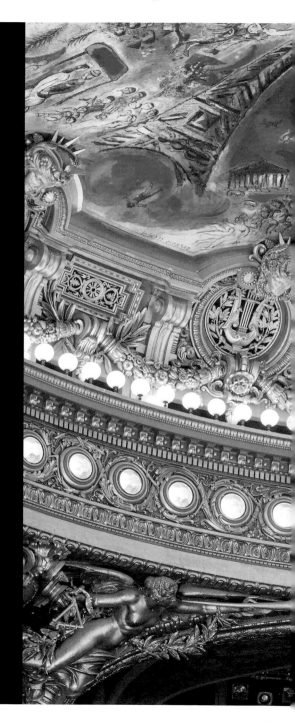

CHAPTER 2

CLOSE

Rio de Janeiro, Brazil
By Alexandre Salem

⊖ -22.9068
⏐ -43.1729
↑ 900m (2,952ft)

This is the iconic Christ the Redeemer, created by the artist Paul Landowski and the engineer Heitor da Silva Costa, and constructed at the peak of Corcovado, a mountain located in the city's Tijuca Forest National Park.

The photographer, Alexandre Salem (see also pages 136, 138–40 and 142–43), often takes nature as his subject, and his drone accompanies him on his numerous hiking trips across the country. For this photograph, taken at sunset, he used a GoPro HERO4 camera and a DJI Phantom 1.

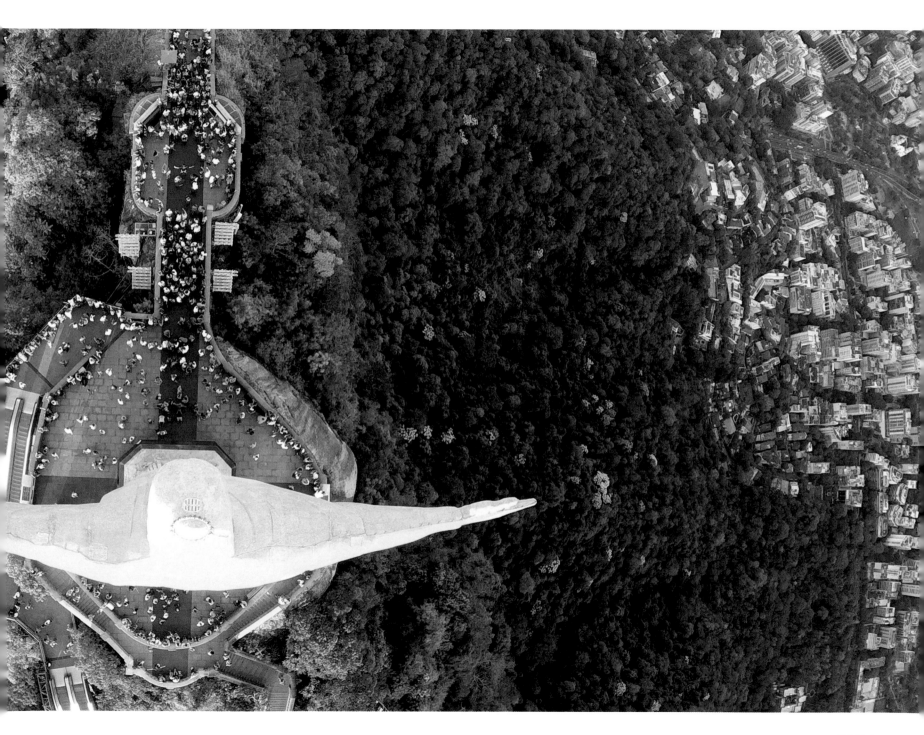

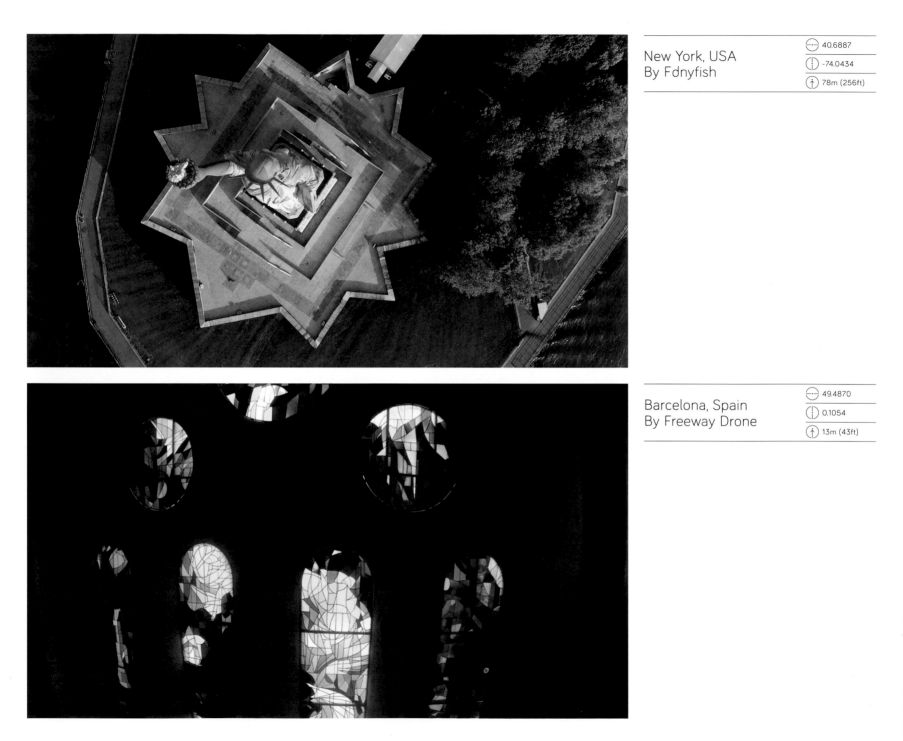

New York, USA
By Fdnyfish

40.6887
-74.0434
78m (256ft)

Barcelona, Spain
By Freeway Drone

49.4870
0.1054
13m (43ft)

Barcelona, Spain
By joanlesan

⊖ 41.4036
⌀ 2.1743
↑ 155m (508ft)

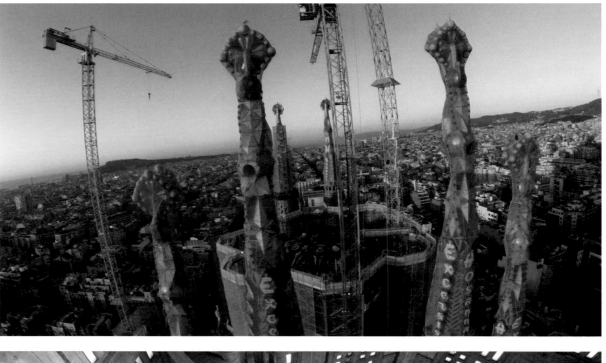

Le Havre, France
By Freeway Drone

⊖ 49.4910
⌀ 0.1012
↑ 75m (246ft)

A view from inside the 84m (275ft) steeple of St Joseph's Church in the city of Le Havre in France, taken by the dronester duo Freeway Drone while shooting the Tour de France. This vertiginous shot was made using a DJI S1000 and DJI Zenmuse Z15-GH4.

Members of Dronestagram since 2013, Freeway Drone are professional photographers otherwise known as Michael Gisselere and Christelle Bozzer. Between them they have a wealth of experience of working in television and making documentary films. See also pages 38–39, 42, 148–49 and 166.

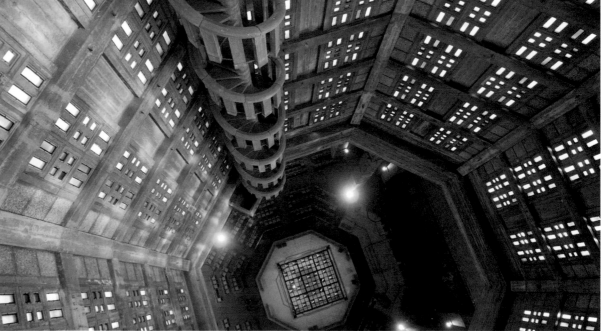

Marseille, France
By princehamlet

⊖ 43.2843
⊘ 5.3712
⊕ 226m (740ft)

Kapiti Coast,
New Zealand
By grant

⊖ -40.9174
⊘ 175.0181
⊕ 12m (39ft)

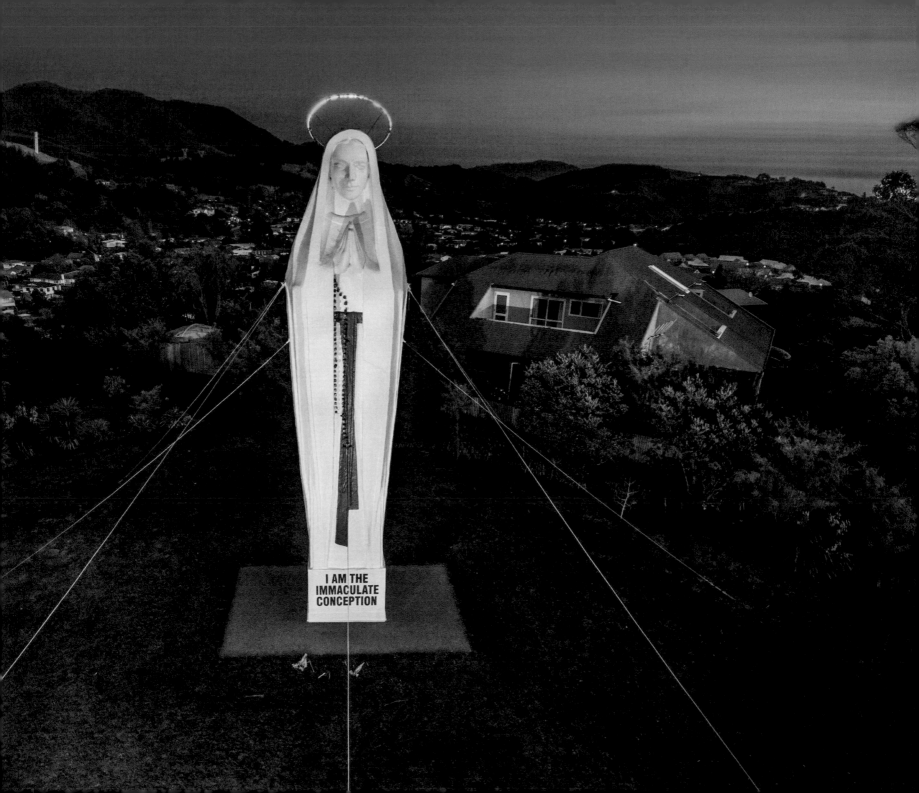

San Francisco, USA
By GotShots

37.8255
-122.4791
27m (88½ft)

Shot using a DJI Phantom 2 Vision+, this picture nearly didn't come to fruition. It took GotShots six months of returning to the site before the weather conditions were just right for flying and taking the perfect image.

Launching the quadcopter from the Marin Headlands to the north side of the bridge, an area in which the wind speeds can reach up to 35mph, the photographer found it a challenge to control the drone. However, after several attempts, he finally achieved the composition he had envisaged, with the pillars of the bridge acting as a frame through which the city could be seen. The composition is slightly off-centre to show as much of San Francisco as possible. With state regulations cracking down on drones flying in the area, pictures like this one could soon be a thing of the past.

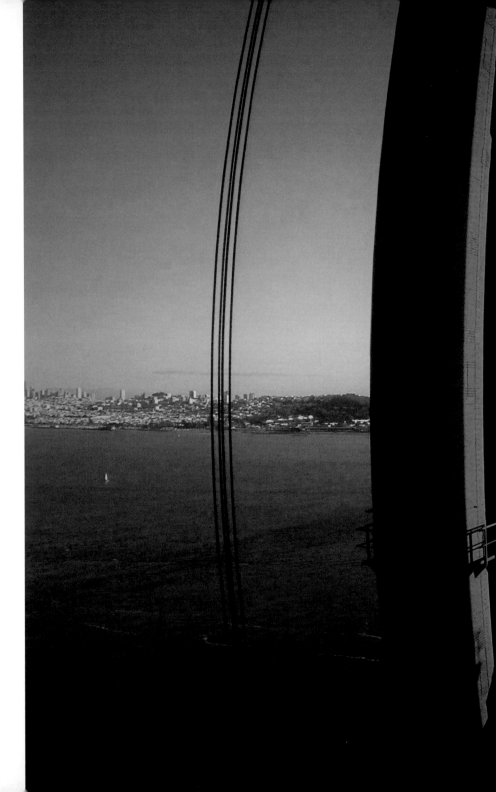

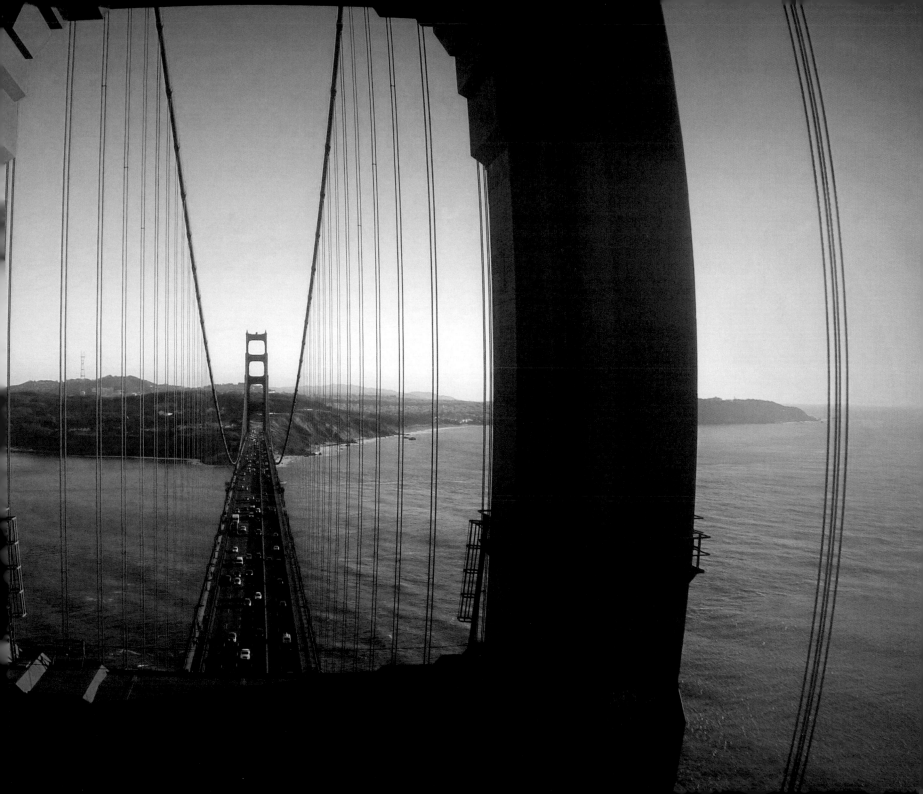

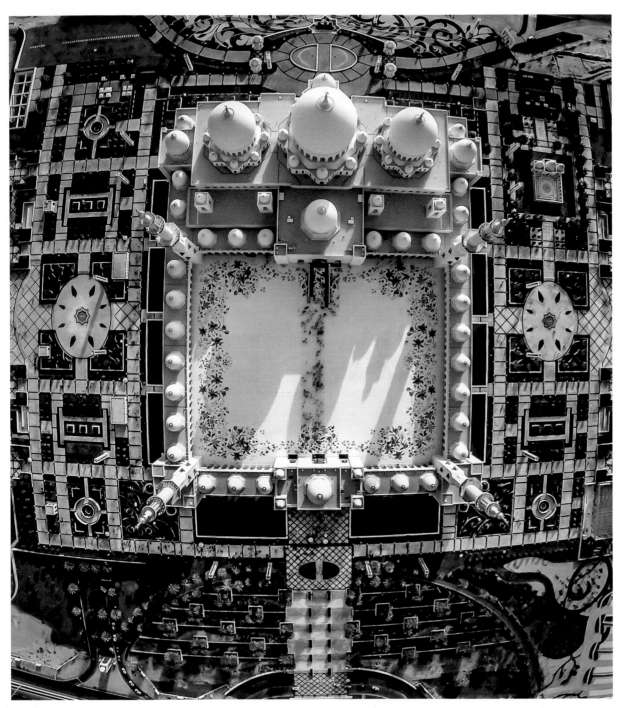

Abu Dhabi, UAE
By JoRoMedia

○┈┈ 24.4125
│! 54.4749
↑ 11m (36ft)

Kalyazin, Russia
By AAvdeev

○┈┈ 57.2438
│! 37.8572
↑ 100m (328ft)

The Kalyazin Bell Tower is a 74.5m-
(244ft)-high Neoclassical structure built
in 1796–1800 and located in a reservoir on
the Volga River near Kalyazin in Russia.
When the Uglich Dam was constructed
in 1939 to form the reservoir many
historical structures, including this one,
were submerged in water. Now a tourist
attraction, this icon was captured by the
photographer (full name Alexey Avdeev)
using a DJI Phantom 2 with a GoPro HERO3
Black camera and DJI Zenmuse H3-2D
gimbal and FPV system.

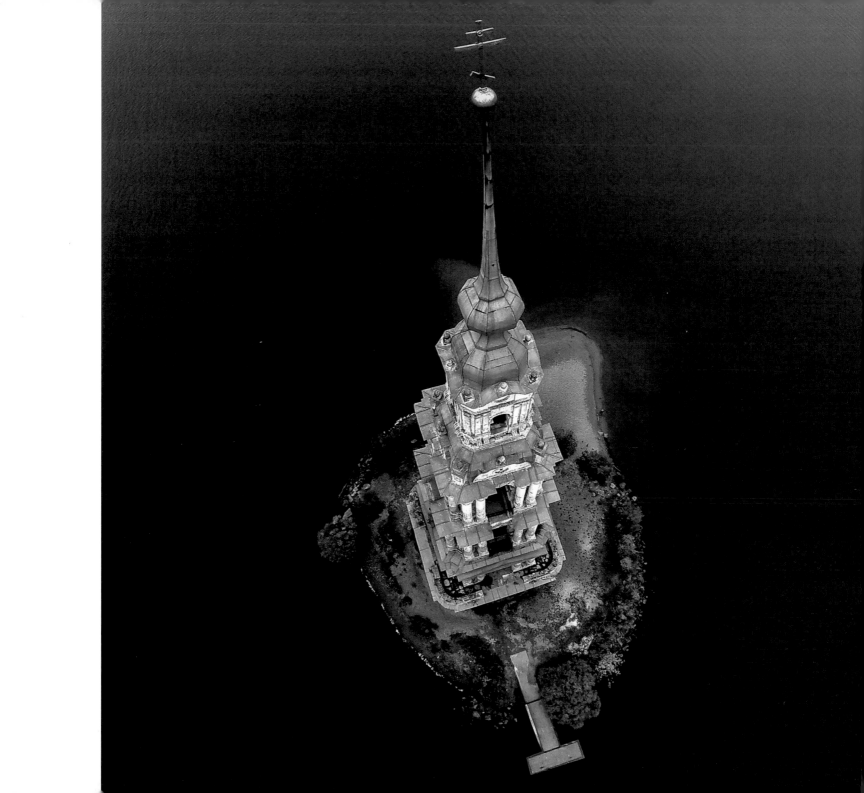

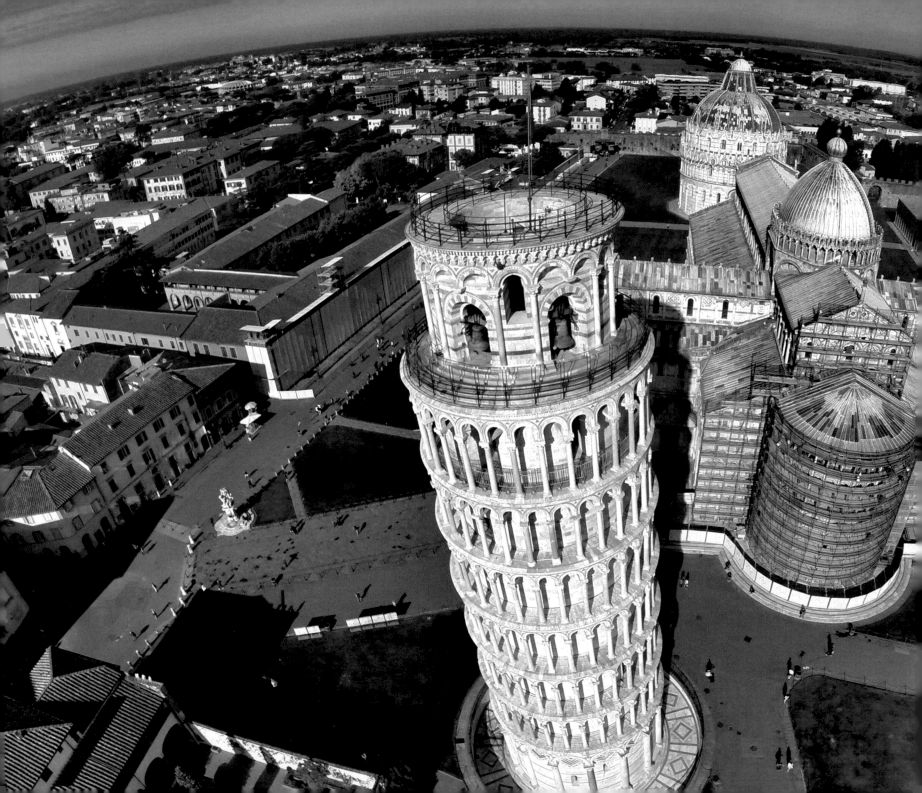

Pisa, Italy
By kolibik-foto

⊕ 43.7229
⊘ 10.3944
↑ 60m (197ft)

CHAPTER 3

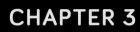

URBAN

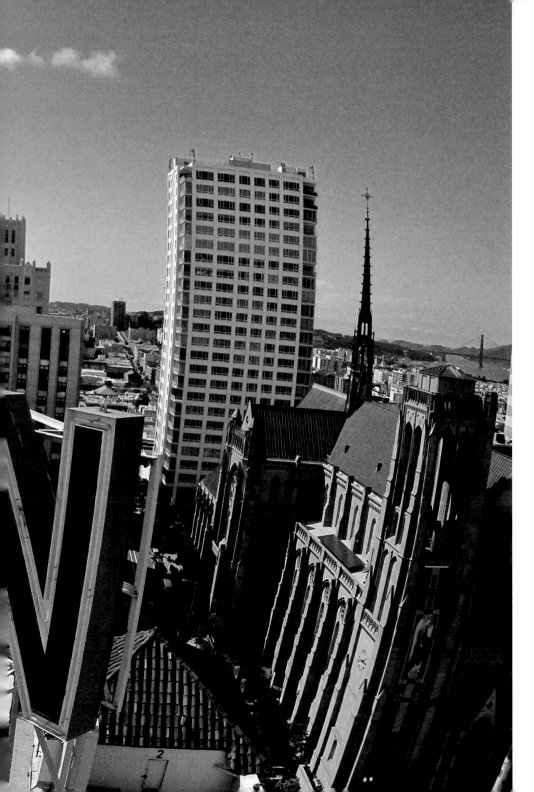

San Francisco, USA
By cameralends

⊖ 37.7912

⌀ -122.4118

⊕ 230m (754½ft)

One of the 'big four' atop San Francisco's
Nob Hill, the Huntington Hotel is one of
the city's most iconic buildings. This shot
was taken by the photographer using a DJI
Phantom 2 Vision.

Marina Bay, Singapore
By Jefftan

⊖ 1.2637

◐ 103.8108

⬆ 60m (197ft)

Captured with a DJI Phantom 3
Professional, this aerial panorama
shows Singapore's Marina Bay at night,
a 360-hectare development that merges
into the city's downtown district.
Dronester Jefftan has been sharing his
drone photography, which focuses largely
on the areas in and around Singapore,
on Dronestagram since 2015.

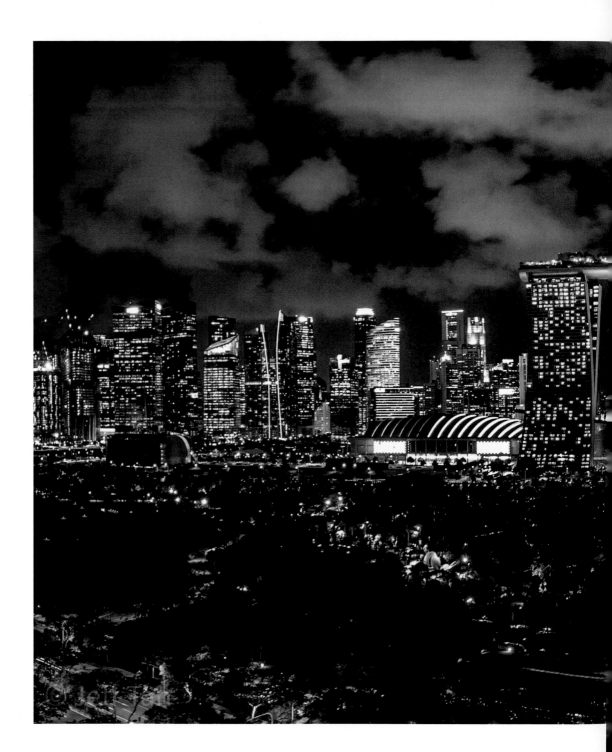

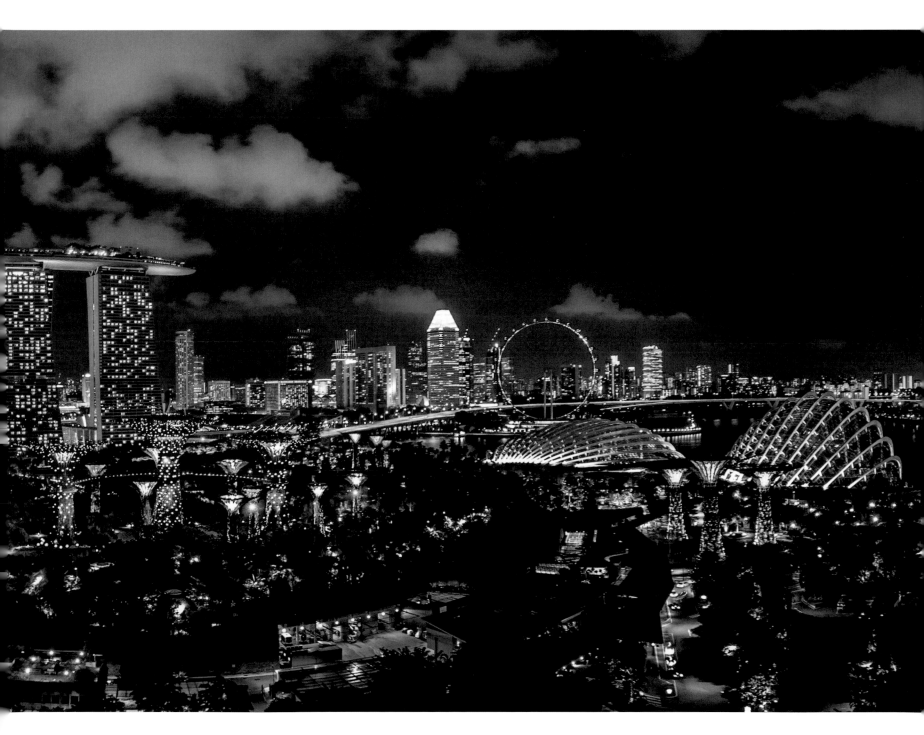

Edinburgh, Scotland
By Francesco Gernone
Photo

⊖ 55.9494
⊙ -3.1911
⊕ 30.8m (103ft)

Taken with a DJI Phantom 2 Vision+, this image captures a section of Edinburgh's Royal Mile, a succession of streets a mile long running through the heart of the city's old town, and connecting Edinburgh Castle with the Palace of Holyroodhouse.

The photographer describes the photograph: 'To the right of this scene is St Giles's cathedral, to the left, the houses typical of the period in which the "mile" was constructed, and in the centre, the iconic pathway. The presence of these three elements, along with the few people that populate the shot, make this a unique visual.' See also page 198.

Katowice, Poland
By droneland.pl

⊖ 50.2633
⊙ 19.0341
⊕ 100m (328ft)

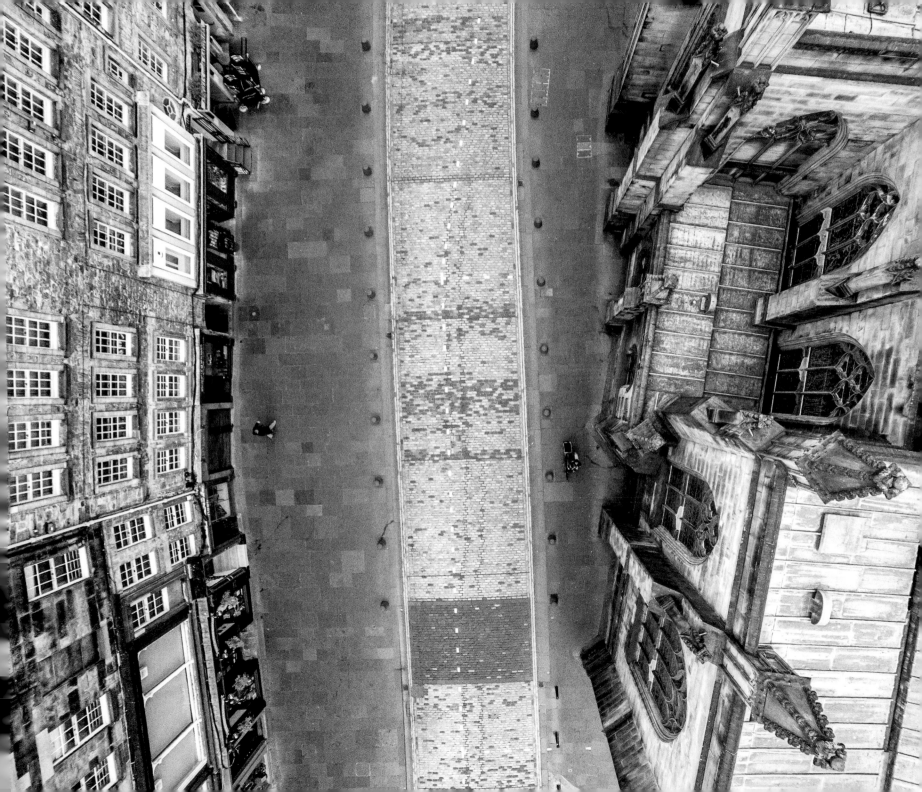

New York, USA
By Tushevsaerials

⊖	40.7486
⊕	-73.9451
⊕	121m (397ft)

Tushevsaerials has been building his
own remote-control aeroplanes and
quadcopters for more than a decade,
but he now most frequently operates a
DJI Phantom 3 Professional. Based in
Long Island City in New York, he uses his
drone to record the rapid redevelopment
of this area, as well as the unrivalled views
it offers of the city's skyline. This shot
shows the 50-storey Citibank building,
which fast became a landmark after its
completion in 1990.

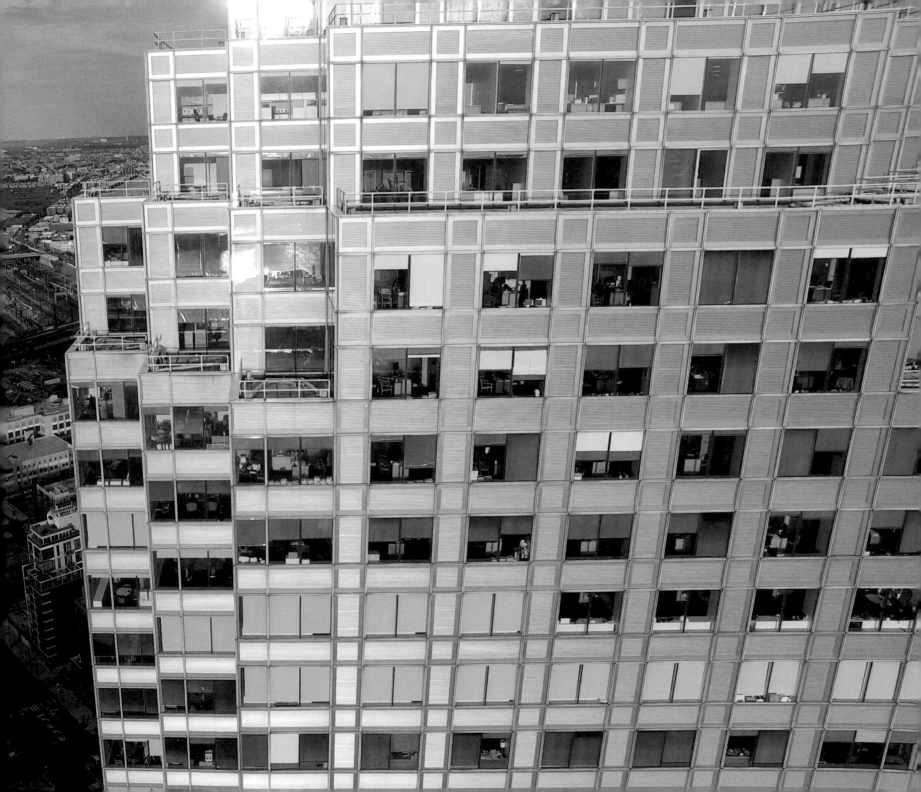

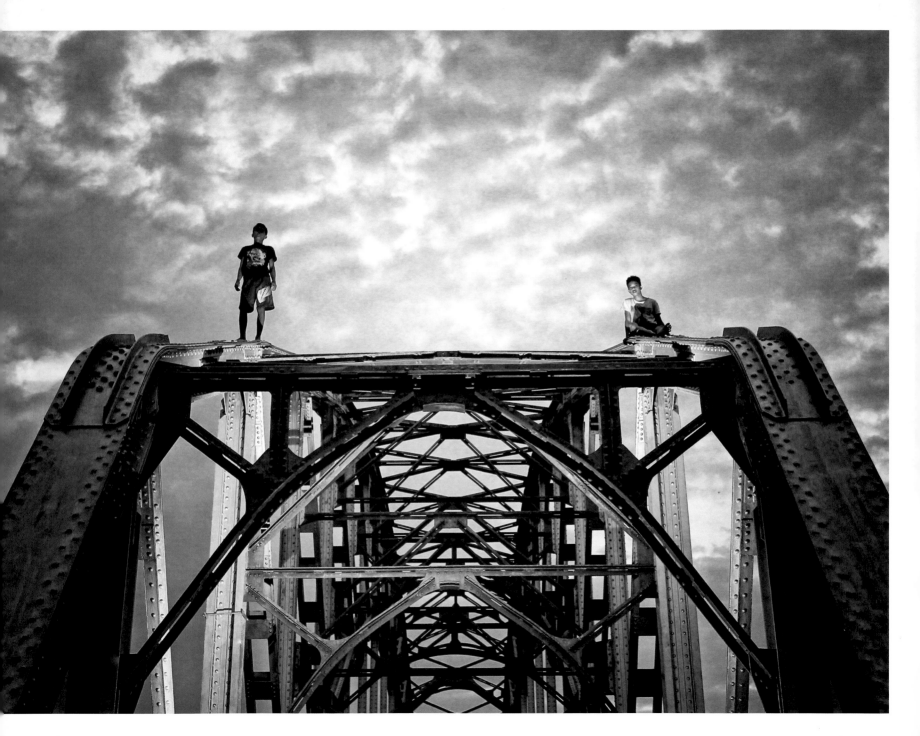

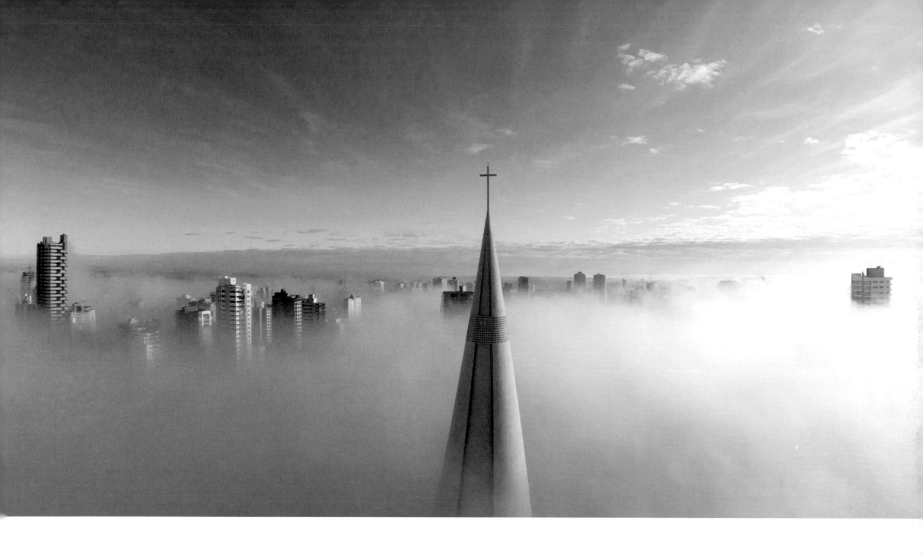

Maringá, Brazil
By Ricardo Matiello

⊖ -23.4262
◐ -51.9382
↑ 550m (1,804ft)

This image, showing the spire of Maringá's
cathedral through the morning mist, was
the recipient of the 2015 Dronestagram/
National Geographic international drone
photography award, in the category 'Places'.

Medan, Indonesia
By ajdaulay

⊖ 3.5835
◐ 98.5706
↑ 9m (30ft)

Plovdiv, Bulgaria
By IceFire

⊖ 42.1448
◐ 24.7603
↥ 323.2m (1,060ft)

Mérida, Mexico
By jelipegomez

⊖ 20.9911
◐ -89.6013
↥ 15m (50ft)

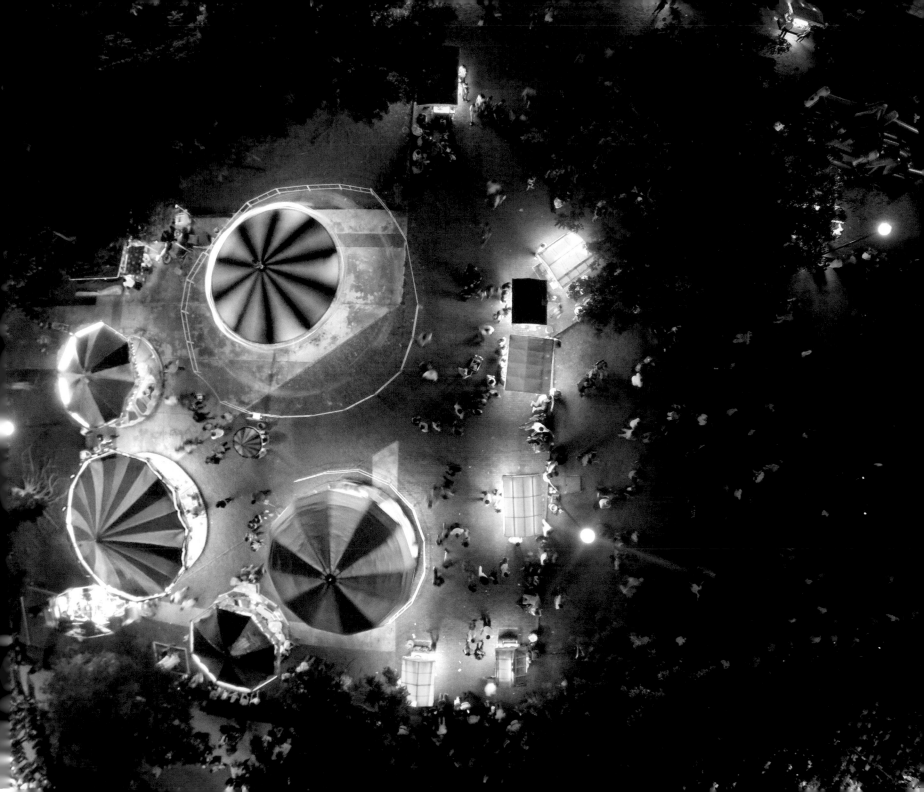

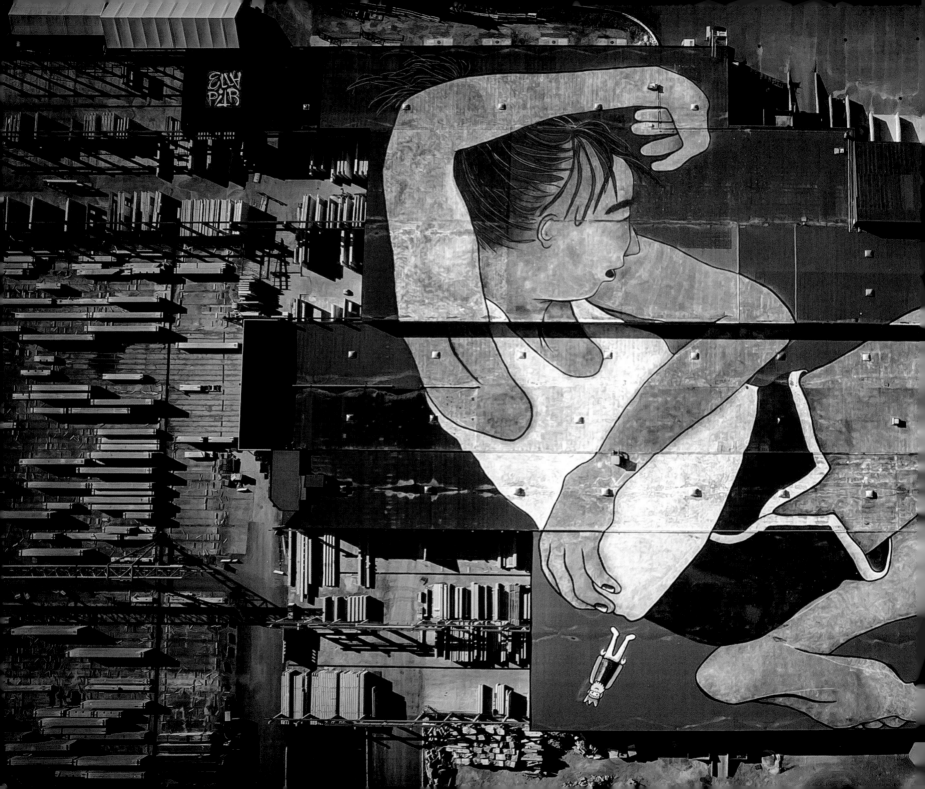

Klepp, Norway
By brentdebleser

⊖ 58.7839

⏱ 5.7053

↑ 199.9m (656ft)

This is the world's largest outdoor mural, commissioned by Norway's Nuart Festival and made by the artists Ella & Pitr. The project covers 21,000m² (226,000ft²) and can be seen from the aircraft flying into and out of Stavanger airport nearby. Titled *Lilith and Olaf,* it shows a woman whose body has been contorted to fit the dimensions of the roof, with a small figure appearing to fall from her fingers. That figure is King Olaf I of Norway, who ruled the country from 995–1000. The mural was photographed by brentdebleser using a DJI Phantom 3.

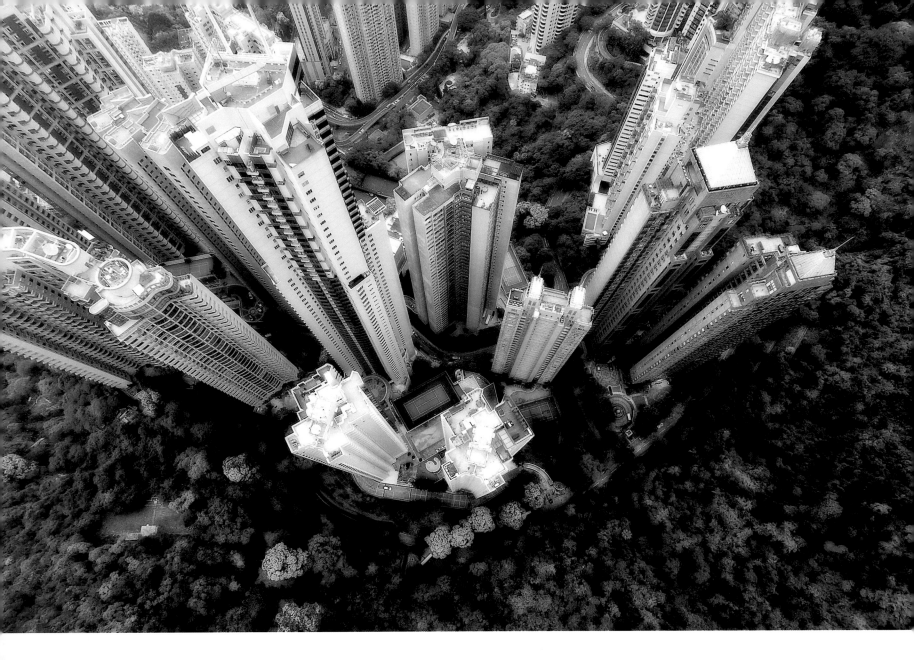

Hong Kong, China
By iP

⊖ 22.2738
① 114.1519
↑ 448m (1,470ft)

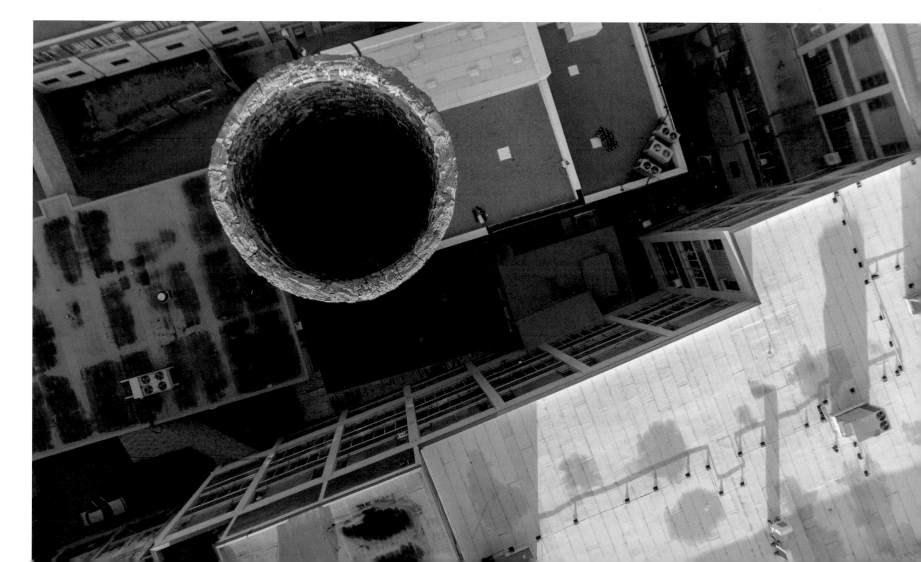

Vancouver, Canada
By mikebish

49.2560
-123.2639
22m (72ft)

Verdun, Canada
By Meantux

45.4548
-73.5698
33m (108ft)

With his DJI Phantom 2 Vision+, Meantux captures here the demolition of the Eglise Notre-Dame-de-la-Paix in Verdun in 2014, before its redevelopment into a six-storeyed building to provide public services for older people. See also page 69.

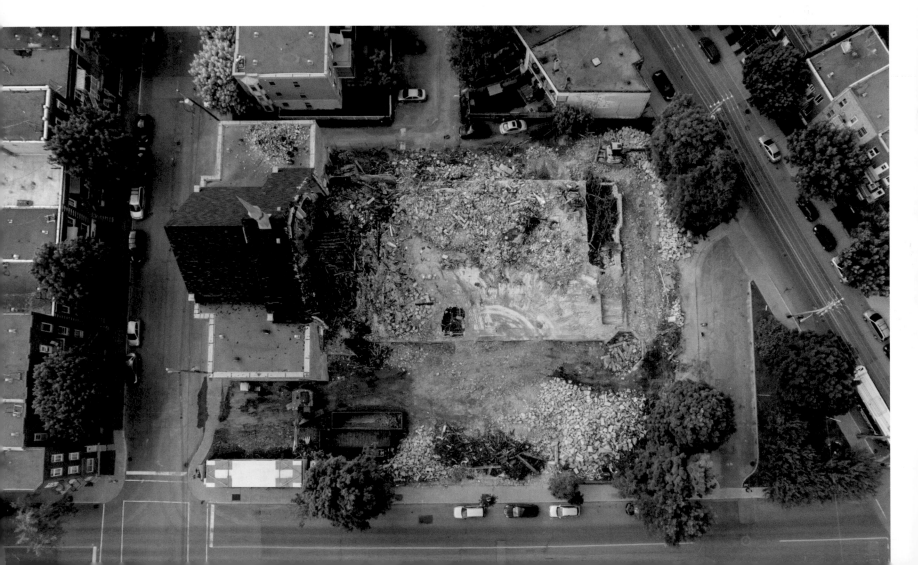

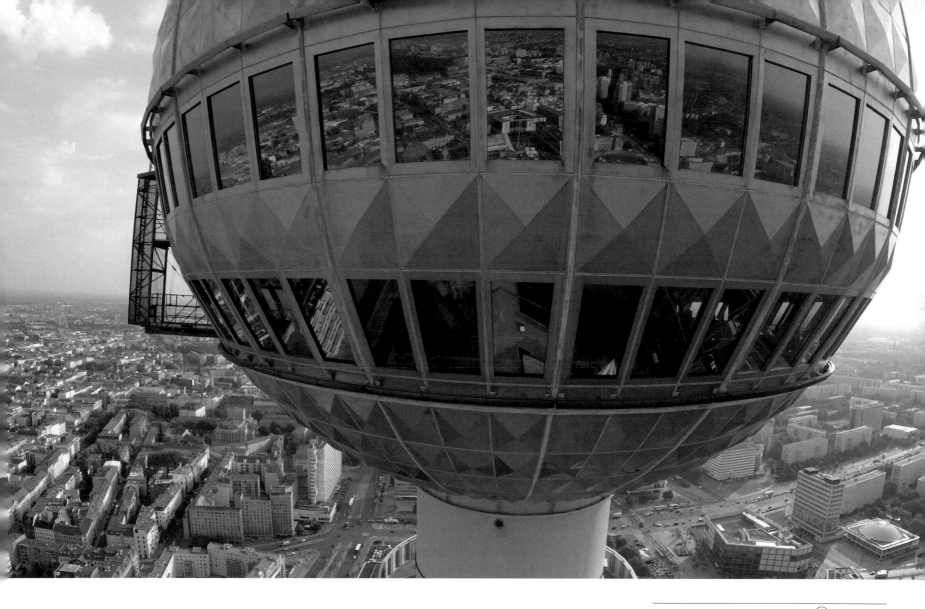

Berlin, Germany
By Benson750

⊕ 52.5208

◷ 13.4094

↥ 230m (754½ft)

Titled *The Windows of Berlin*, this picture
was taken with a GoPro HERO4 and a DJI
Phantom 1 and shows a close-up of Berlin's
television tower.

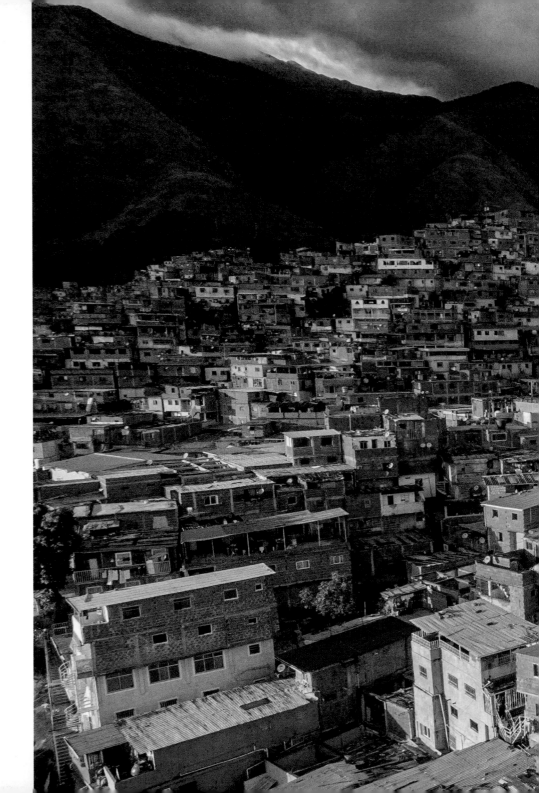

Caracas, Venezuela
By vectordragonfly

⊖ 10.4704

⏸ -66.7992

⊕ 155m (508½ft)

These are the favelas of the Petare
neighbourhood in Caracas, Venezuela,
photographed by vectordragonfly using a
DJI Phantom 2 Vision. This picture shows
only a small section of what is one of the
biggest slums in South America, with a
population of 400,000. This dronester lives
and works in Caracas and has been
a member of Dronestagram since 2015.

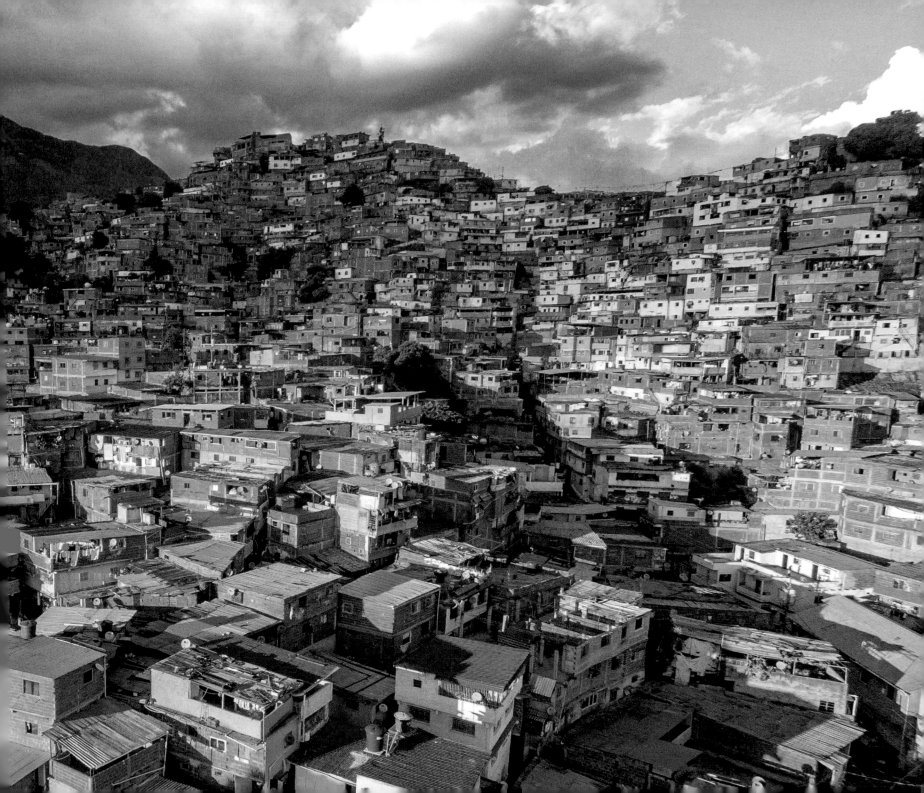

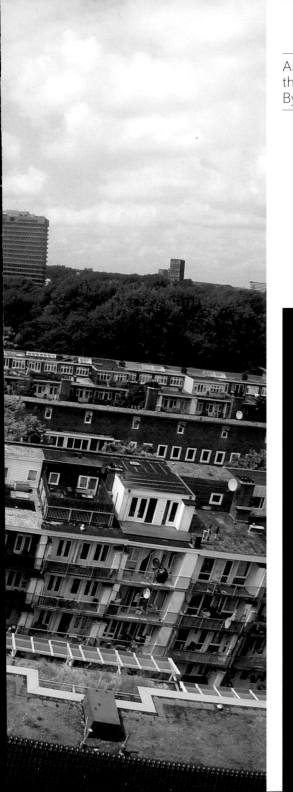

Amsterdam,
the Netherlands
By sandermuts

⊖ 52.3690
(!) 4.8509
(↑) 30m (100ft)

Paraná, Brazil
By Ricardo Matiello

⊖ -23.6035
(!) -51.6433
(↑) 120m (394ft)

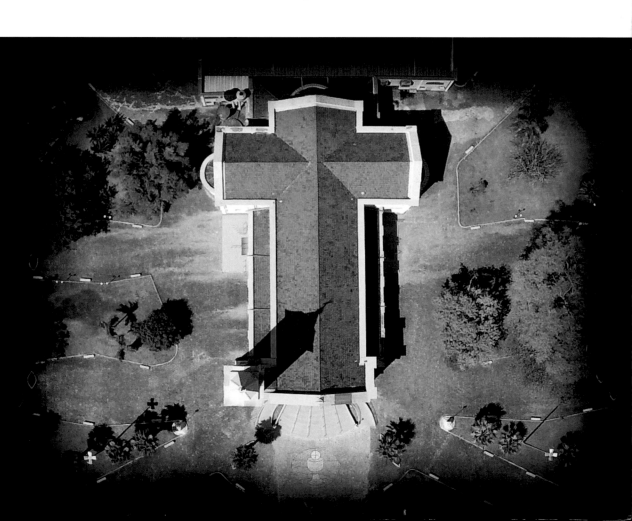

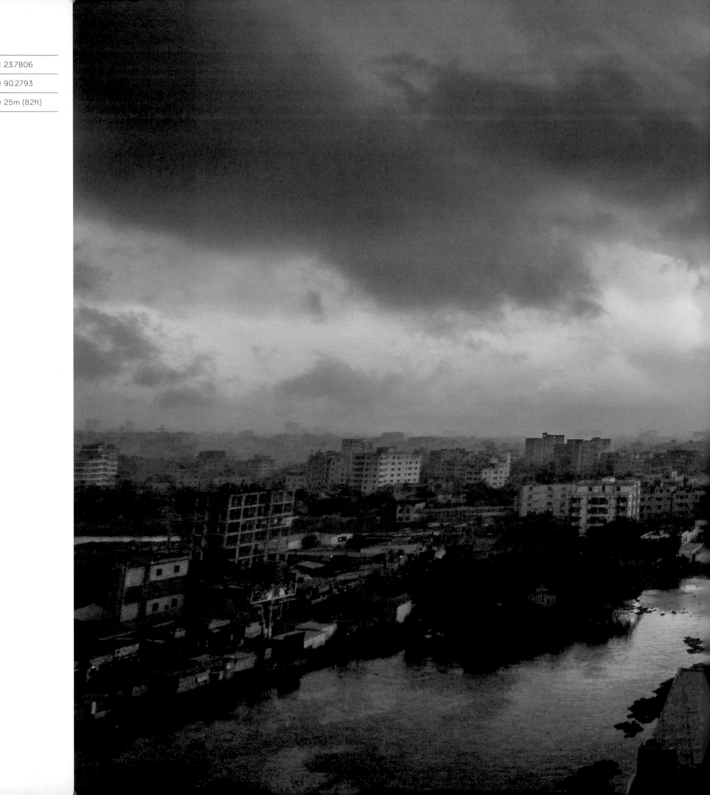

Dhaka, Bangladesh
By zayedh

23.7806
90.2793
25m (82ft)

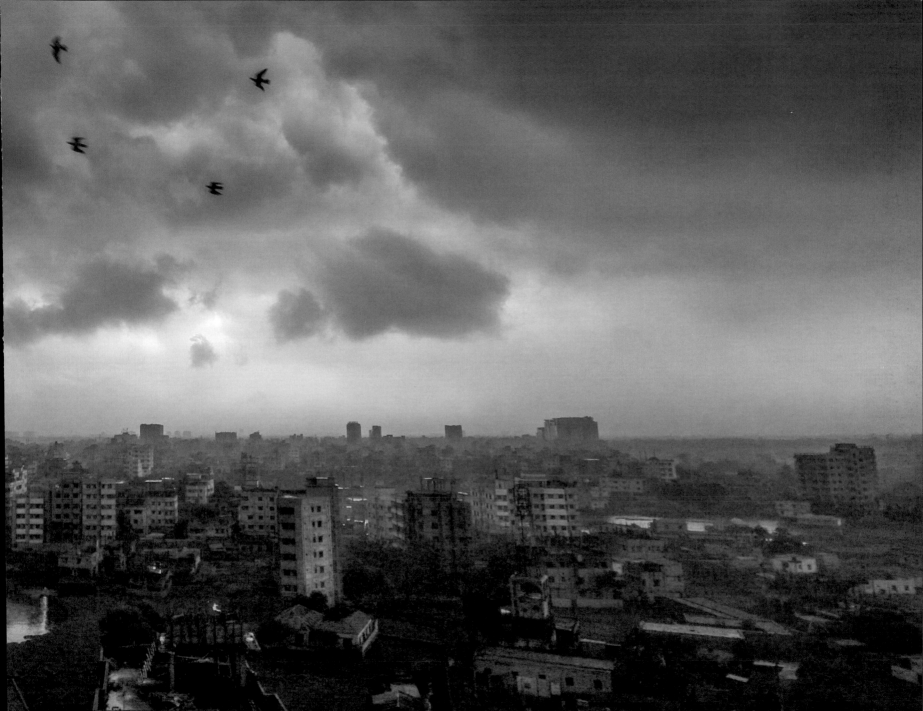

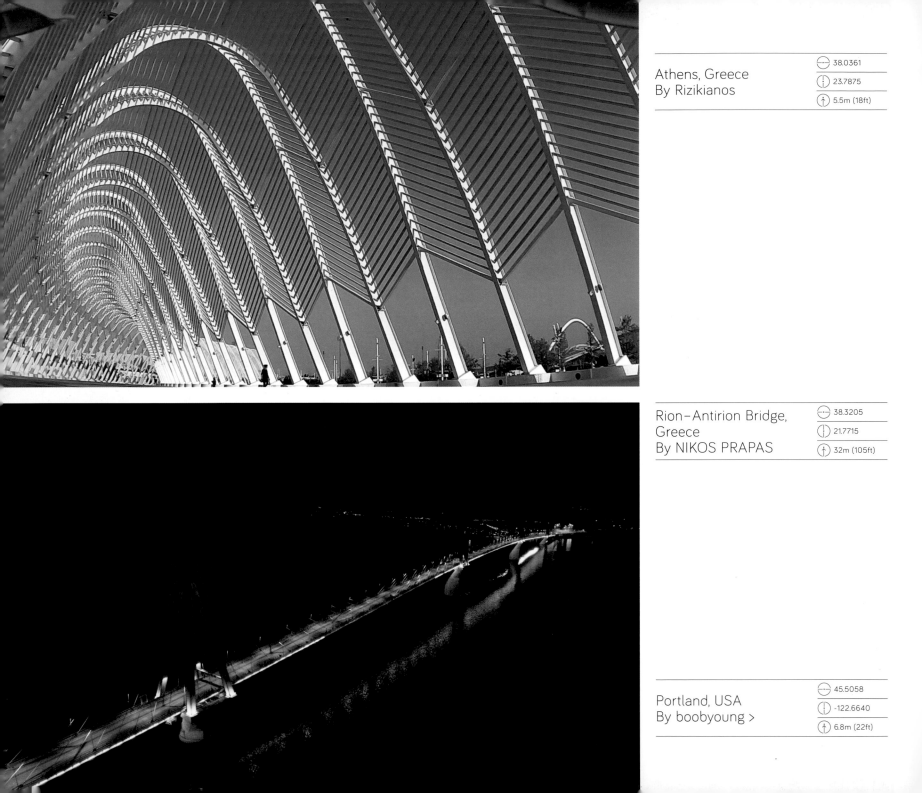

Athens, Greece
By Rizikianos

⊖ 38.0361
◔ 23.7875
⬆ 5.5m (18ft)

Rion–Antirion Bridge,
Greece
By NIKOS PRAPAS

⊖ 38.3205
◔ 21.7715
⬆ 32m (105ft)

Portland, USA
By boobyoung >

⊖ 45.5058
◔ -122.6640
⬆ 6.8m (22ft)

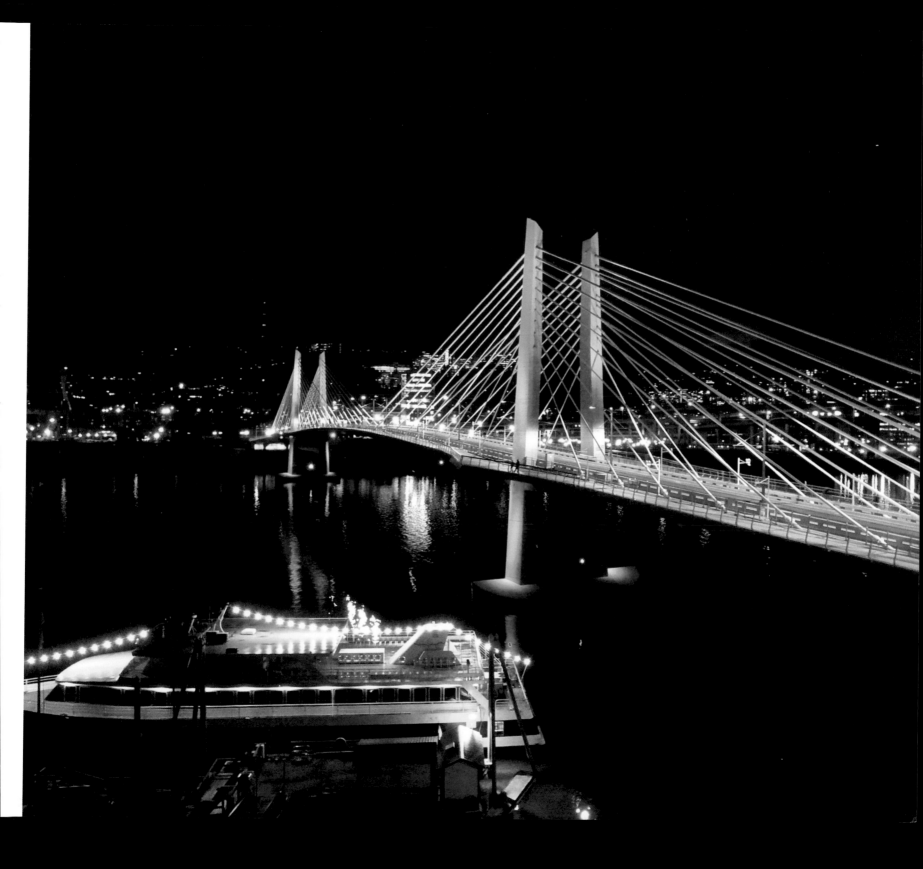

Miami, USA
By iMaerial_com

25.7818
-80.1352
40m (131ft)

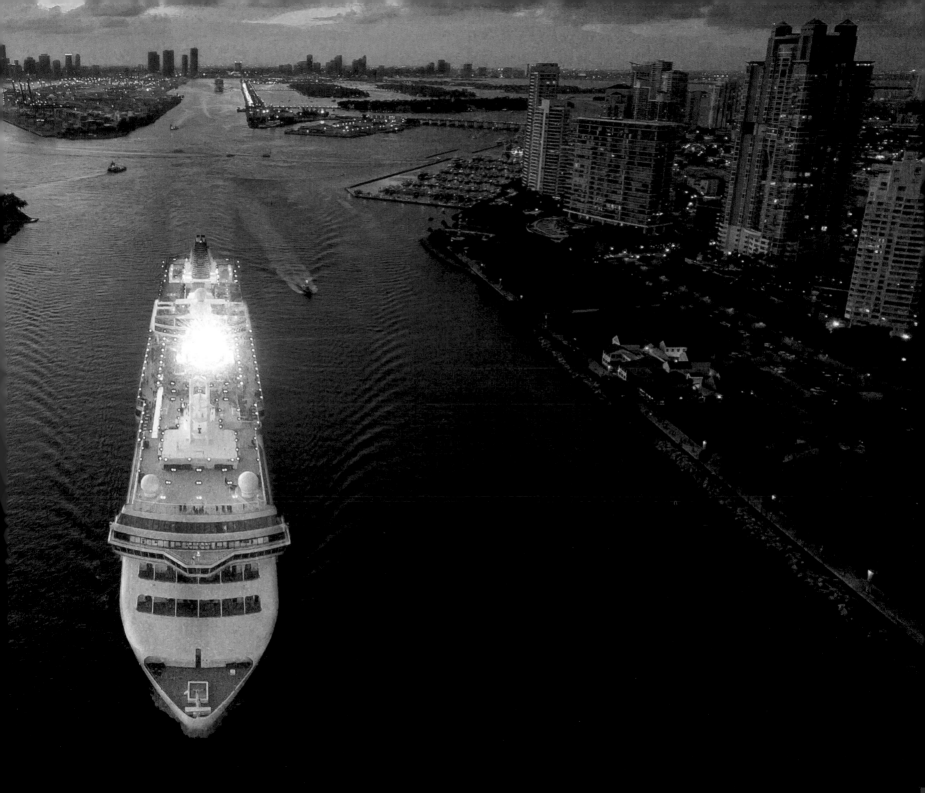

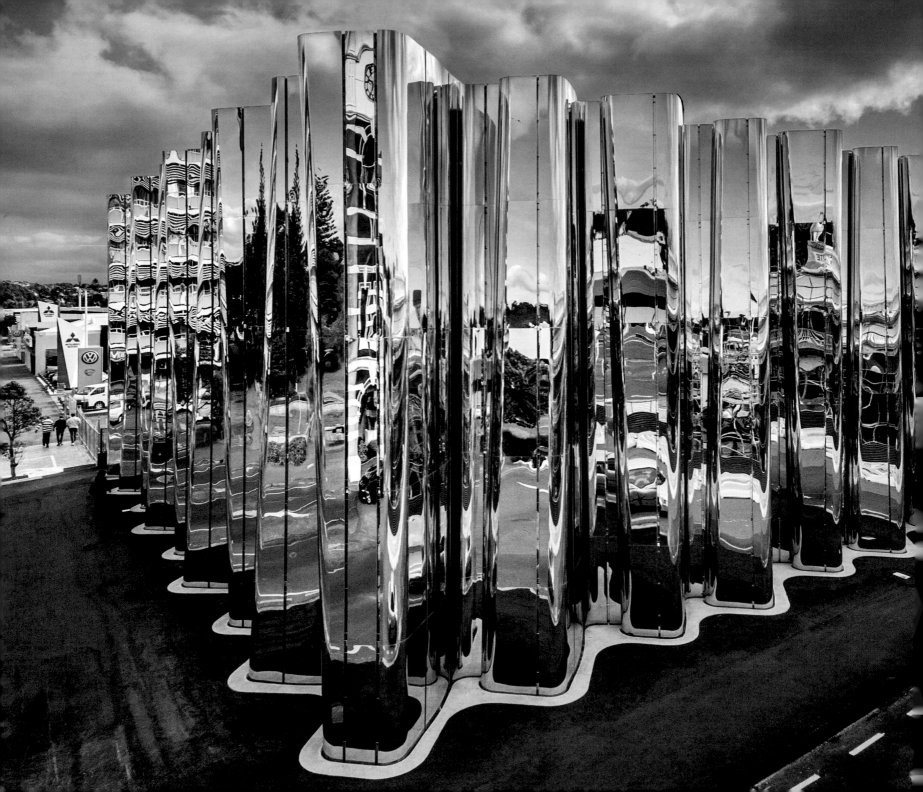

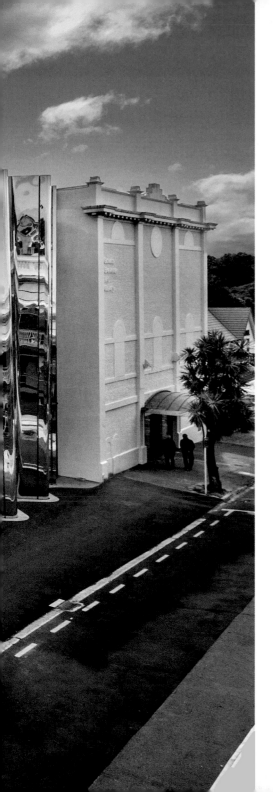

New Plymouth City,
New Zealand
By grant

⊖ -39.0647
① 174.0729
⬆ 8.9m (29½ft)

This 'stepped' mirror building is the
Govett-Brewster Art Gallery in New
Plymouth, New Zealand. Len Lye was an
internationally renowned and influential
filmmaker and kinetic sculptor, who
worked in the USA in the 1920s and 1930s.
The photo was taken by grant using a DJI
Phantom 1, which he had to launch from
a hotel balcony across the street because
he was not allowed to fly from the road
below. See also page 101.

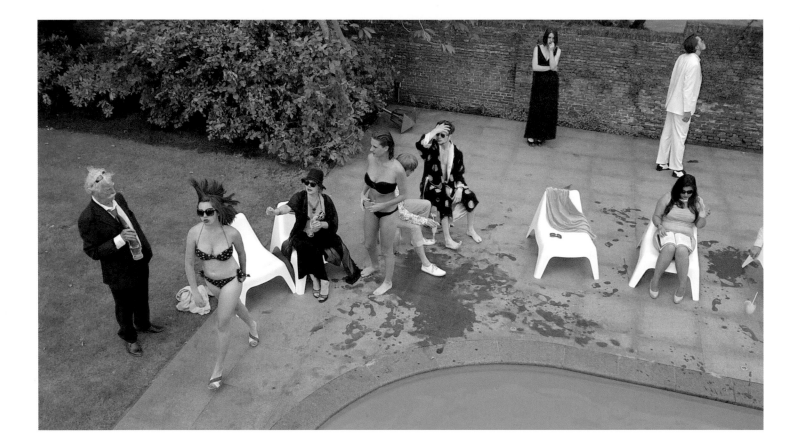

Rijnsburg,
the Netherlands
By Toine

⊖ 52.1984

⊙ 4.4300

⬆ 3.2m (10½ft)

While this aerial shot suggests that the
photographer has stumbled upon
the private scenes of a pool party, it in
fact shows a group of actors, from the
Dutch theatre group Hardt, on set. It was
taken by Toine, who also runs his own
film and photography company. Aircarus
Productions, using a DJI F550 with GoPro
HERO3 Black with MP10 lens.

San Jose, USA
By romeoch

⊖ 37.3355

⊙ -121.8914

⬆ 14.5m (48ft)

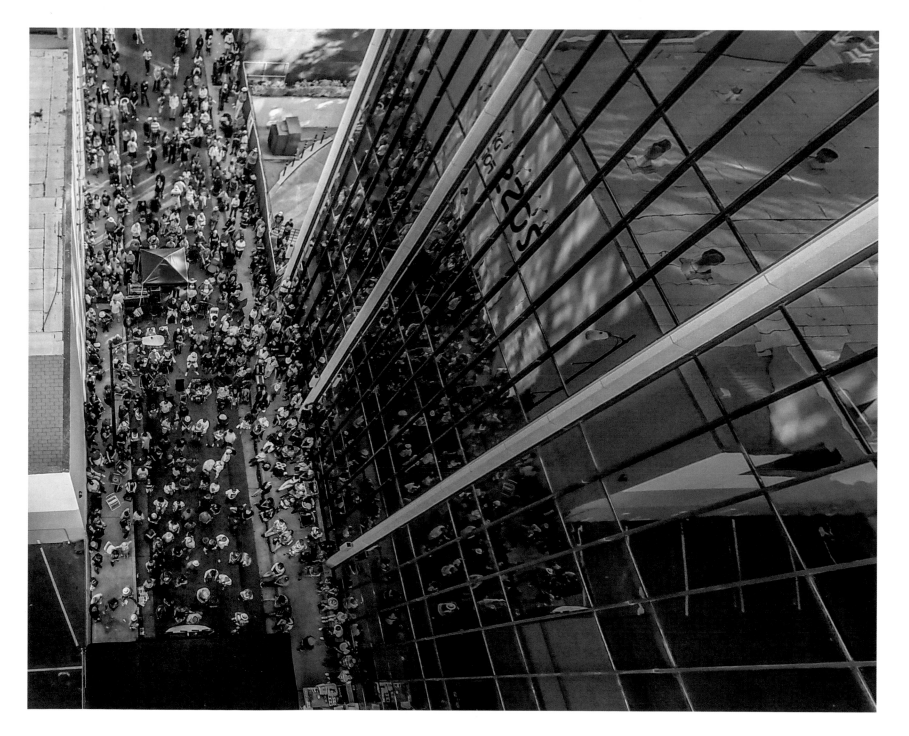

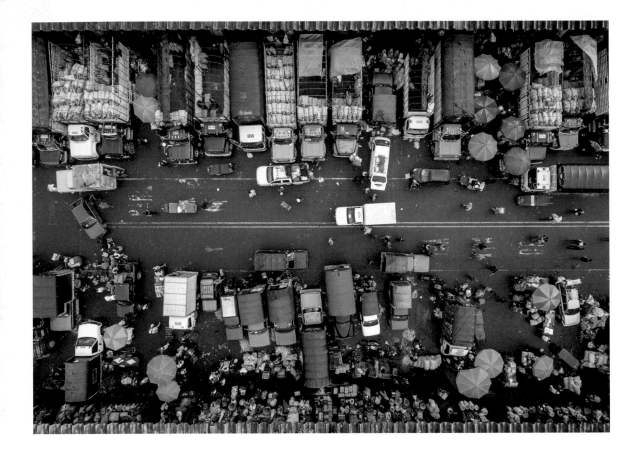

Bogotá, Colombia
By AlexVisbal

⊕ 4.6313
⌀ -74.1613
↑ 13m (43ft)

This shot was taken by photographer Alex Visbal in collaboration with Alejandro Pabon, using a DJI Phantom 3. It shows one section of the sprawling and colourful market of Corabastos, one of the largest in Bogotá.

Austin, USA
By 1138 Studios

⊕ 30.2716
⌀ -97.7412
↑ 5.5m (18ft)

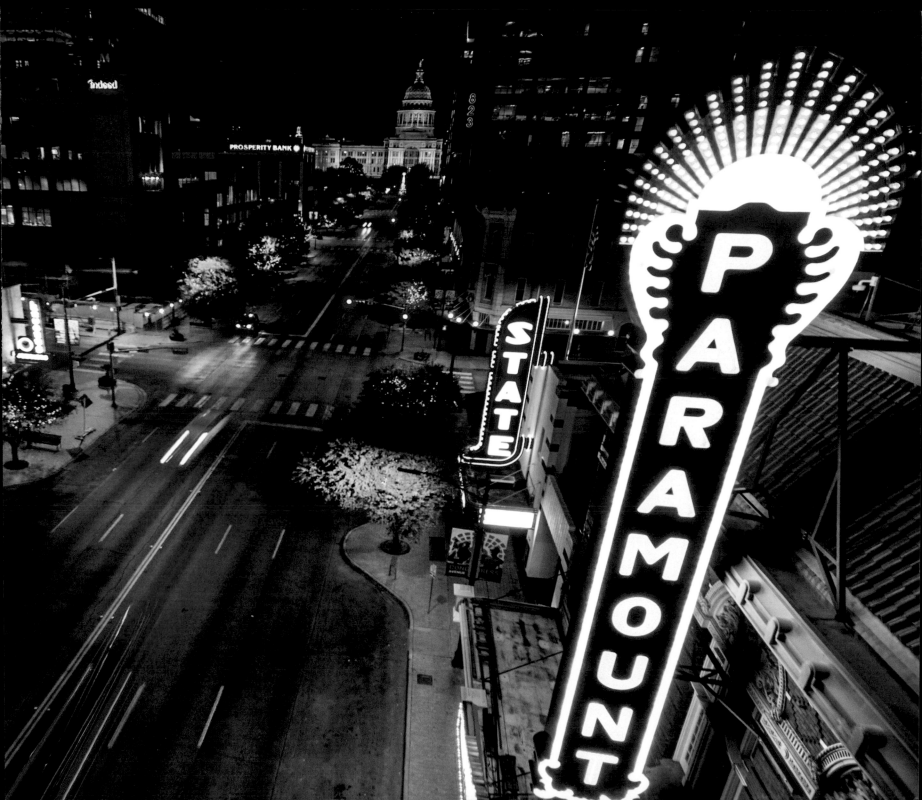

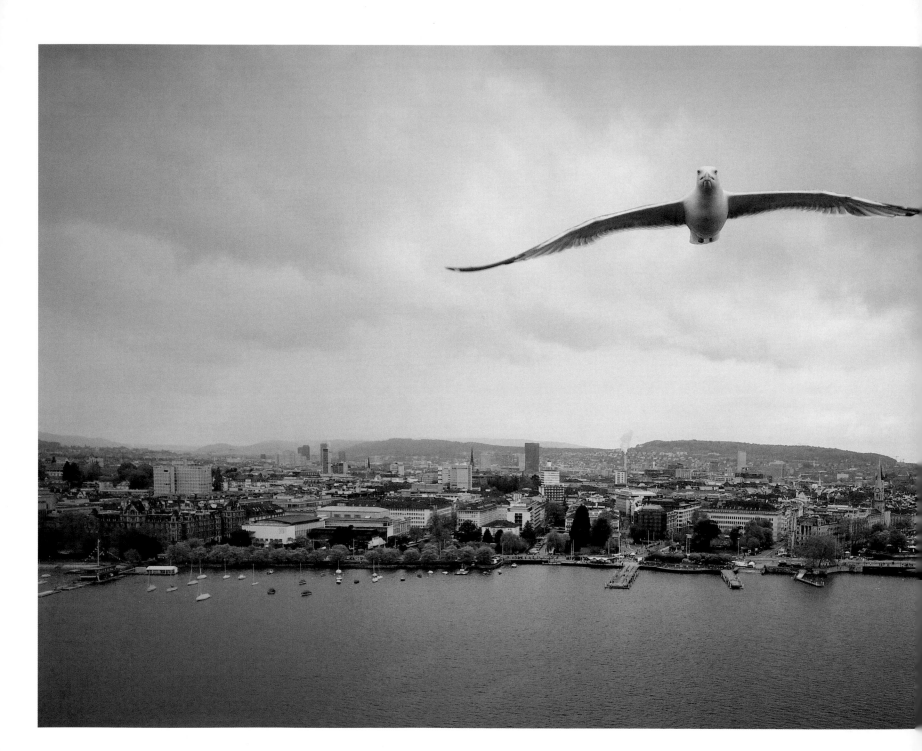

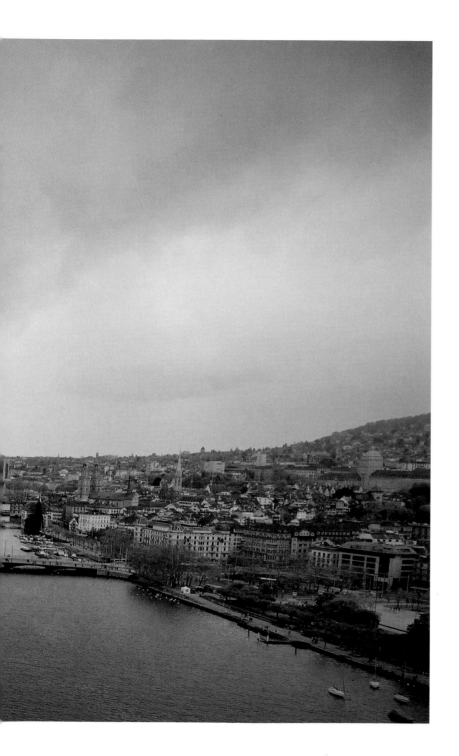

Zurich, Switzerland
By AirDroner

47.3657

8.5475

28m (92ft)

This shot was taken by AirDroner while he was out testing his new drone, a DJI Phantom 3. Just after take off, a flock of birds became curious about the drone and began flying harmoniously alongside it, allowing the photographer to capture this striking image.

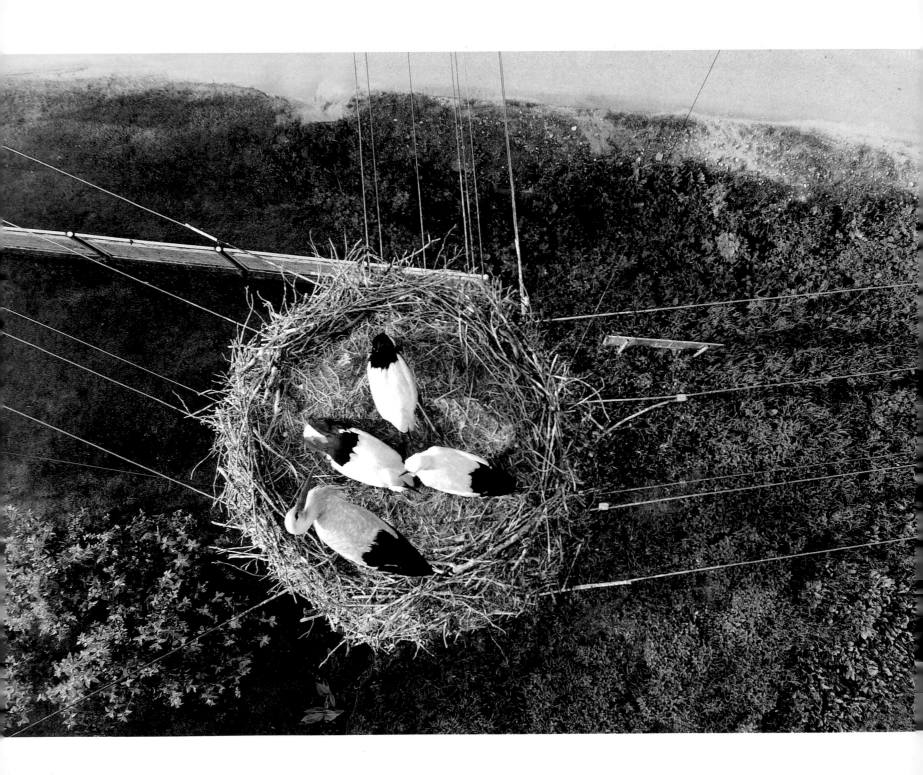

FAUNA

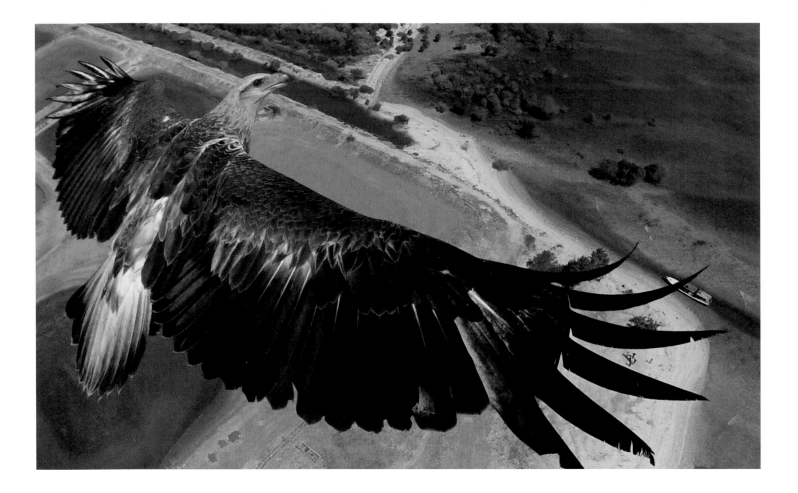

Bali Barat National
Park, Indonesia
By capungaero

⊖ -8.1276
ⓘ 114.4731
↑ 150m (492ft)

This image was taken in 2012, while the
photographer was producing aerial eco-
tourism photographs at the Bali Barat
National Park in west Bali. He had been
shooting on autopilot when suddenly
the eagle appeared and started chasing
the drone. When it seemed that the eagle
was trying to play with the drone rather
than attack it, the photographer switched
to manual control, and encouraged the
bird to follow the drone so that he could
position the camera just above and achieve
this incredible shot.

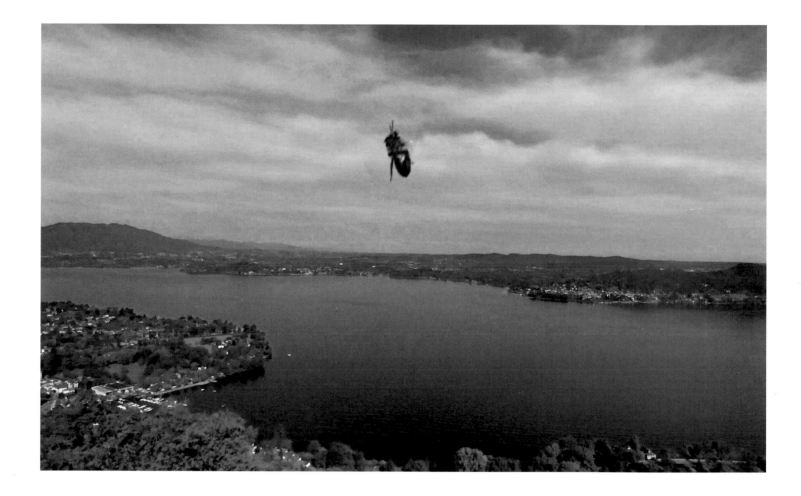

Arona, Italy
By m15alien

45.8143
8.5372
405m (1,329ft)

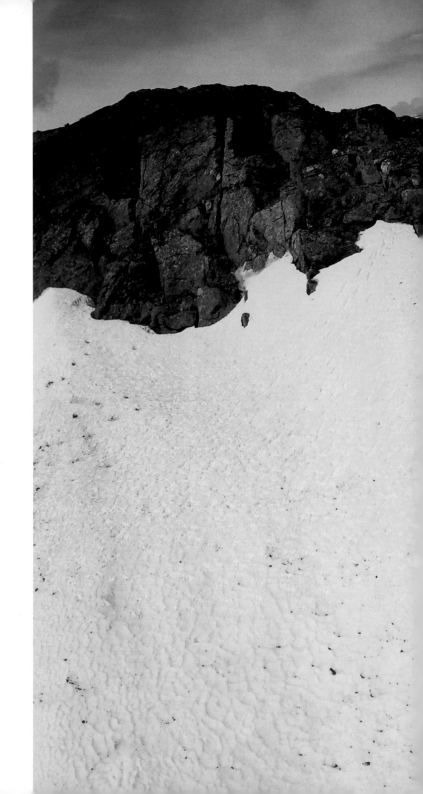

Besseggen, Norway
By martinkoudela

⊖ 61.5005

⊕ 8.7140

⤊ 1,350m (4,429ft)

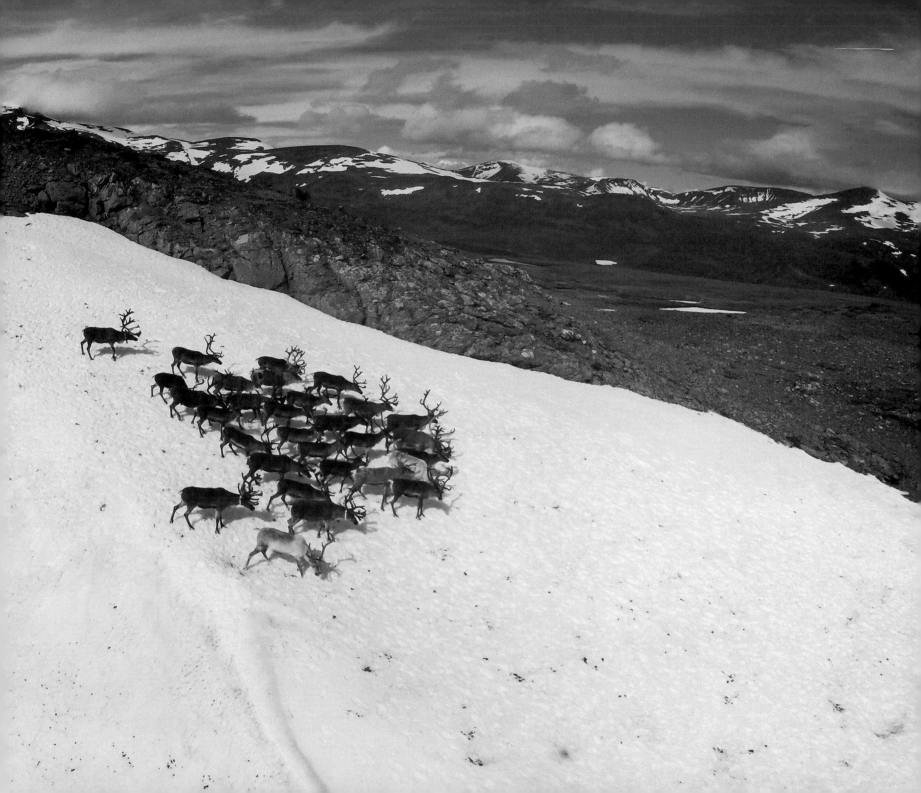

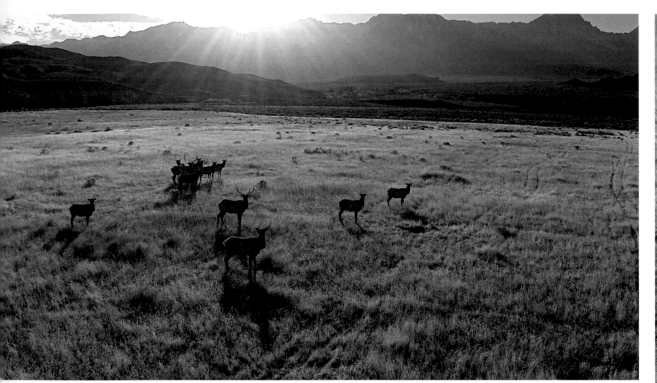

Yosemite National
Park, USA
By mikebish

⊖ 38.2203

❗ -119.2291

↥ 45m (147½ft)

Durban, South Africa
By Cloud 9
Photography.SA

⊖ -29.8422

❗ 29.8422

↥ 24.5m (80ft)

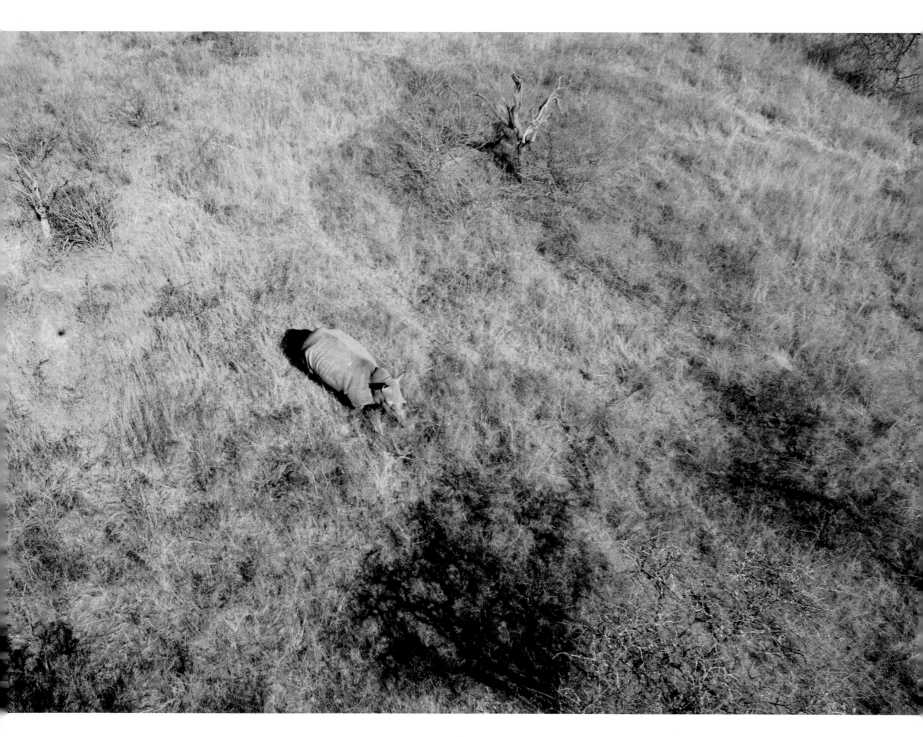

Nether Heyford, UK
By jamesnorden

⊖ 52.2079

⊘ -1.0474

⊕ 22m (73ft)

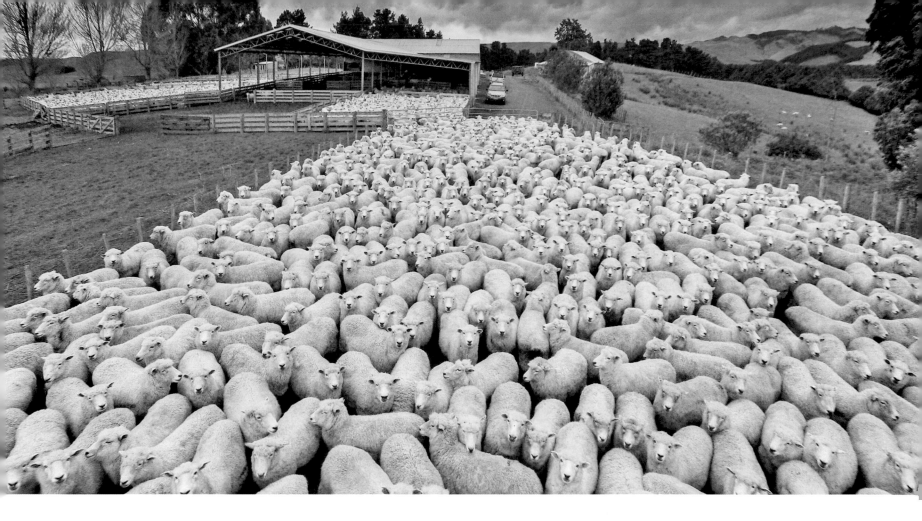

Kereru Village,
New Zealand
By grant

⊖ -39.6044
(!) 176.3852
(↑) 3.5m (11½ft)

While photographing at Kereru Sheep Station in Hawkes Bay, New Zealand, this dronester (see also pages 84–85) chose to shoot a flock of sheep in a yard waiting for shearing to begin. So as not to frighten them, he brought his DJI Phantom 2 Vision+ very slowly down, to just 3.5m (11ft) above the animals, and let it hover there. To the dronester's surprise practically every one of the 800 sheep were looking up at the drone quizzically and continued to do so for at least a couple of minutes while he took his photos.

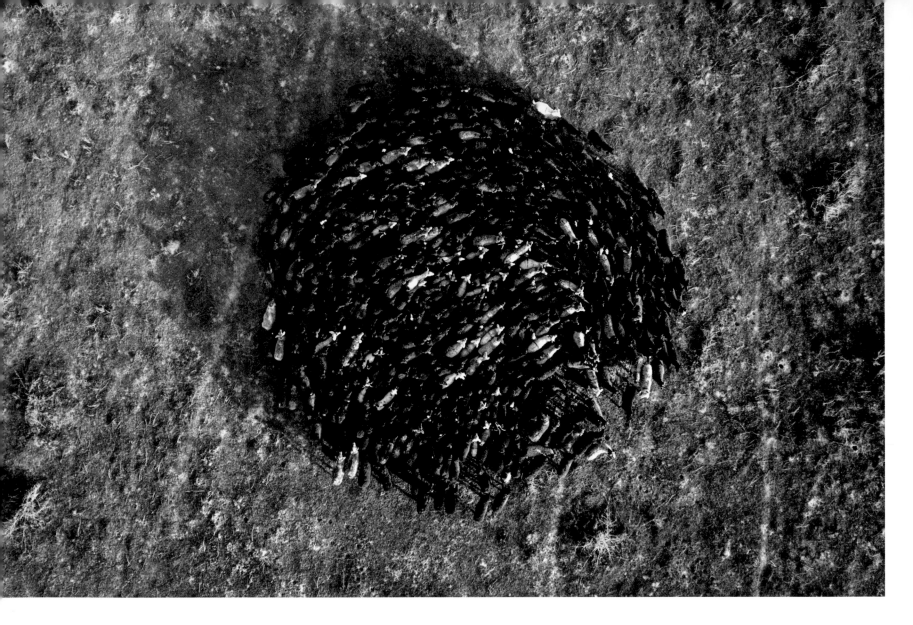

Almaty, Kazakhstan
By balakirev

⊖ 42.8279
⊕ 69.1600
↑ 21.6m (71ft)

Ndouni, Gabon
By cvigna

⊖ -0.0919
⊕ 9.3320
↑ 8m (26½ft)

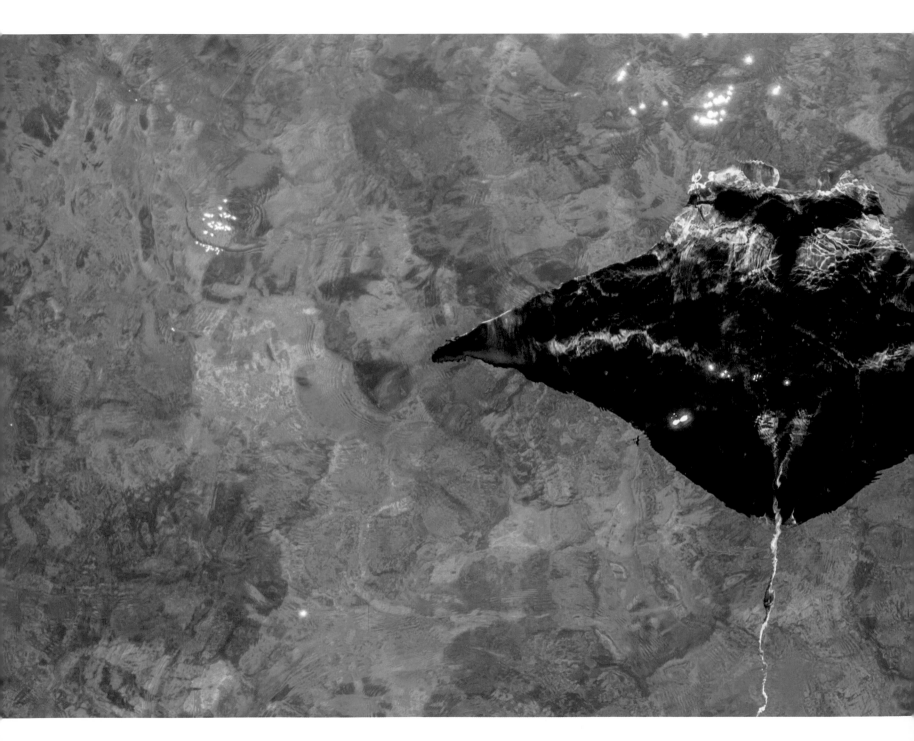

Yasawa Islands, Fiji
By Droneworks New
Zealand

⊖ -16.7705

◉ 177.5133

⬆ 3m (10ft)

2DroneGals

AGE	Unknown (Kim Wheeler)		AGE	18 (Makayla Wheeler)
PROFESSION	Retired aerospace engineer		PROFESSION	Filmmaker
NATIONALITY	American		NATIONALITY	American
BASED IN	Florida, USA		BASED IN	Florida, USA
USES DRONES SINCE	2013		USES DRONES SINCE	2013
DRONE PIX TAKEN	1,000+		DRONE PIX TAKEN	1,000+
EQUIPMENT	3DR Solo / GoPro HERO4 Black		EQUIPMENT	3DR Solo / GoPro HERO4 Black

Merritt Island, USA

28.3828
-80.6661
18m (59ft)

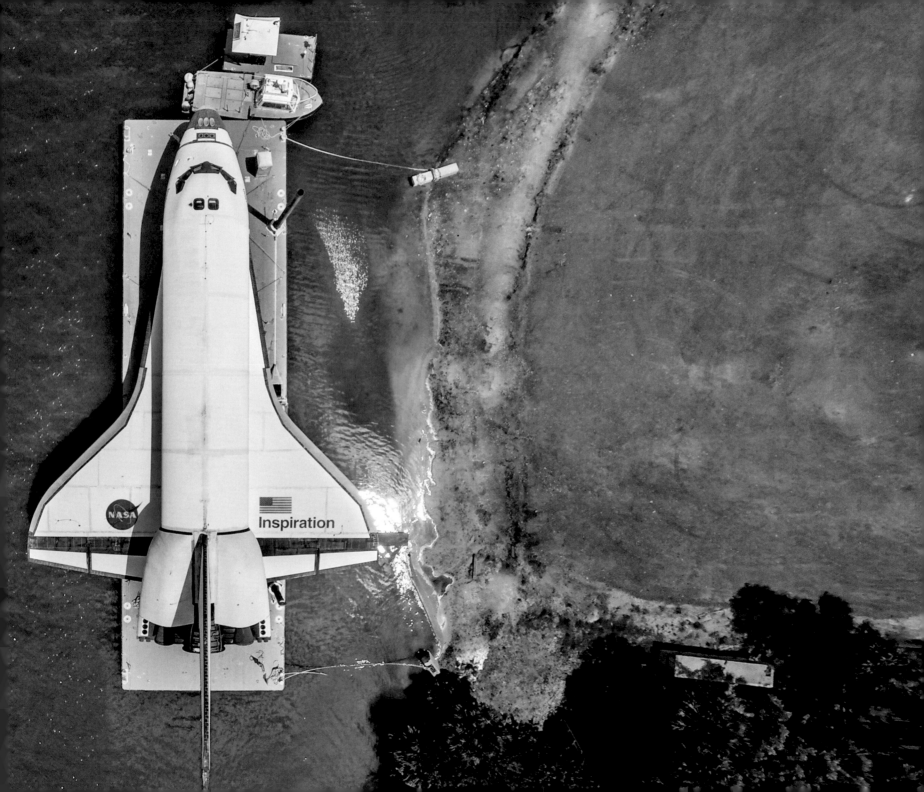

Merritt Island, USA

28.4337
-80.6777
18m (60ft)

Merritt Island, USA

28.4089
-80.6655
19m (62ft)

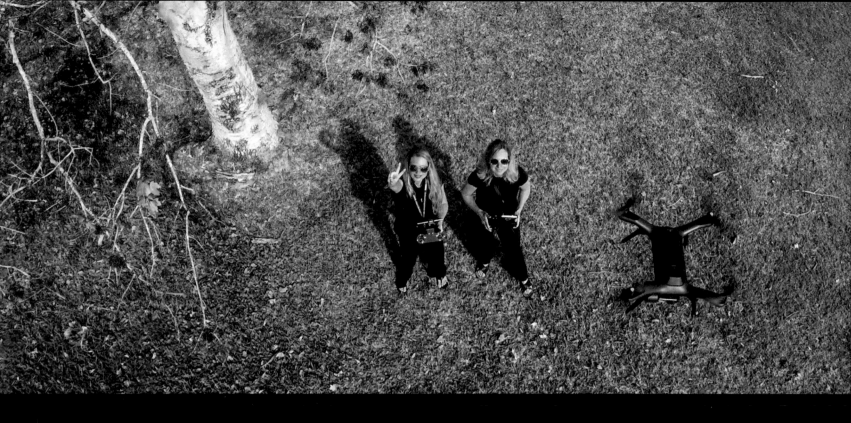

2DroneGals are a unique mother/daughter drone team otherwise known as Kim and Makayla Wheeler. They enjoy flying and promoting the beneficial use of drones for diverse applications including films, documentaries, events, wildlife monitoring, ecological surveying, controlled burns, agriculture and hydrology.

With more than forty years experience of filmmaking and photography between them, it has only been relatively recently that they have started flying drones together. Makayla started making films and photographs at a young age, winning prizes for her images of the natural world as early as age ten. Kim is a retired aerospace engineer and was involved in the Atlas Rocket program in Florida, the area in which they both still live and work.

Makayla started using drones for personal video productions, with Kim joining her as drone maintenance manager and spotter, later taking up drone flying herself. Occasionally they operate two drones at the same time but most often one will fly while the other performs the role of spotter, to ensure a successful mission.

'Sometimes, it can be a challenge to collaborate in a male-dominated industry because, as women, we are not always taken seriously. However, we aim to let our content speak for itself.'

'I'd like to be able to say we film above, below and beyond.'

Their main source of inspiration is the area in which they live, the Space Coast of Florida. The Florida Springs are a favourite location for shooting, 'because of their uniqueness and beauty, not to mention their great importance to the drinking water supply', with aerial perspectives such as theirs providing conservationists the opportunity to monitor the water flow and levels of algae growth in the area. In all their works they promote the use of drones to help observe and protect the natural world. Their photograph of an osprey nesting on a dead pine (page 108), for example, highlights the deployment of drones to monitor birds – the benefits and safety of which are still being weighed up by conservation agencies (the concerns being that drones may disturb the behaviour or habitat of birds) in relation to the more intrusive form of helicopters.

Likewise, their image of the Pine Island Conservation Area in Merritt Island (opposite, below) demonstrates how the use of drones to view and assess wetlands is becoming a more widely acceptable practice. The other benefits of drone photography on which they focus in their work include the monitoring of the agriculture industry, crop and cattle health and invasive plant species.

Not all scenes that they shoot focus on conservation and ecology, however. Their pictures of Space Shuttle Inspiration (pages 106–07) – a full-size mock-up of a shuttle made in plastic and wood and built in 1972 as a travelling museum – intimate more otherworldly interests. And with Makayla also being an experienced underwater videographer, the pair really does cover all grounds, as she explains: 'I'd like to be able to say we film above, below and beyond.'

2DroneGirls are also a rare example of drone user – women – in a community that is still predominantly male, though this is slowly changing: 'Sometimes, it can be a challenge to collaborate in a male-dominated industry because, as women, we are not always taken seriously. However, we aim to let our content speak for itself.'

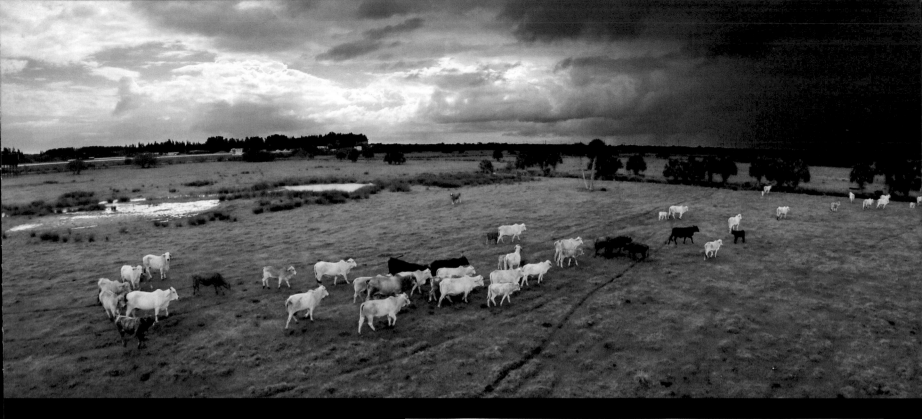

Cocoa, USA

⊖ 28.2830

⏸ -80.7128

⏏ 5m (16½ft)

PROBE

Dhaka, Bangladesh
By zayedh

⊖ 23.8334

◐ 90.4347

⊕ 113m (371ft)

Taken with a Parrot AR.Drone, this image
shows the Lake City Concord area in Dhaka
submerged in the dawn fog, an eerie
occurrence that happens on a daily basis
in this part of the city. See also pages 78–79
and 134–35.

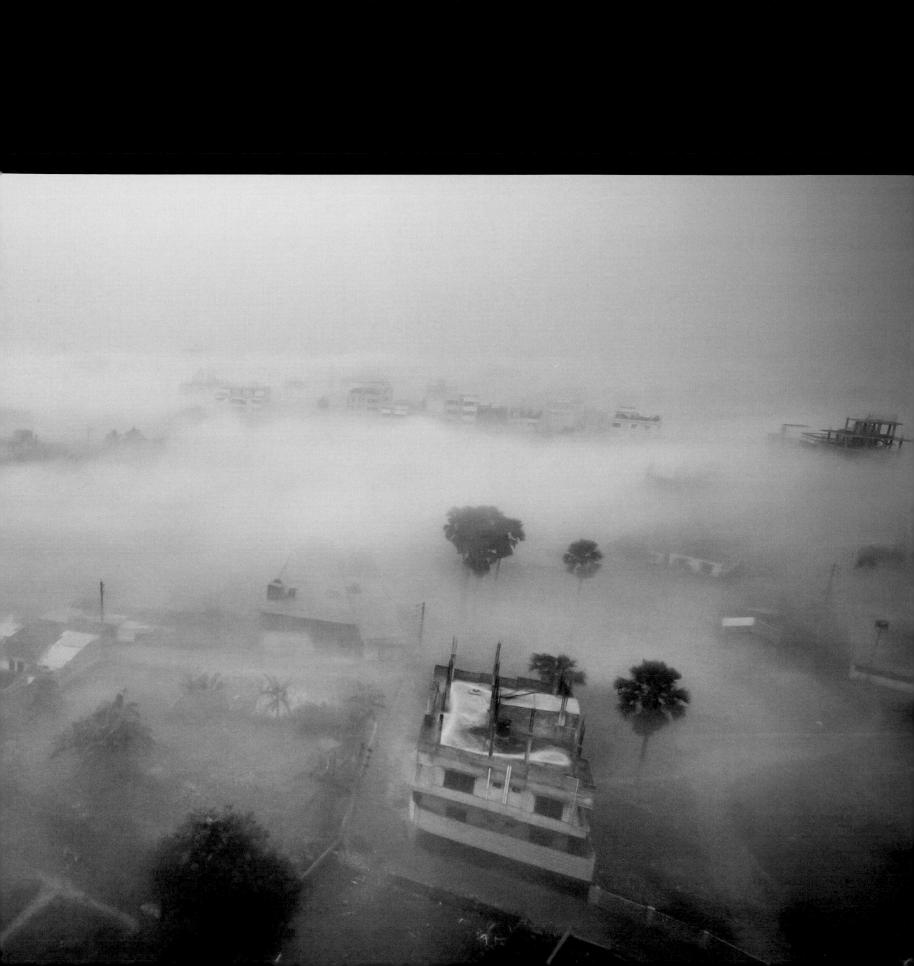

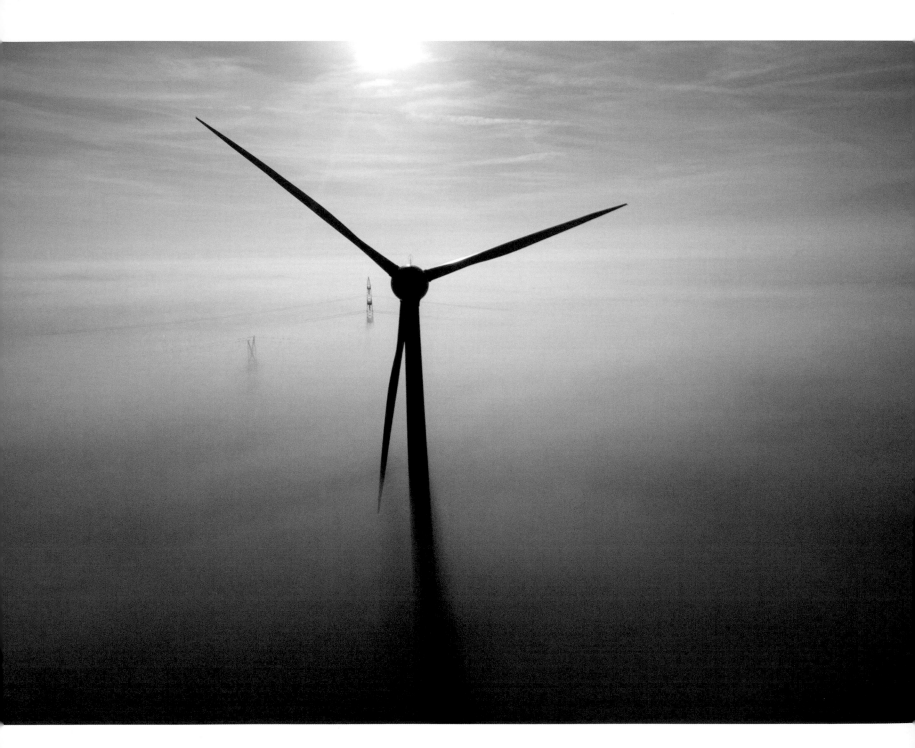

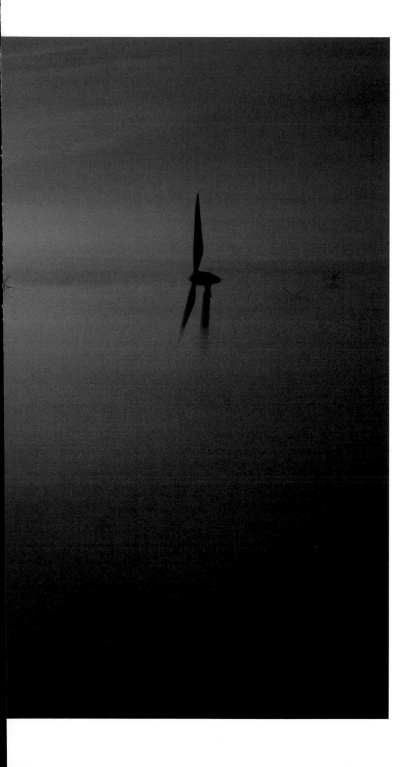

Bremen, Germany
By SkyPro

53.2220
8.5294
72.6m (238ft)

Saint-Malo, France
By Easy Ride

⊖ 48.6612

⊙ -2.0099

⊙ 16.1m (53ft)

This image captures the moment at which a large wave came crashing into the defence walls of the French town of Saint-Malo, which is renowned for the ferociousness of its high tides, some of which are the greatest in Europe. This image was shot on a DJI Phantom 3 Professional. In 2015 the area experienced a 'supertide' that, in some places, reached heights of 14m (45ft).

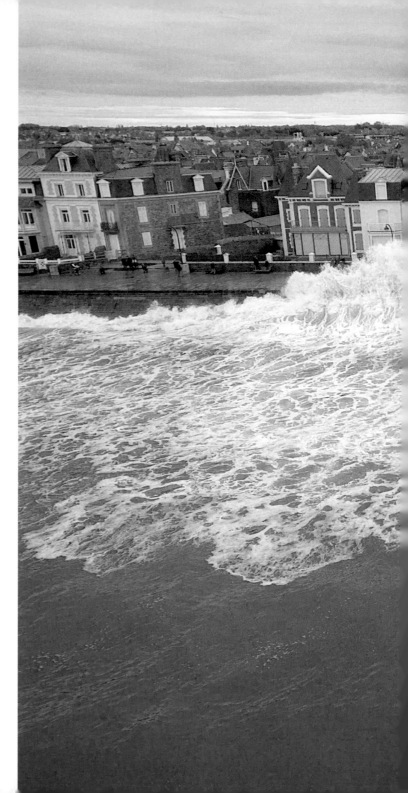

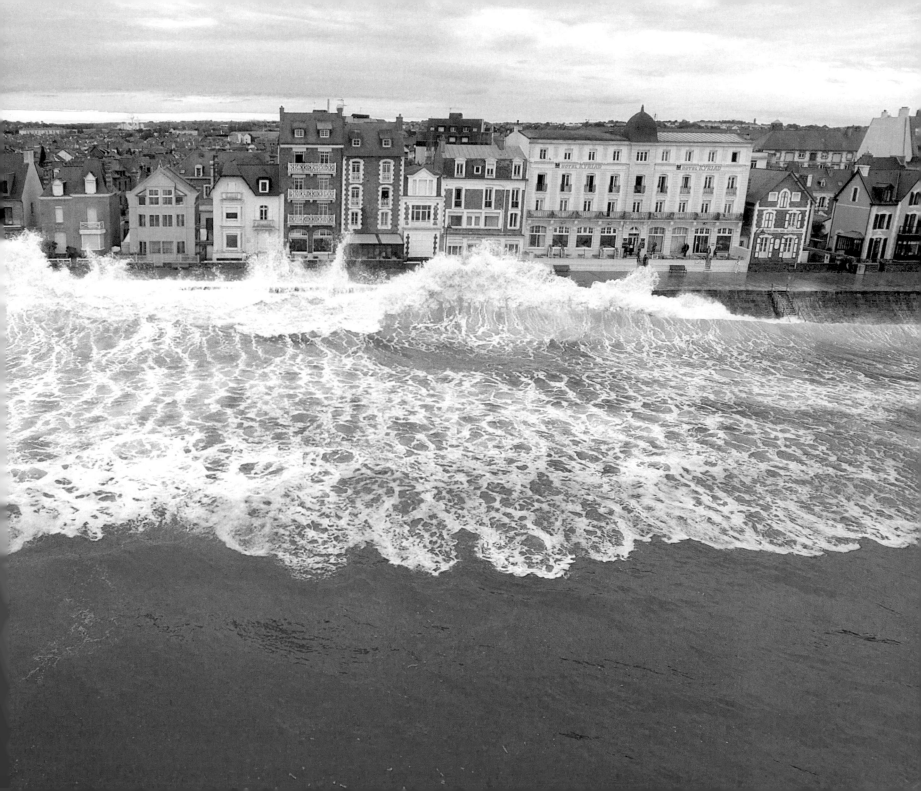

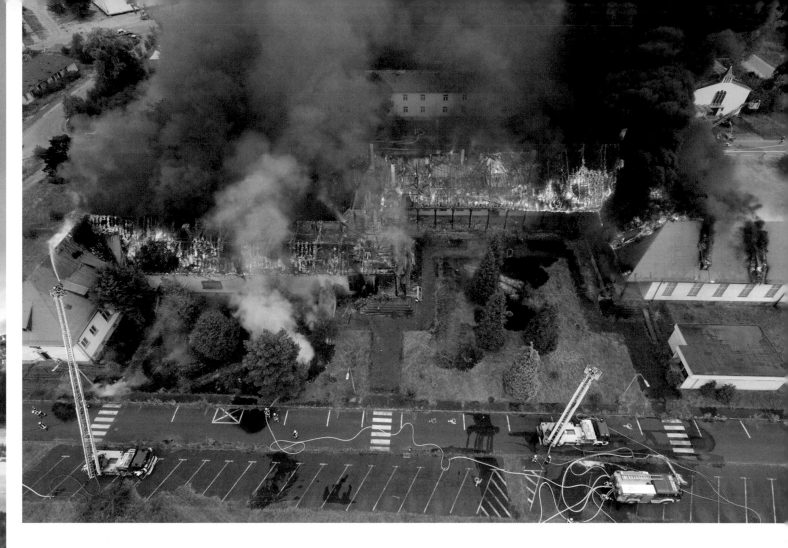

Gasseldorf, Austria
By Thanner Gregor

⊖ 47.2120
⌽ 14.6151
↑ 100m (328ft)

Taken with a Canon Ixus 125 HS with CHDK
firmware this shot shows the emissions of
a paper factory. Gregor says that he always
flies with CHDK-enabled Canon cameras,
because they allow for maximum control
of the final image. The HDR (high dynamic
range) effect was applied using Photomatix.

Erlensee, Germany
By jenst4

⊖ 50.1711
⌽ 8.9714
↑ 61.1m (200ft)

A massive fire in an unused former US
military airbase in the city of Erlensee, shot
with a DJI Phantom 3 Professional. After
noticing smoke on the horizon from his
home in Hanau, jenst4 rushed to the scene,
arriving just as the firefighters had the blaze
under control, and made this dramatic shot.

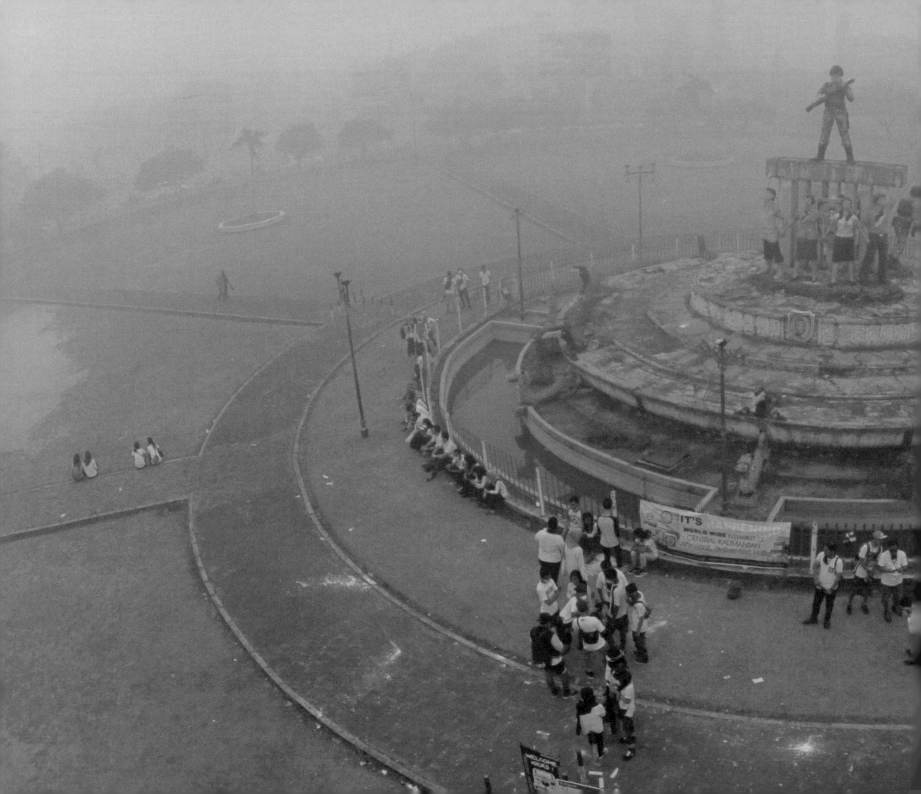

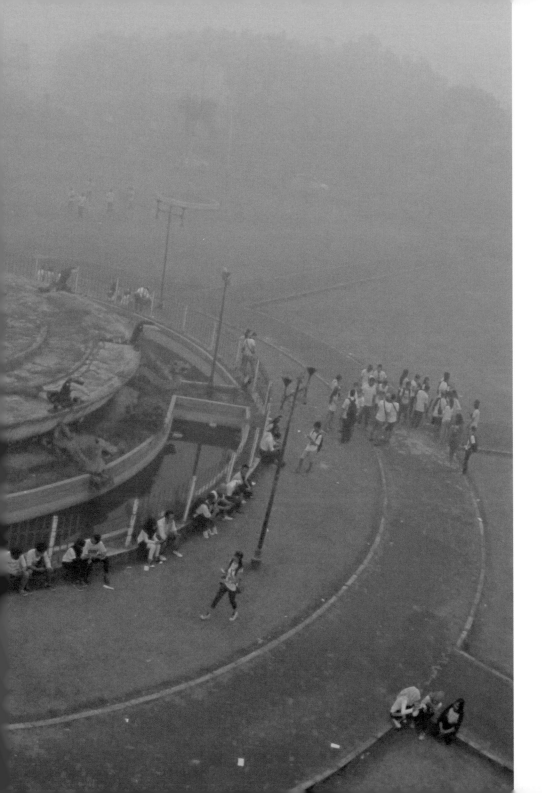

Palangka Raya,
Indonesia
By Markurius Sera

⊖ -2.2072
ⓘ 113.9161
↑ 30m (100ft)

This photograph was taken in October 2015, during a campaign initiated by the photographer and his friends called 'Kalteng with Love', which involved the provision of free masks, milk and vitamins to the people living in the city of Palangka Raya in Central Kalimantan, Indonesia. Pollution had reached toxic levels in the city as a result of fires in the Borneo peatlands started to clear land for plantations. As a result, hundreds of thousands of people suffered from respiratory problems. Schools were closed, flights stopped operating and the economic system was paralysed. Borneo is known as the fifth largest greenhouse gas emitter in the world.

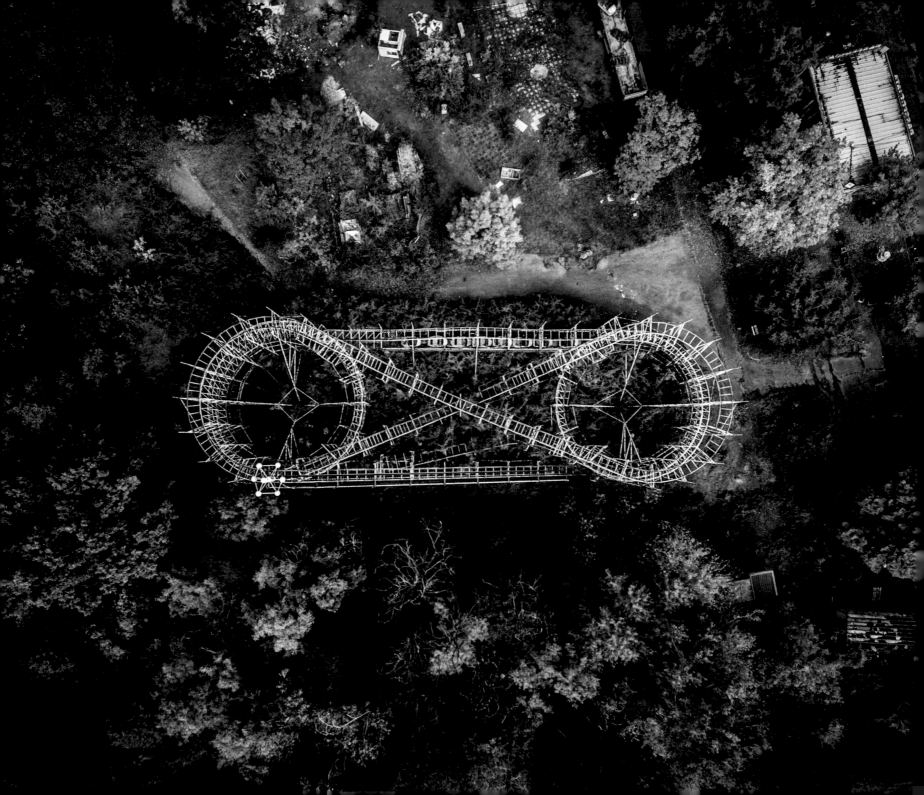

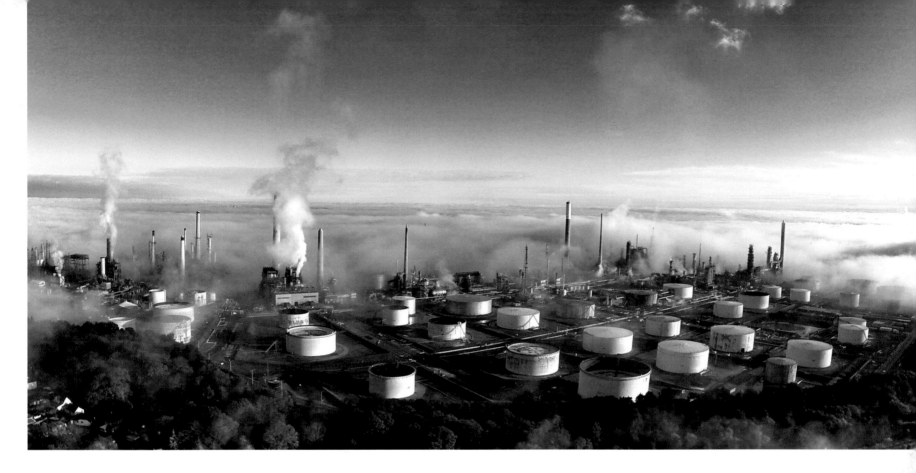

Limbiate, Italy By pescart	⊖ 45.5964
	⟨!⟩ 9.1113
	⟨↑⟩ 78.9m (259ft)

This abandoned rollercoaster is part of what was once an amusement park known as 'Greenland'. Located north of Milan, it was built in 1965 as an urban getaway for families and children, with a lake, rides and several attractions. However, after a prosperous period during the end of the 1980s, concerns about safety and hygiene led the authorities to close the park. It is now almost reduced to wasteland. This shot, taken using a DJI Phantom 3 Advanced, shows the geometrical shape of the rollercoaster being almost swallowed by the autumnal forest. See also pages 132 and 151.

Holbury, UK By mark baker	⊖ 50.8252
	⟨!⟩ -1.3730
	⟨↑⟩ 106m (348ft)

Tonopah, USA
By JackFreer

⊖ 38.6342

⌖ -116.2162

↑ 91m (298½ft)

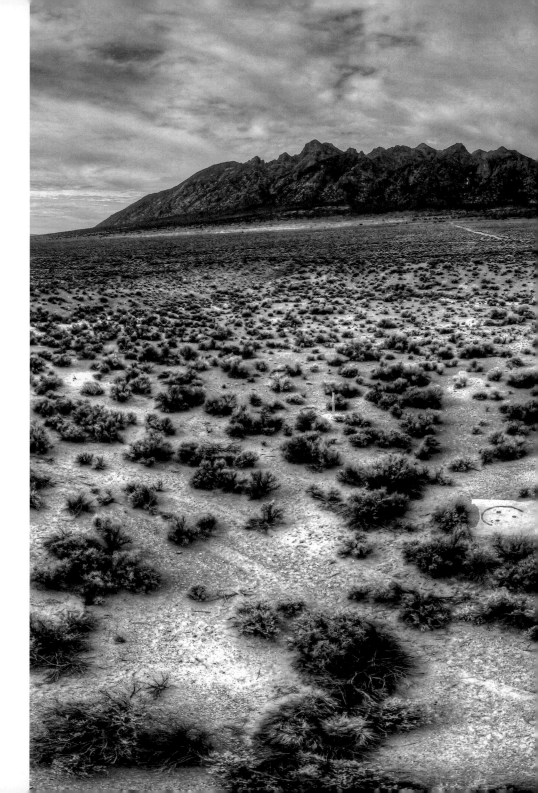

This apparently unassuming shot, taken with a DJI Phantom 2 carrying a GoPro HERO3+, shows the Central Nevada Test Area (CNTA), which was acquired by the US Atomic Energy Commission, now the US Department of Energy (DOE), in the early 1960s to develop alternative sites to the Nevada Test Site (currently the Nevada National Security Site), for underground nuclear testing.

The 2.5m (8ft) diameter steel pipe in the centre of the image extends some 975m (3,200ft) into the ground below, to the site of an underground nuclear explosion chamber. Before detonation the top of the pipe was level with the ground, however, the force of the explosion caused the ground to collapse, leaving the top 3m (10ft) of the pipe exposed.

For more work by this photographer see page 153.

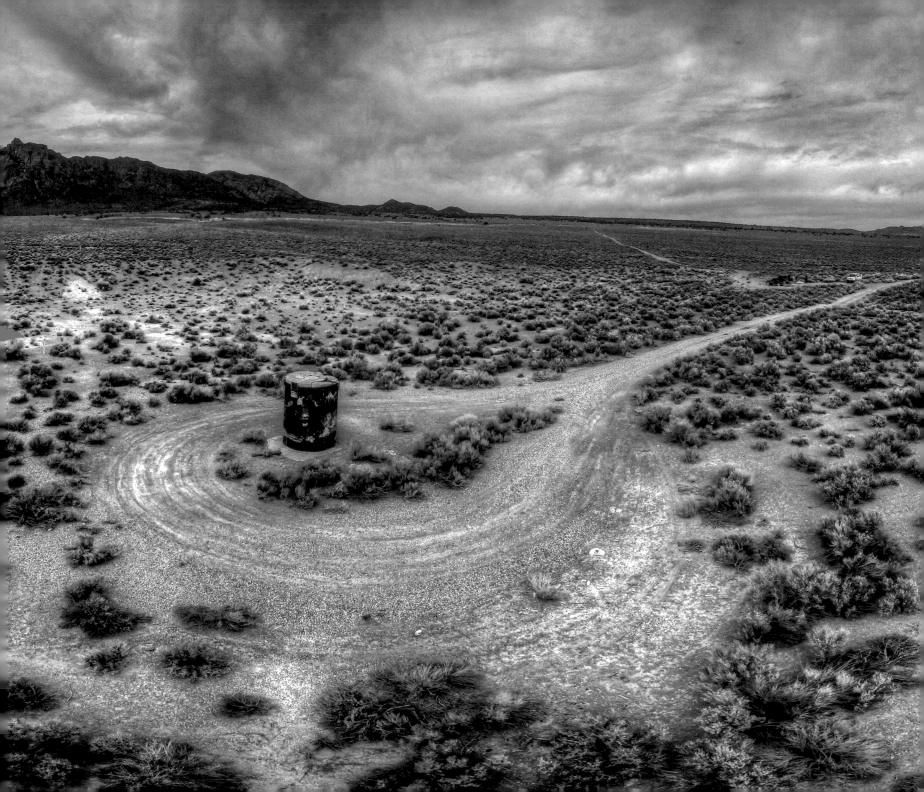

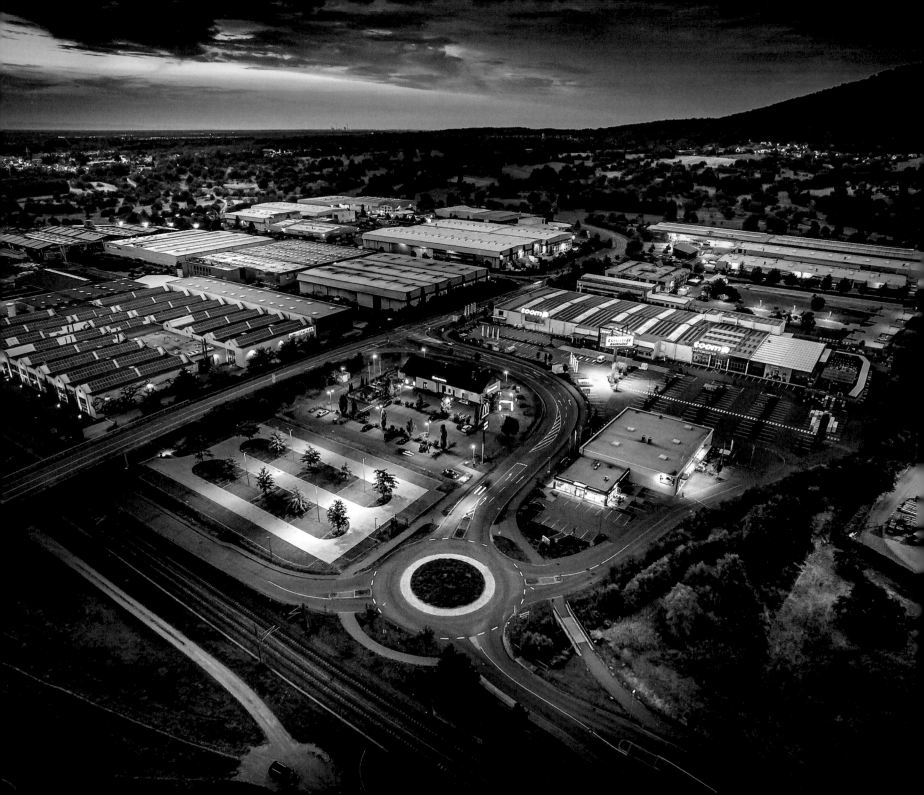

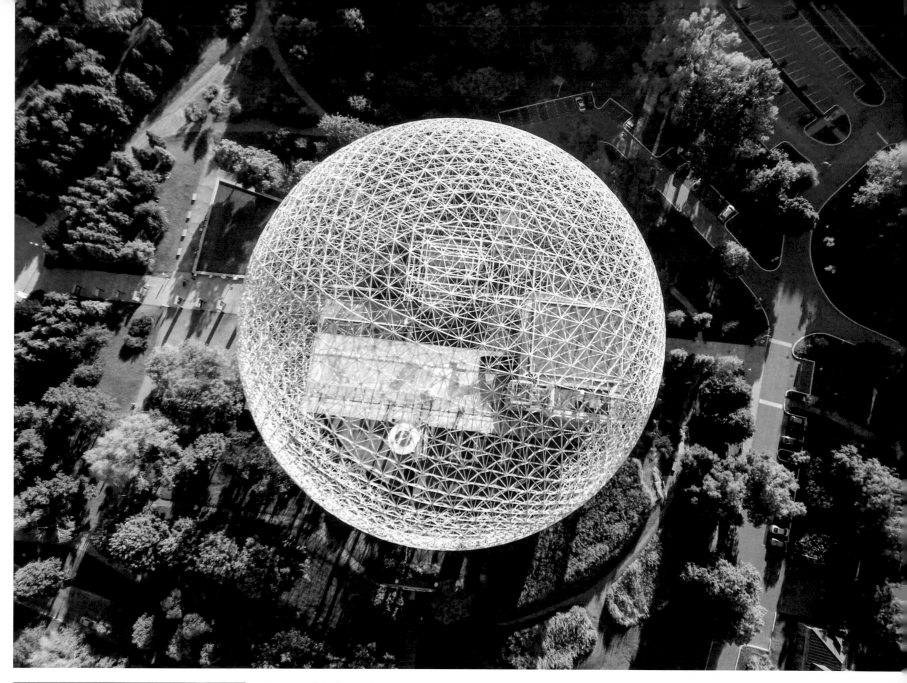

Gaggenau, Germany
By einfachMedien.de

⊖ 48.8212
⊕ 8.2953
↑ 89m (292ft)

Gaggenau's industrial zone, taken by this dronester, a member of Dronestagram since 2014, using a DJI Phantom 3.

Montreal Biosphère,
Canada
By pixup

⊖ 45.5143
⊕ -73.5379
↑ 178.8m (586½ft)

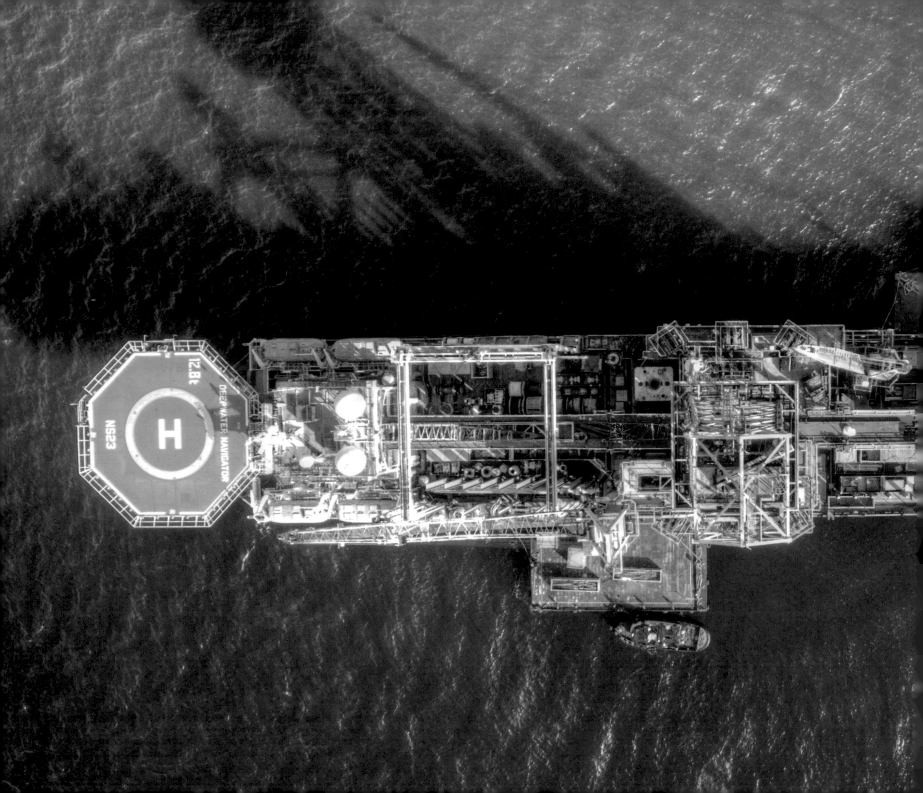

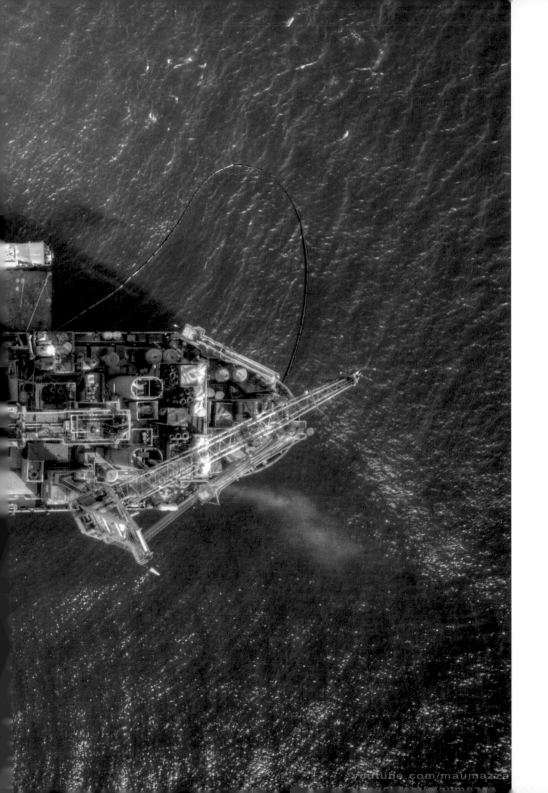

Ilha Grande, Brazil
By MAZZA_FPV

⊖ -23.2734
◐ -44.6304
⊕ 12m (39ft)

Shot with a DJI Inspire 1 drone and DJI
Zenmuse X3 camera this image shows
the 'Deepwater Navigator' off the coast of
Ilha Grande, Brazil. For more work by this
dronester see page 200.

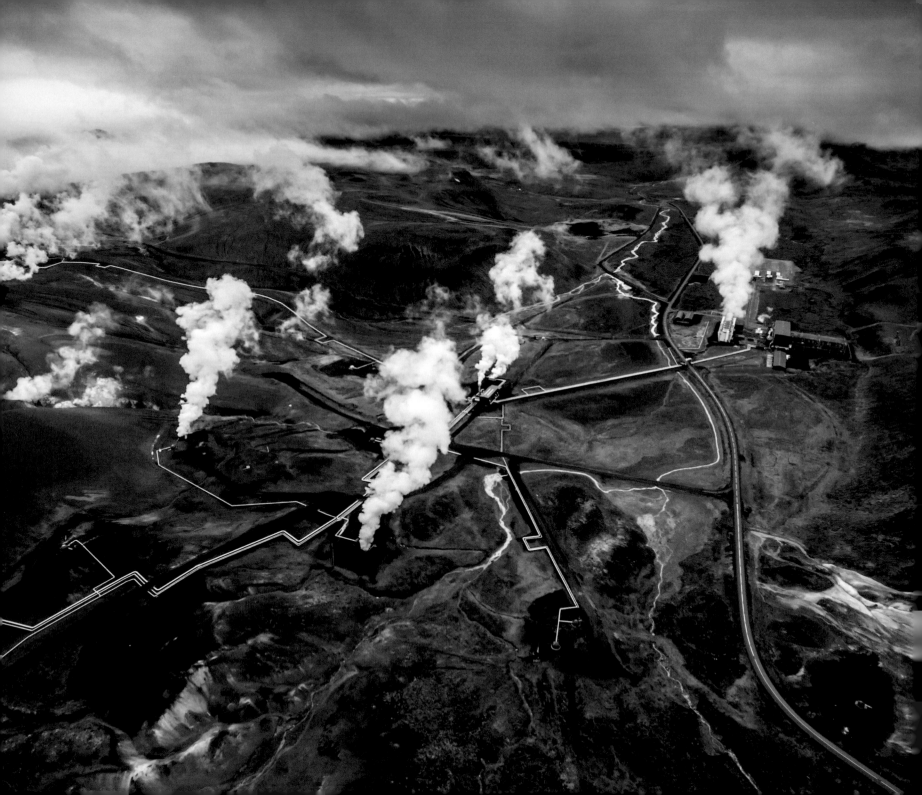

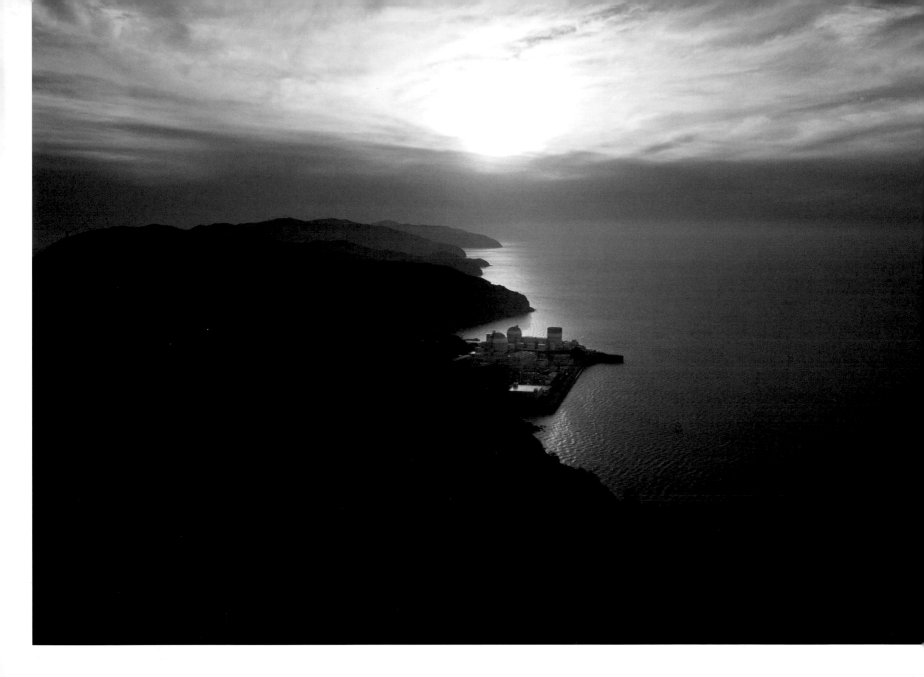

Krafla, Iceland
By pescart

⊖ 65.7199
⊕ -16.7699
⬆ 257.3m (844ft)

The Krafla Power Station,
a geothermal energy plant that
generates electricity for Icelanders.
See also pages 124 and 151.

Ikata Nuclear Power
Plant, Japan
By K-max07

⊖ 33.5069
⊕ 132.3419
⬆ 219.9m (72½ft)

Dhaka, Bangladesh
By zayedh

⊖ 23.8352
⊕ 90.4328
↥ 31.3m (102½ft)

Shot with a Parrot Bebop 2, zayedh captures here a playing field that he used as a child, but which has now been bought and redeveloped by real-estate companies. With the green of the field now all gone, this scene is typical of how the city's landscape is rapidly changing. See also pages 78–79 and 114–15.

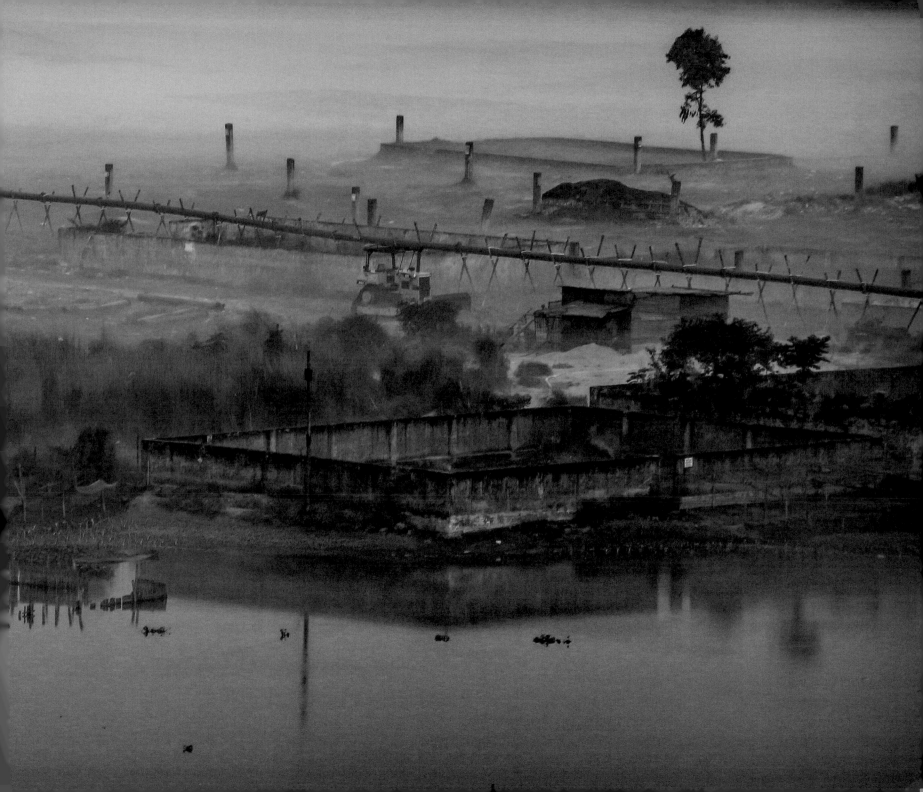

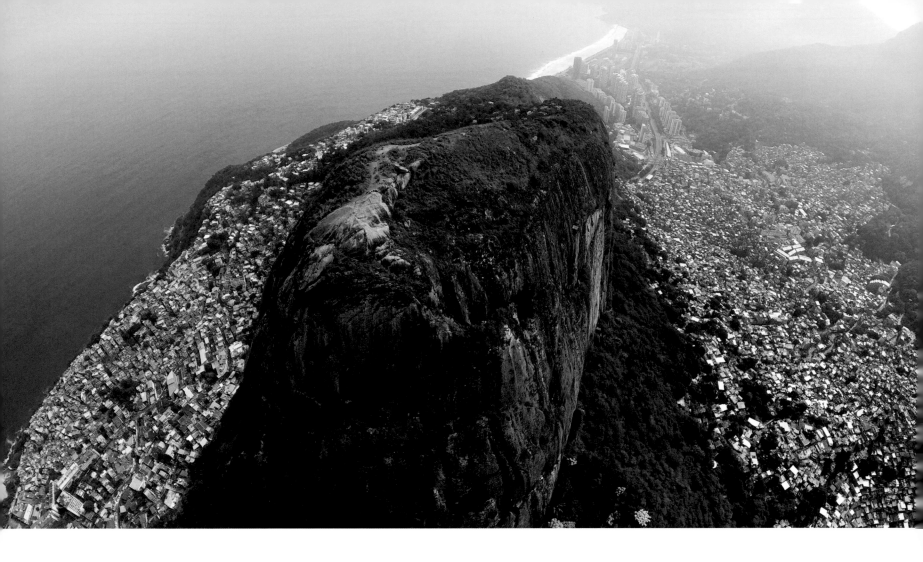

Rio de Janeiro, Brazil
By Alexandre Salem

⊖ -22.9900

⊙ -43.2379

⊕ 23m (75ft)

This mountain, called 'Twin Brothers Hill', is surrounded by two of Rio de Janeiro's main slums: Vidigal and Rocinha. For a long time, the mountaintop could only be reached by the slums' inhabitants. In 2012, however, when the police put in place initiatives to make the slums safer, visitors were allowed to visit the top of the hill. This photo was taken with a DJI Phantom 2 and GoPro HERO4, during Salem's first visit to the mountain. See also pages 40–41, 138–40 and 142–43.

Annecy-le-Vieux, France
By fp74

45.9228
6.1757
110m (360ft)

In spite of the visual similarities to Rio de Janeiro's Vidigal and Rocinha districts (opposite) when seen from above, the town of Annecy-le-Vieux in the French Alps is a far more prosperous area. This shot was taken with a DJI Phantom 3.

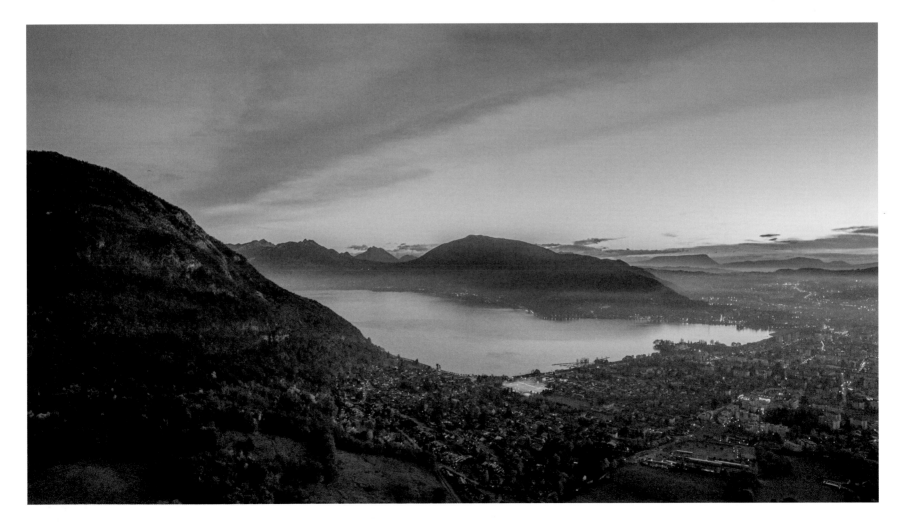

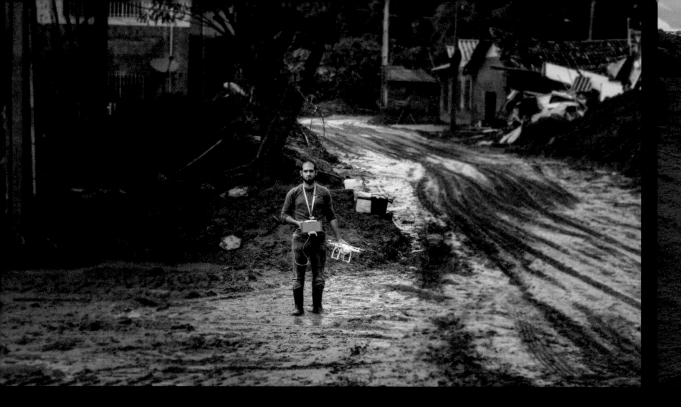

Alexandre
Salem

Brasilinha, Brazil

⊖ -20.2941

⊕ -43.2294

⊕ 61.2m (201ft)

AGE	32
PROFESSION	Photographer
NATIONALITY	Brazilian
BASED IN	Rio de Janeiro, Brazil
USES DRONES SINCE	2014
DRONE PIX TAKEN	10,000+
EQUIPMENT	DJI Phantom 1, DJI Phantom 2 and DJI Phantom 3 / DJI Phantom 3 Professional, GoPro HERO4 and GoPro HERO4 Black

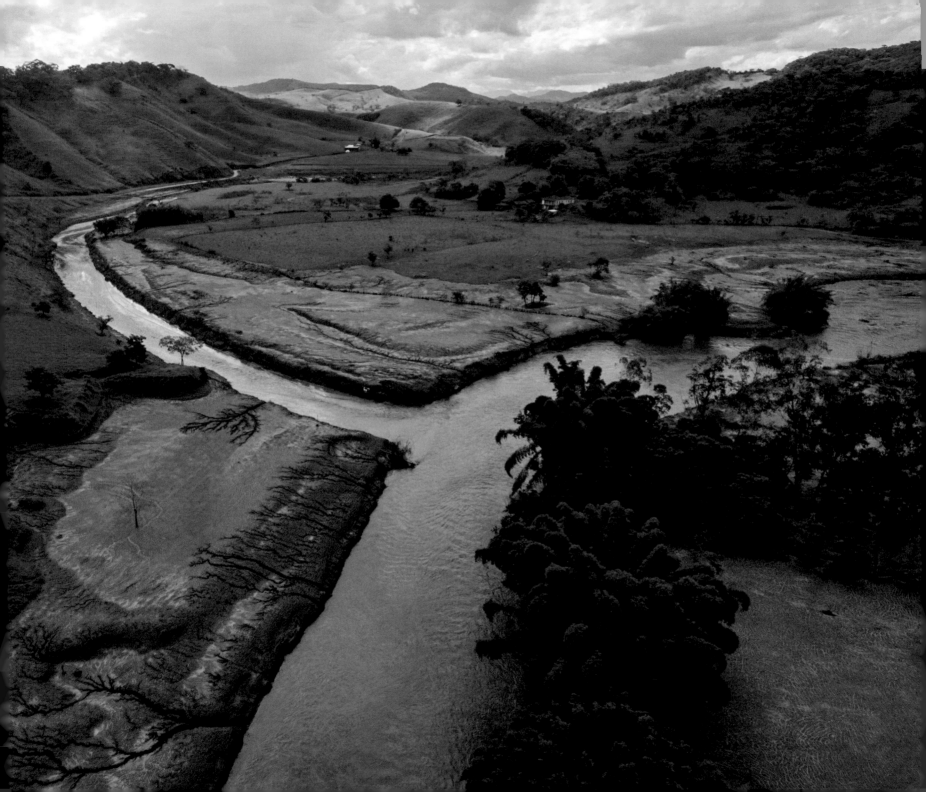

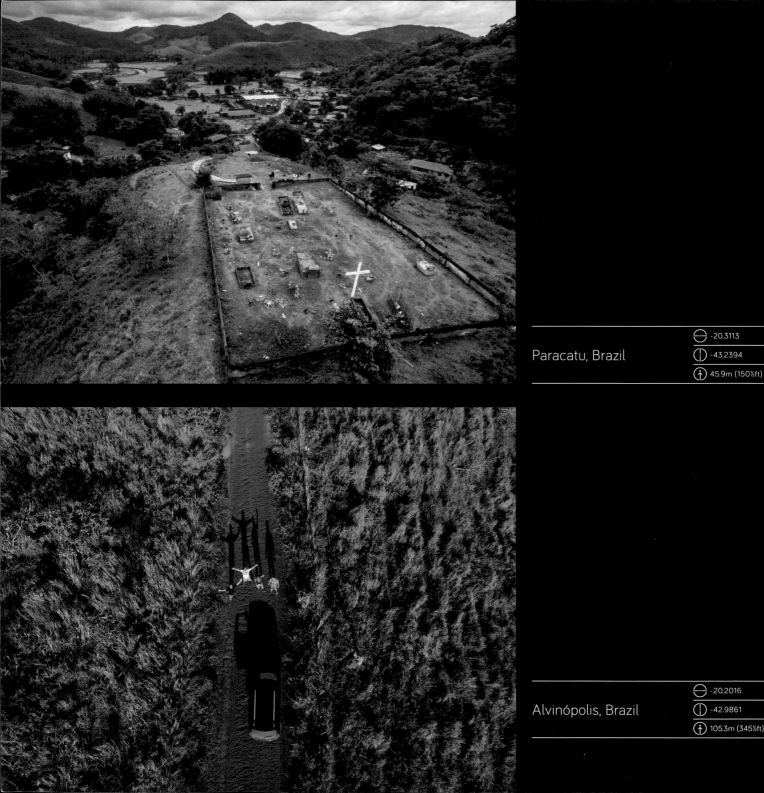

Paracatu, Brazil

⊖ -20.3113
⌀ -43.2394
⬆ 45.9m (150½ft)

Alvinópolis, Brazil

⊖ -20.2016
⌀ -42.9861
⬆ 105.3m (345½ft)

Alexandre Salem was working as an analyst in an investment bank before he took up aerial photography in 2014. It was then that he bought his first drone, a DJI Phantom 2, and what started out as a hobby soon turned into a passion and new career, and he hasn't looked back since.

Salem's work focuses largely on his hometown of Rio de Janeirio and, whether capturing the iconic Christ the Redeemer from dizzying heights (pages 40–41), the city's sprawling favelas (page 136) in contrast to more affluent areas such as those surrounding the Lagoa Rodrigo de Freitas lagoon, or sporting events like the World Surf League, his output is suffused with energy. He has also made photographs further afield, including Brazil's Itatiaia National Park.

A significant project has been the documentation of a massive environmental disaster in the Minas Gerais region in 2015 in which, after the collapse of iron ore dams built by mining giant BHP Billiton, toxic mudslides swept away entire villages, causing widespread environmental pollution and costing human lives. The pollutants were carried along the entire course of the 500km (310-mile) Doce river, starting at the small town of Bento Rodrigues and ending up at the Atlantic, threatening the modest fishing communities that have settled there.

Surprised by the lack of media coverage of the incident, described by the country's president as 'possibly the biggest environmental disaster to have impacted one of the major regions of our country', Salem chose to record the disaster as it unfolded:

Brazilian newspapers love catastrophes but, for some reason, this one wasn't being covered as usual. We have had several large environmental tragedies before, with way more human losses. But this was the first time that a huge environmental death was taking place. An entire river was dying, and within a week, the mud would reach the sea, causing inestimable damage. I followed the course of the river for ten days, documenting the tragedy as a whole.'

Joining forces with two filmmakers from Rio de Janeiro, Salem sought to photograph events as fully as possible, showing how local communities and the environment were directly impacted. With access to these areas impossible by road, his drone provided the perfect opportunity to tell the story from a perspective that for most was unreachable, presenting an alternative visual narrative to that which could be seen at ground level.

The city of Paracatu was the only place that Salem chose to photograph rather than film. The mudslide having reached the area just two hours after the dams broke, residents were given just enough warning to escape the area. Some fled by road, but others sought refuge at the local cemetery – located at the highest point of the city – from where they could witness the devastation that the disaster was wreaking directly on their homes. It was here that Salem took many of his photographs.

Salem has self-published these and many of his other works and they have also featured in newspapers and competitions the world over. See also pages 40–41 and 136.

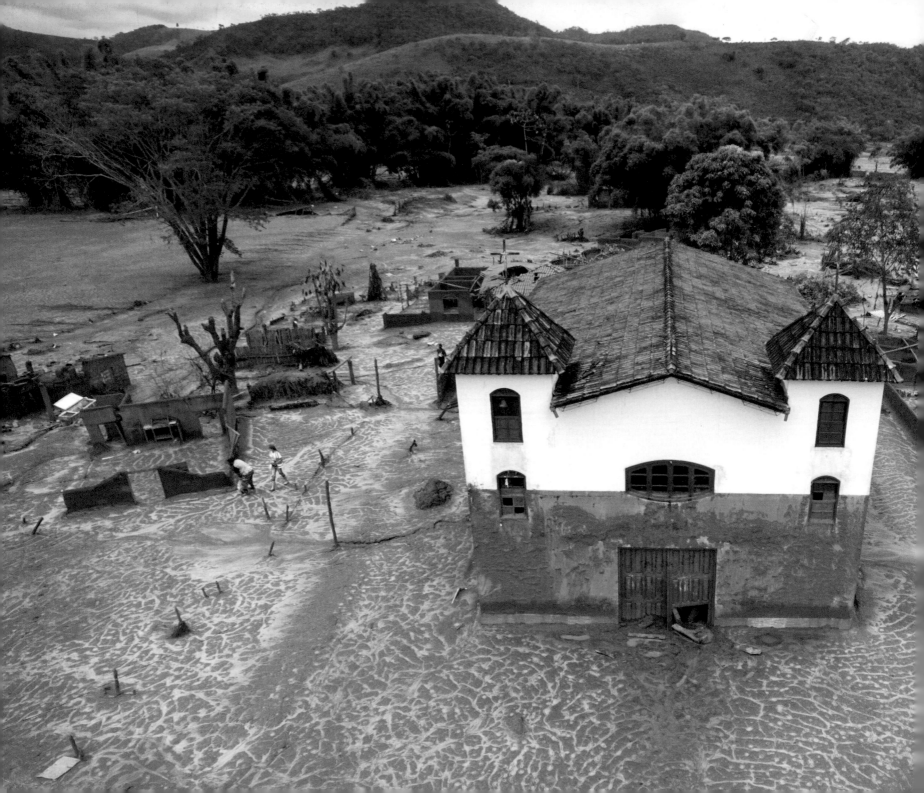

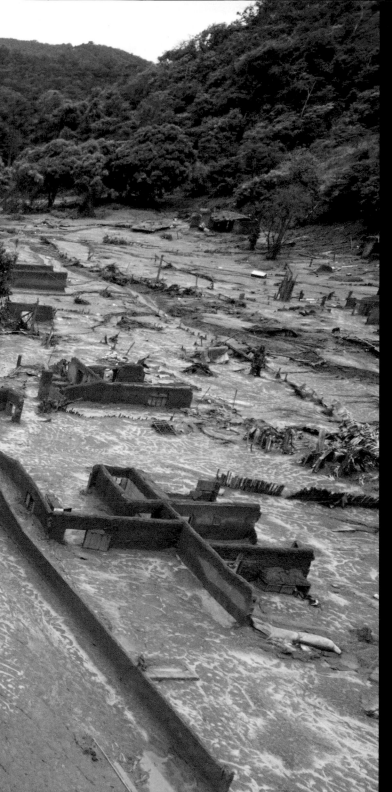

'We have had several large environmental tragedies before, with way more human losses. But this was the first time that a huge environmental death was taking place. An entire river was dying, and within a week, the mud would reach the sea, causing inestimable damage. I followed the course of the river for ten days, documenting the tragedy as a whole.'

Moeda, Brazil

⊖ -20.3073

⊘ -43.9861

⊕ 10.4m (34½ft)

SPACE

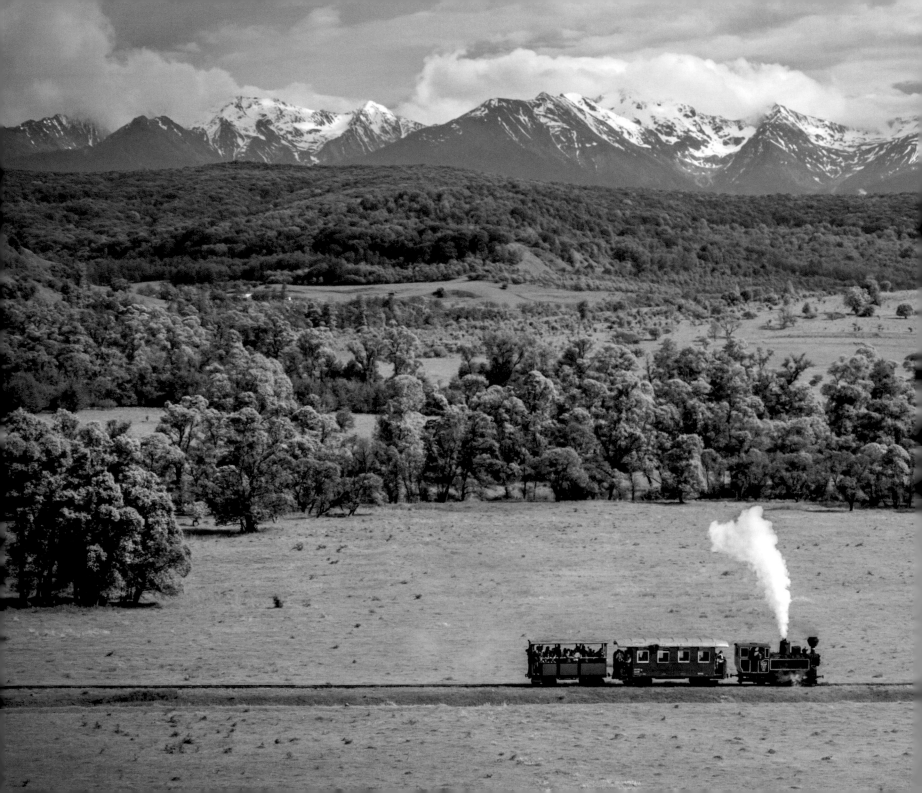

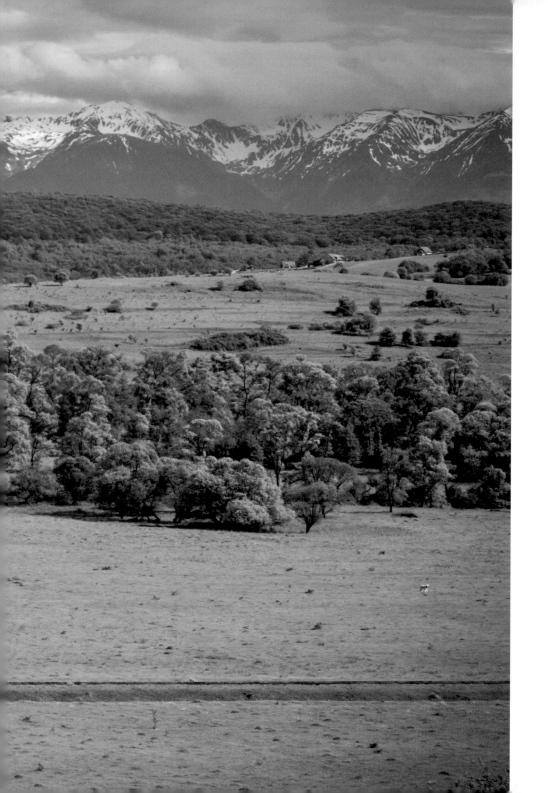

Cornatel, Romania
By flaviatrifan

45.8027

24.3535

26m (85ft)

Machu Picchu, Peru
By Freeway Drone

⊖ -13.1631

⊕ -72.5471

⊕ 18m (60ft)

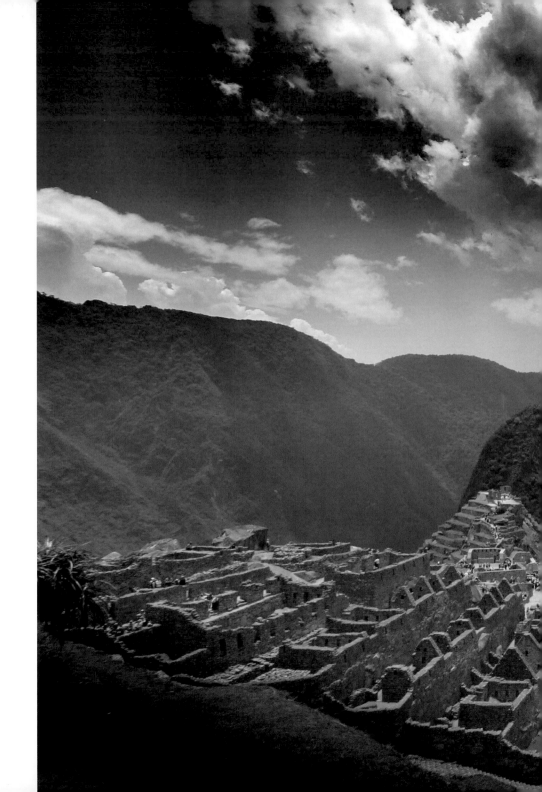

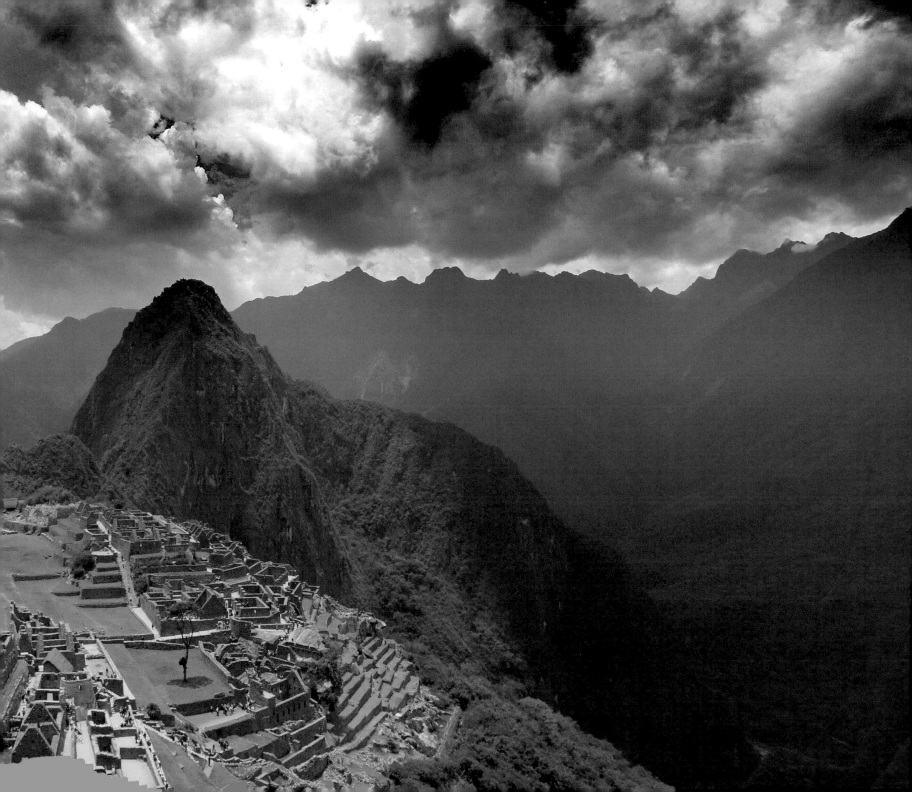

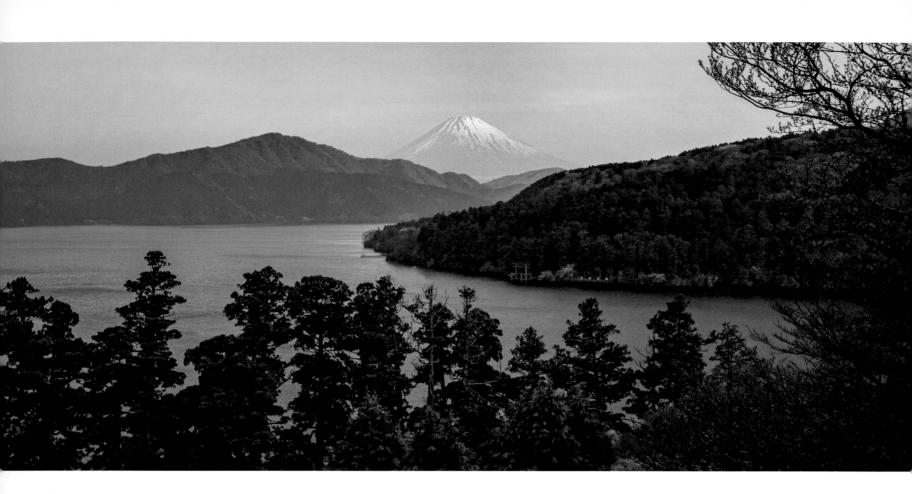

Hakone, Japan
By maxseigal

⊖ 35.1953

◐ 138.9947

↥ 17m (55½ft)

Reykjahlíð, Iceland
By pescart

⊖ 65.7199

◐ -16.5206

↥ 257.3m (844ft)

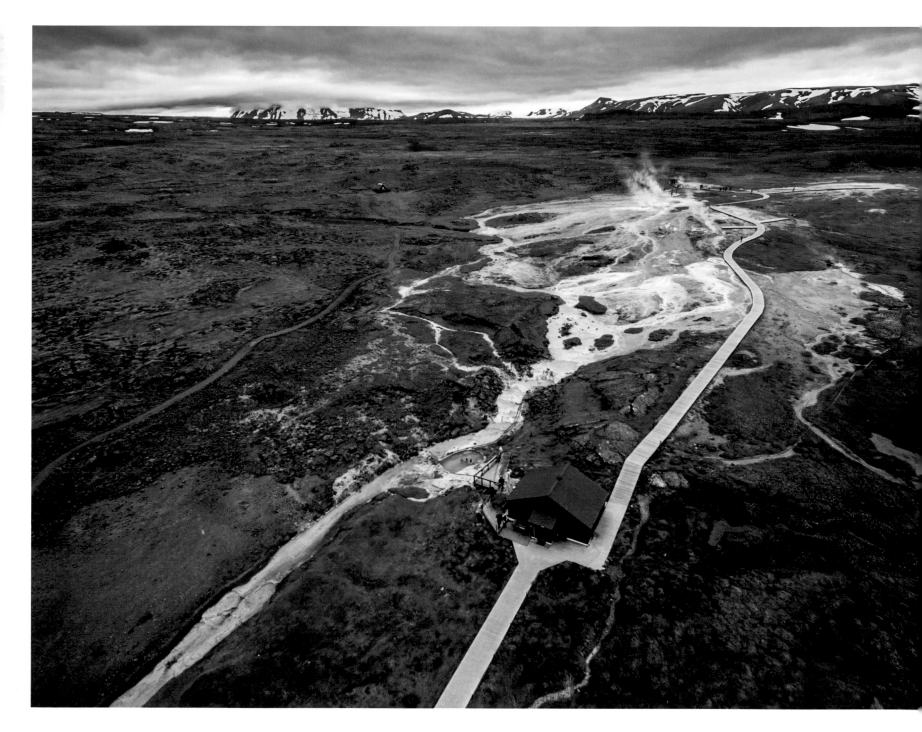

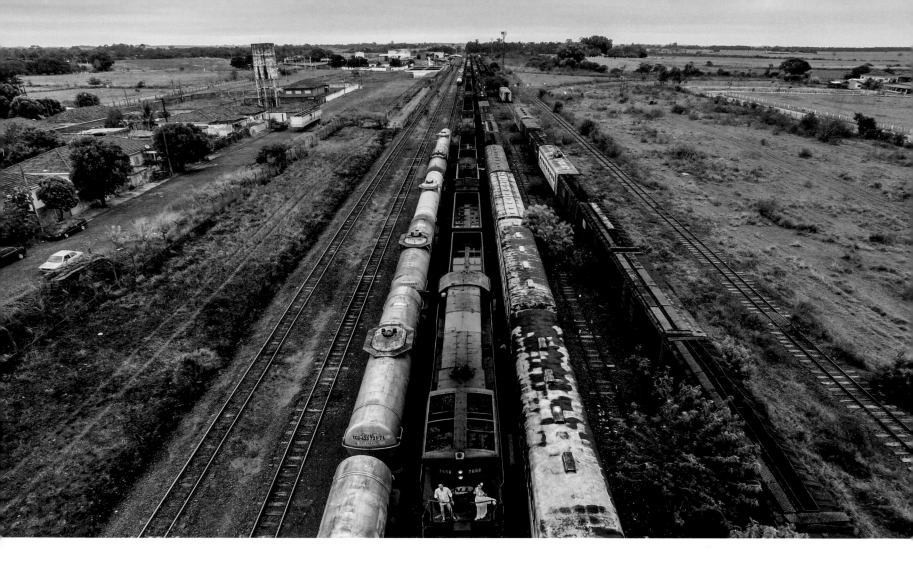

Araçatuba, Brazil
By Marcio Ogura

⊖ -21.2283

◐ -50.5206

⬆ 19.3m (64ft)

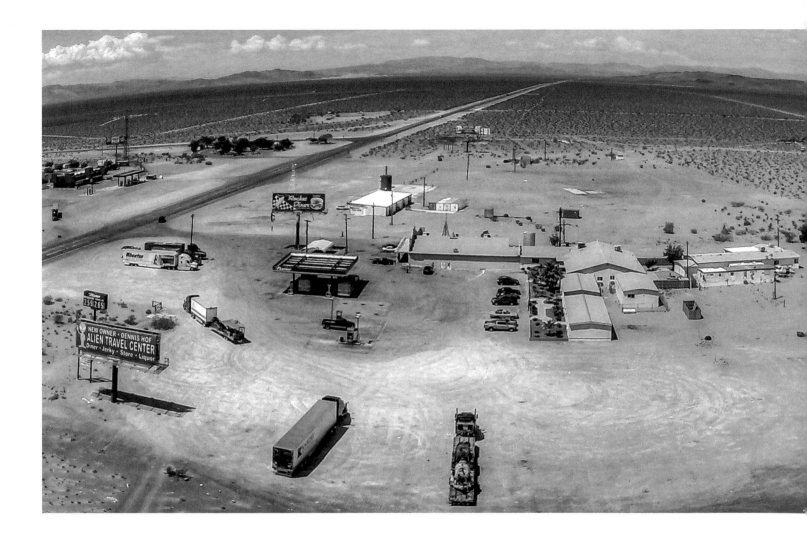

Amargosa Valley, USA
By JackFreer

⊖ 36.6436

◔ -116.3956

↑ 91m (298½ft)

Detroit Lake, USA
By Gary Eidsmoe

44.7129
-122.1793
118m (387ft)

Living in Central Oregon since the end of 2014, this photographer has spent his time exploring some of the most beautiful locations in the area, one of them being Detroit Lake in Detroit. Seen here is Piety Knob, an island in the middle of the lake that experiences low water levels during the winter – captured by Eidsmoe with a DJI Inspire 1.

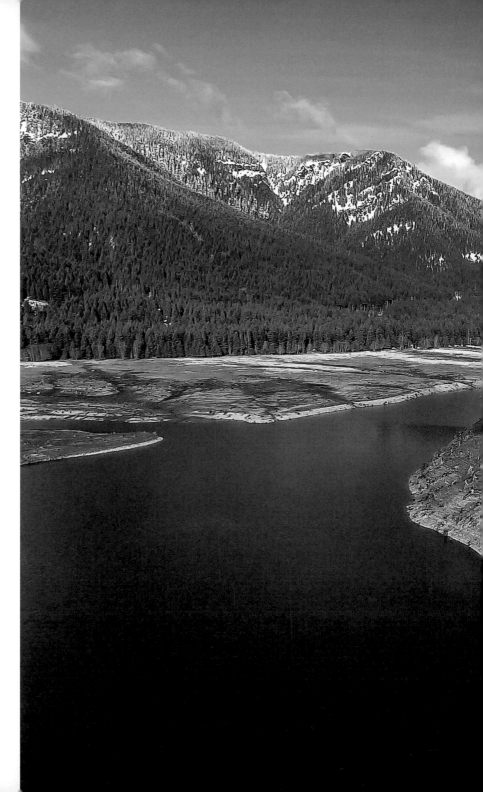

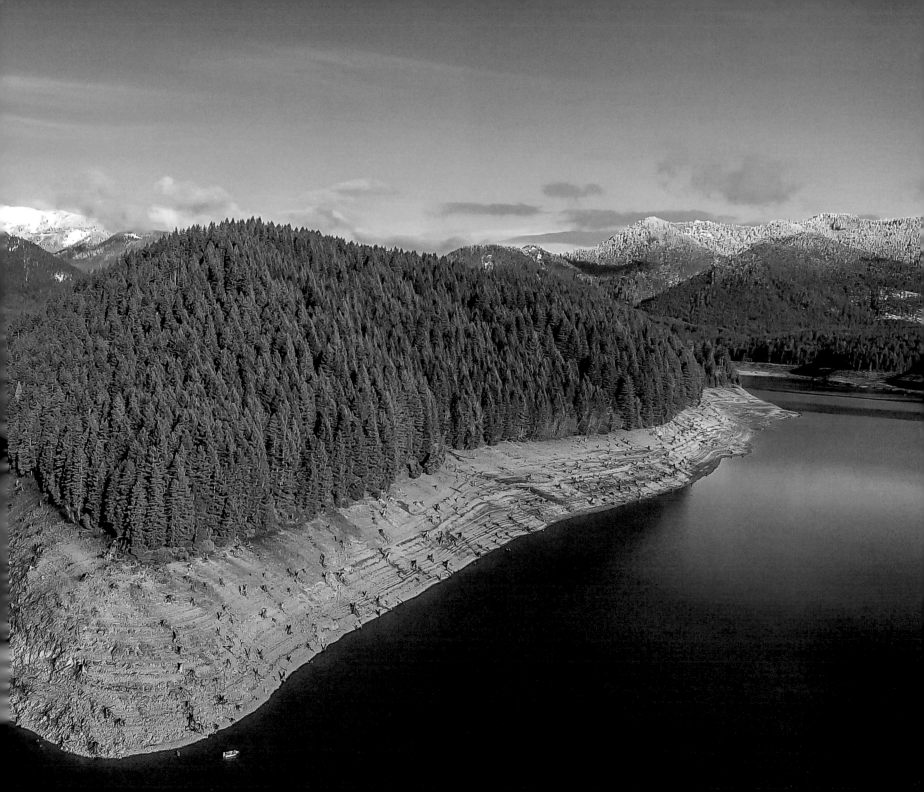

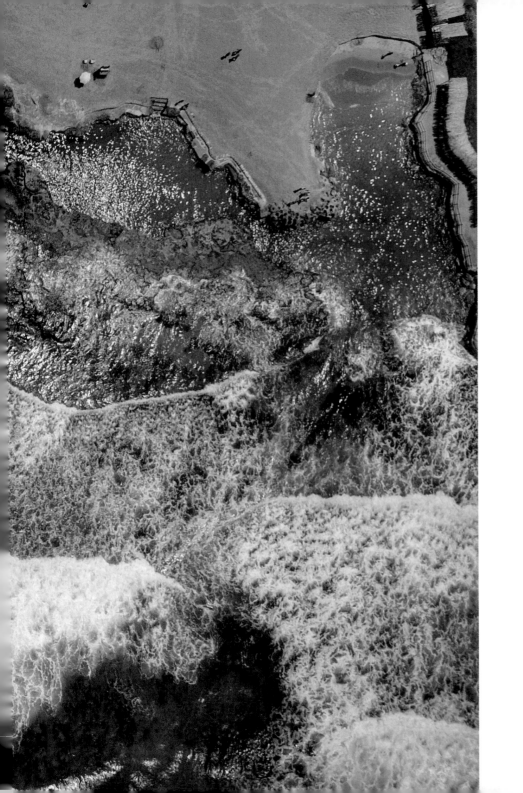

Jiyeh, Lebanon
By sass

33.6824
35.4202
32m (105ft)

Orduña, Spain
By santiyaniz

⊖ 42.9871
⌀ -2.9376
↥ 85m (279ft)

Cilaos, Réunion
By DroneCopters

⊖ -21.1347
⌀ 55.4673
↥ 38m (124½ft)

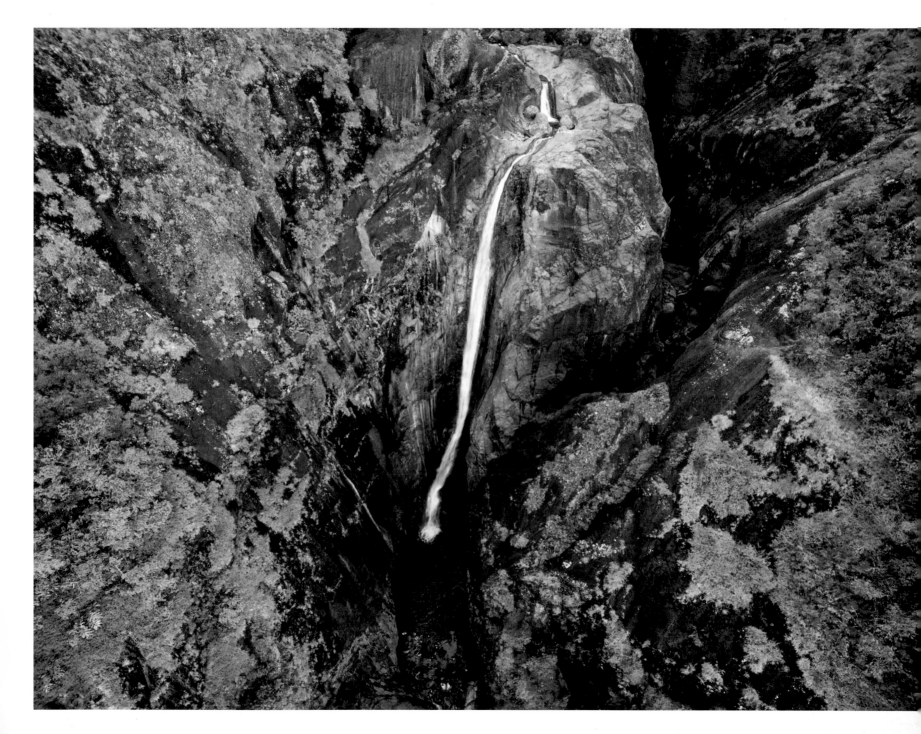

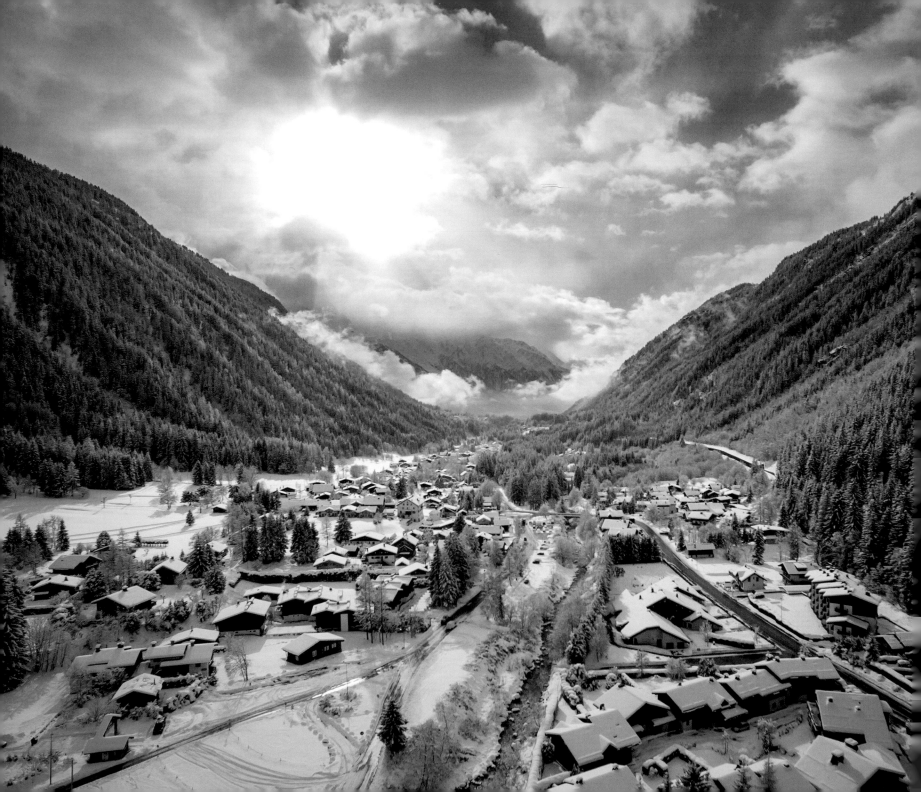

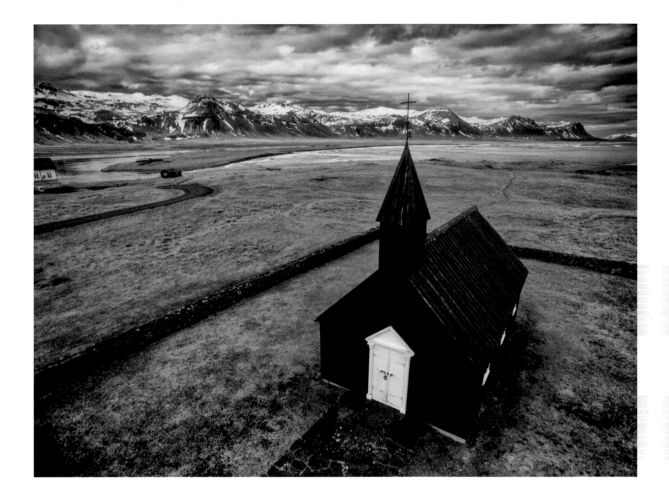

Near Ólafsvík, Iceland
By nairfotografia

⊖ 64.8333

⟨!⟩ -23.5500

⟨↑⟩ 6.5m (21½ft)

Chamonix-Mont-Blanc,
France
By dronealps

⊖ 45.9803

⟨!⟩ 6.9253

⟨↑⟩ 49m (161ft)

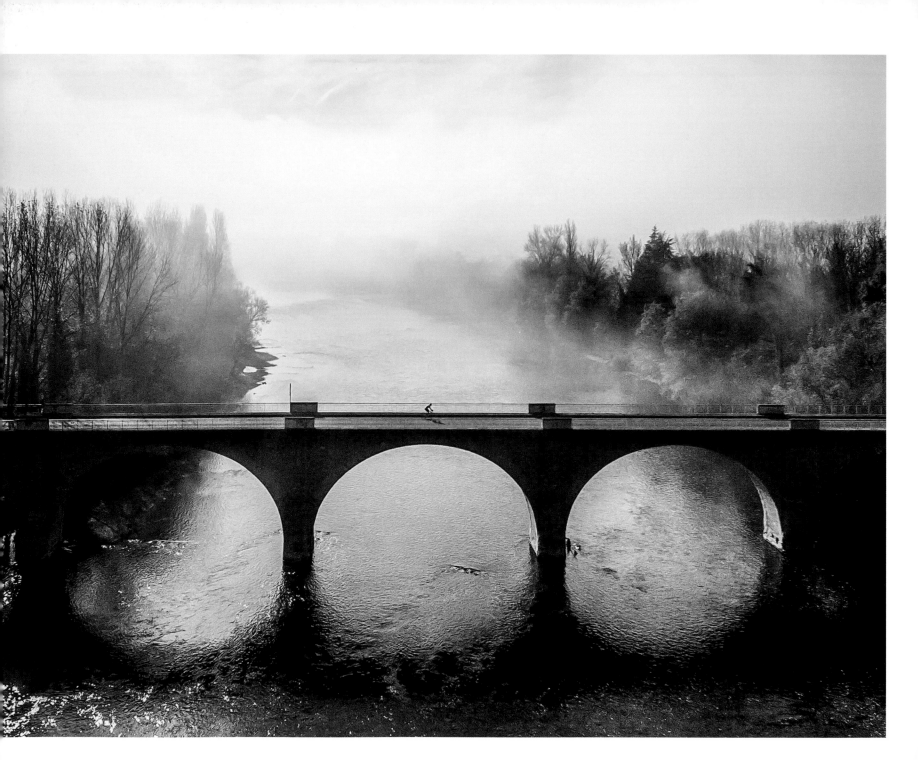

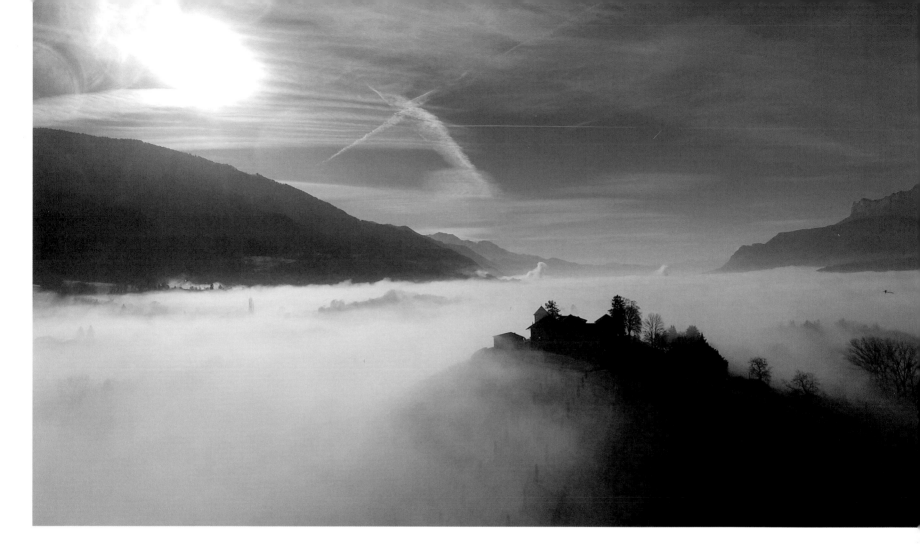

Limeuil, France
By erallion

⊖ 44.8919
① 0.8842
⊕ 34.1m (112ft)

Pontcharra, France
By mountaindrone

⊖ 45.424
① 6.020
⊕ 40m (131ft)

Haute-Savoie, France
By tcoffy

⊖ 46.2866

⊘ 6.5837

⬆ 150m (492ft)

Taken with a DJI Phantom 3, tcoffy captures two hikers on a mountain ridge in France's Haute-Savoie region during a sunny winter morning. Tcoffy has been a member of Dronestagram since 2016 and much of his work focuses on this area of France (see also page 178).

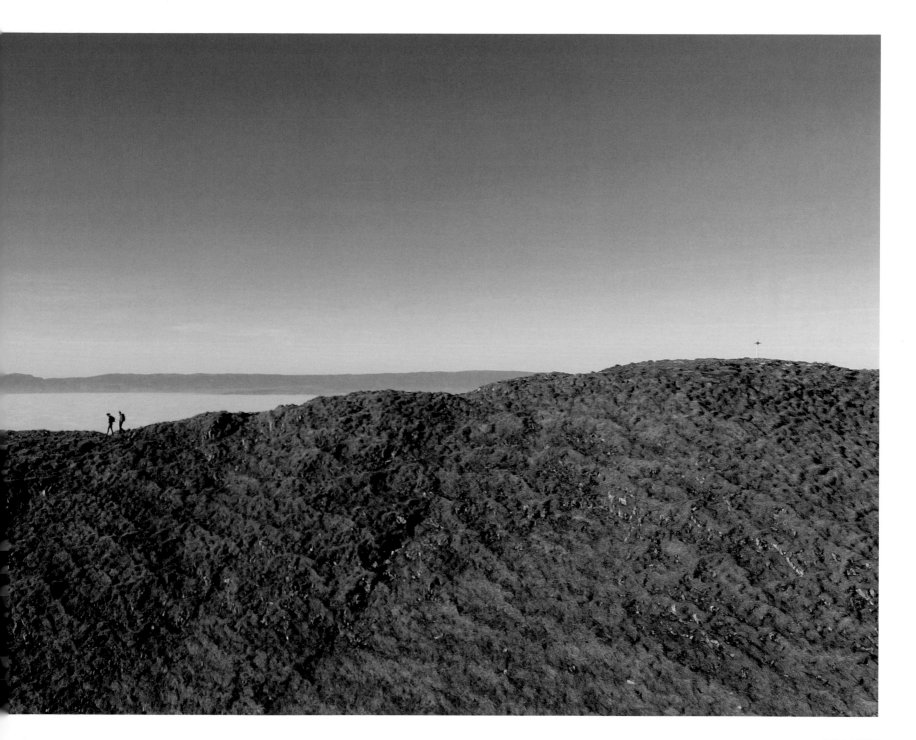

Near Brabant, Antarctica
By Freeway Drone

⊖ -64.6176
⊘ -62.2481
↑ 13m (42½ft)

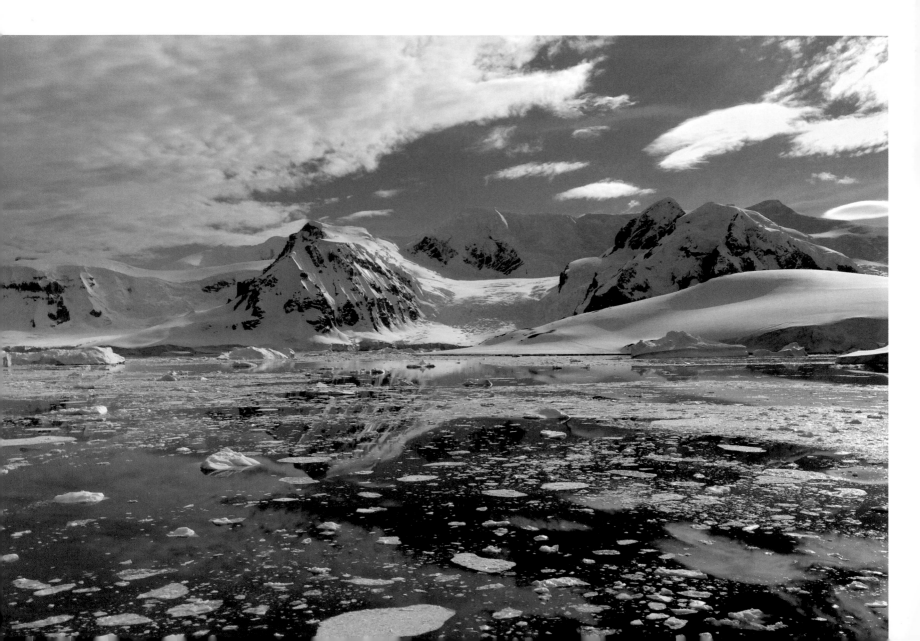

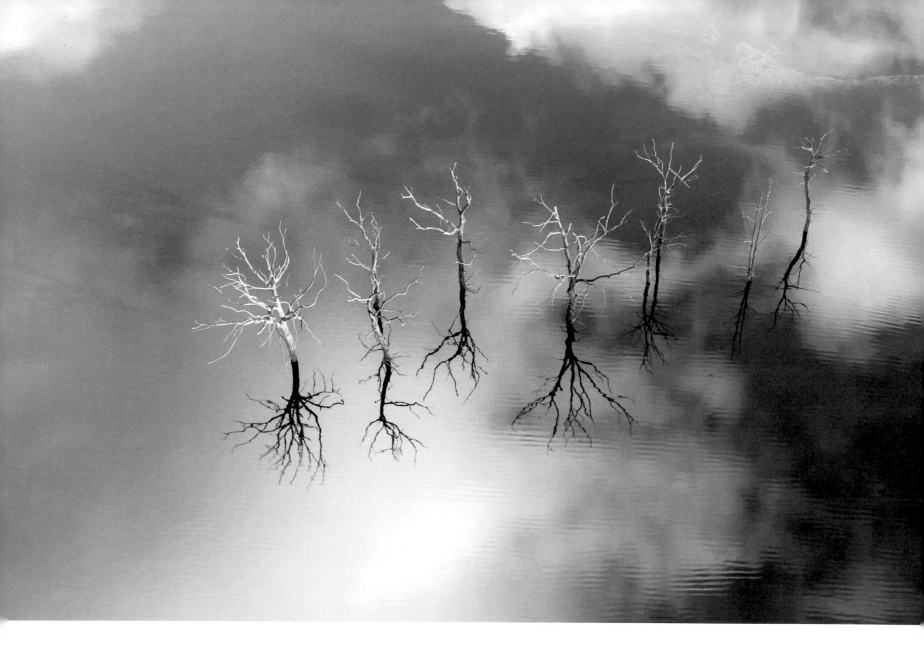

Lake Guerlédan, France
By Nicolas Charles

⊖ 48.2097

⌀ -3.0844

⬆ 30m (98ft)

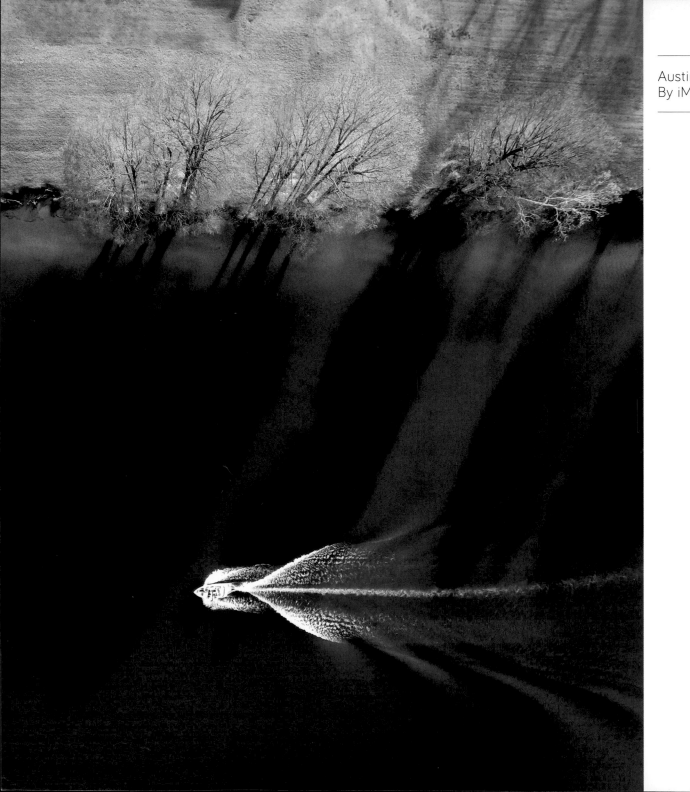

Austin, USA
By iMaerial_com

30.3502
-97.7981
80m (262⅓ft)

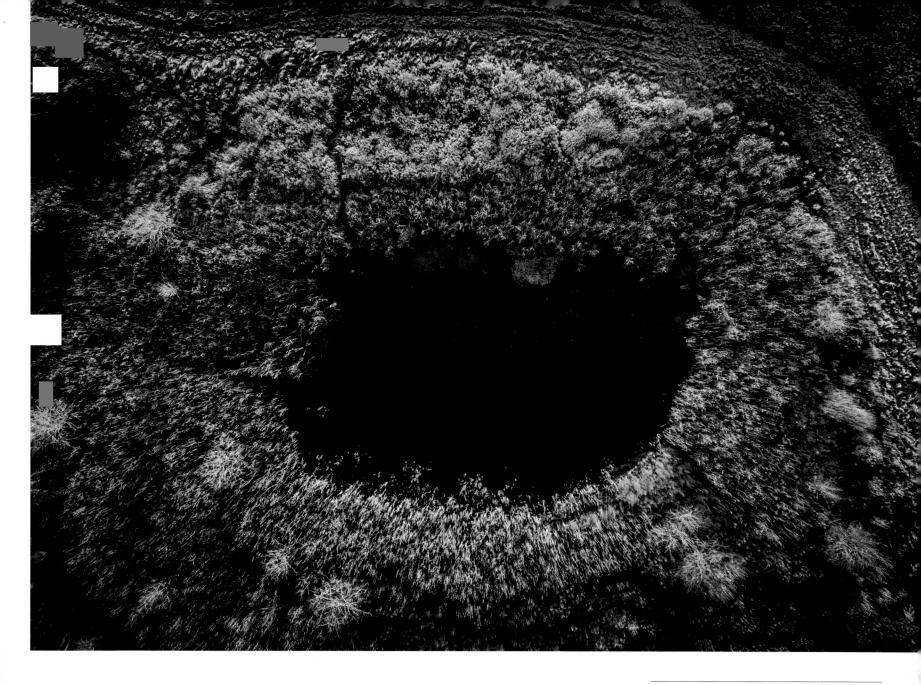

Næstved, Denmark
By mbernholdt

⊕ 55.2294
⌀ 11.8018
↥ 54.2m (178½ft)

Mont Saint-Michel,
France
By wanaiifilms

⊖ 48.6363
⊕ -1.5102
⊕ 130m (426½ft)

The photographer has captured here, with
his DJI Phantom 1 and GoPro HERO4, the
moment at which the iconic Mont Saint-
Michel was engulfed by water, turning
it back into an island, with its causeway
– built to provide access to the area at all
times – completely covered.

The event was the result of a huge
supertide in 2015, soaring nearly 14m
(45ft) in height, a natural occurrence that
happens approximately every eighteen
years. Keen to catch this unusual incident,
the photographer had to seek permission to
fly in the area in advance, arrived early on
the day that the tide had been predicted,
and watched the wave slowly roll in and
subsume the island.

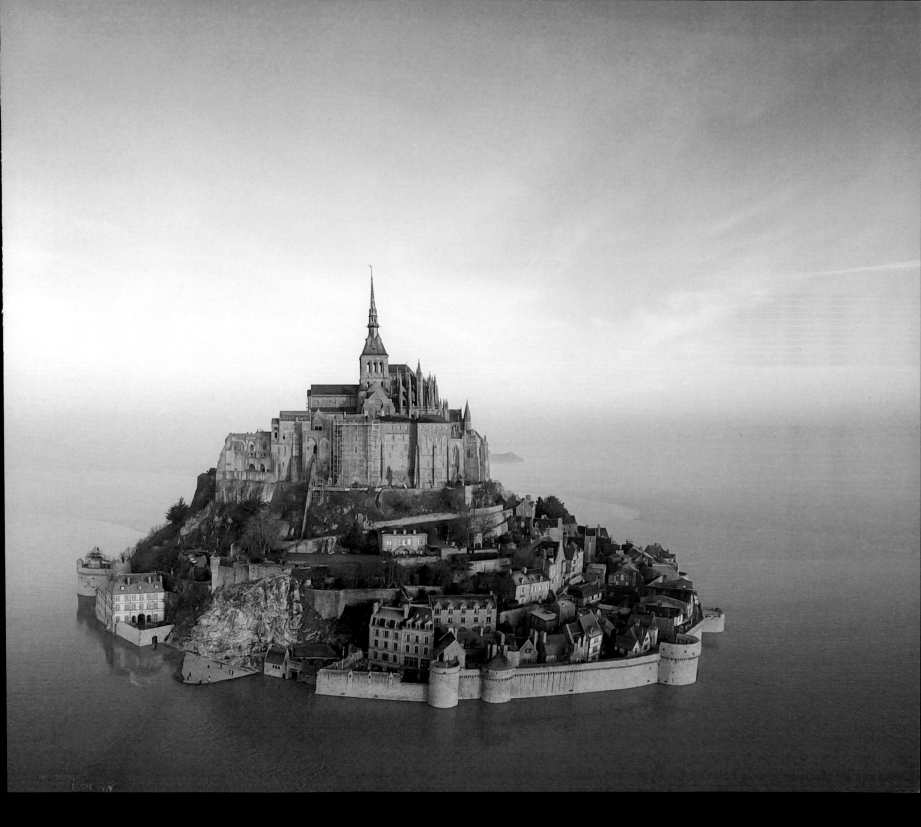

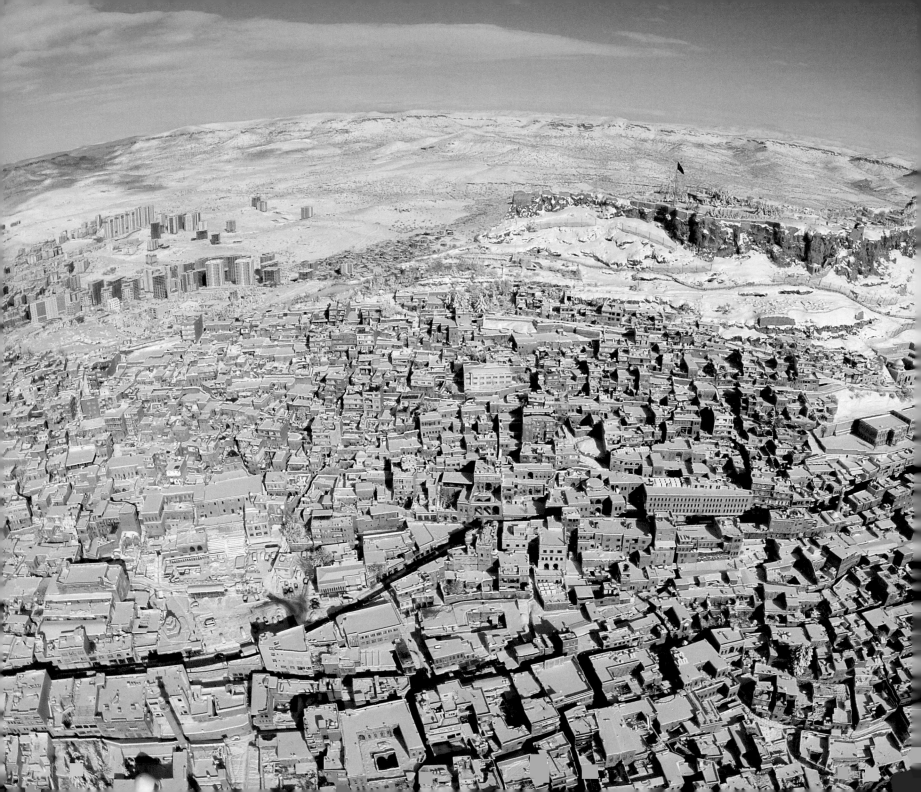

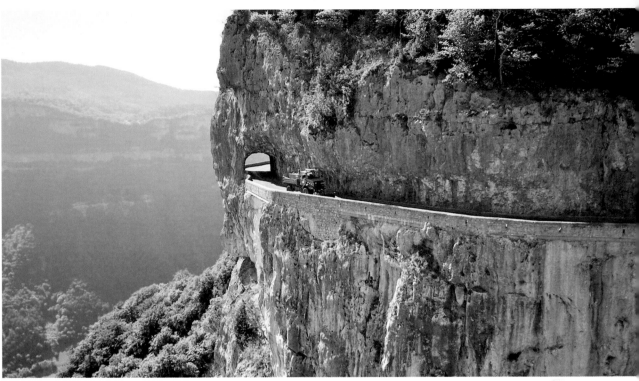

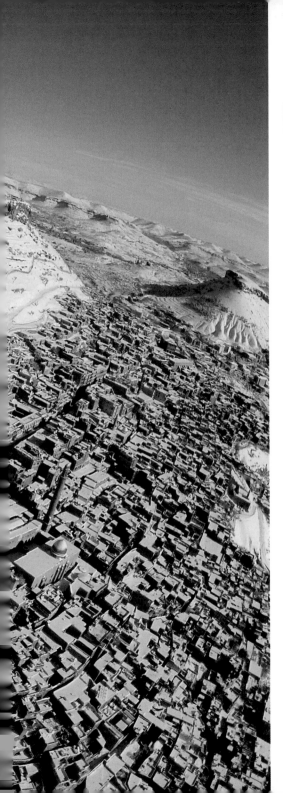

Mardin, Turkey
By Zahit

⊖ 37.3129
⊘ 40.7339
⬆ 150m (492ft)

Saint-Jean-en-Royans,
France
By Ookpik

⊖ 45.0170
⊘ 3.3733
⬆ 600m (1,968ft)

One of the most-viewed images on
Dronestagram, this scene was captured
by the photographer after shooting a film
of the area for the French TV channel,
France 3. It shows the route of an
impossible road in Combe Laval, Vercors,
in the French Alps, in which, at terrifying
heights, vehicles have to squeeze through
a tiny opening in the rockface.

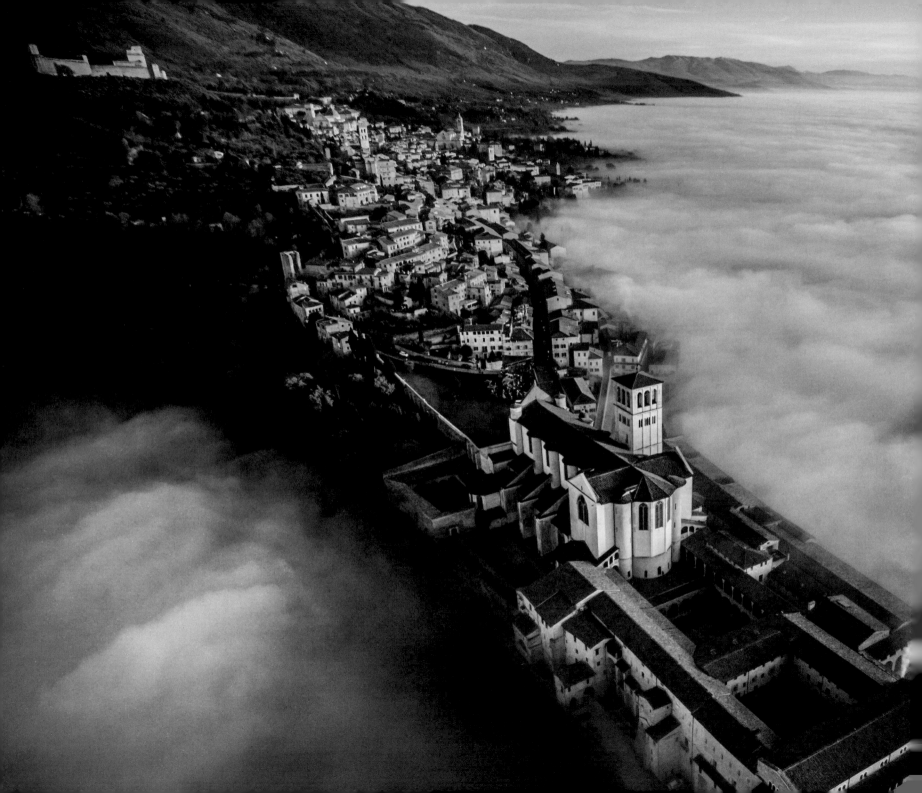

Assisi, Italy
By fcattuto

43.0761
12.6058
56m (184ft)

The Basilica of Saint Francis of Assisi in Umbria, Italy, captured at sunset with the city immersed in fog. This breathtaking shot was taken by the photographer using a DJI Phantom 3. The photograph won the 2016 international drone photography contest organized by Dronestagram and National Geographic, in the category 'Travel'.

Banff, Canada
By mikebish

⊖ 49.2342

⊕ -123.0902

↑ 7m (23ft)

Also working under his full name, Mike
Bishop, this dronester is a prolific member
of Dronestagram, having shared his award-
winning work on the website since 2014.
Though based in Venice, California, many
of the photographs and films he shares
focus on the West Coast of North America.
His drone of choice is the DJI Inspire 1.
See also pages 8–9, 70–71, 98, 176–77
and 254–55.

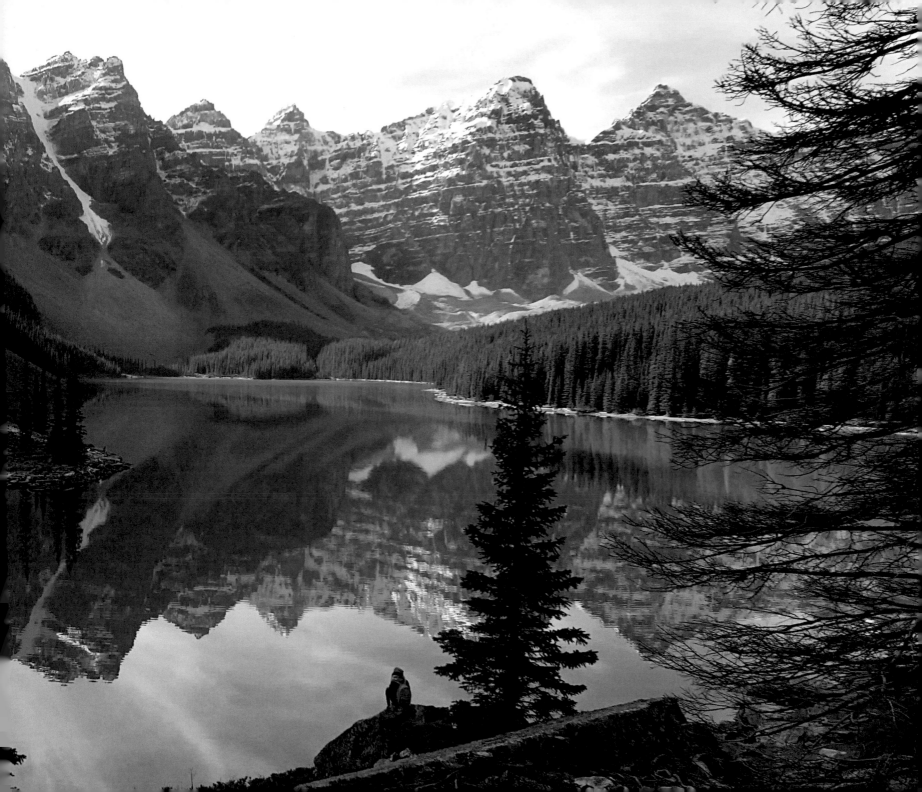

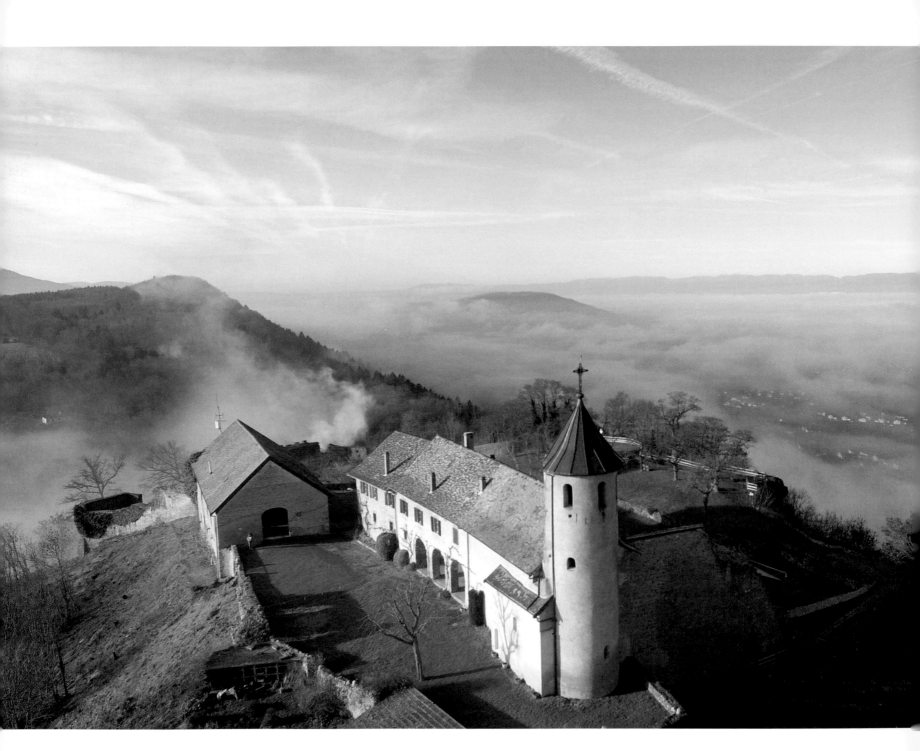

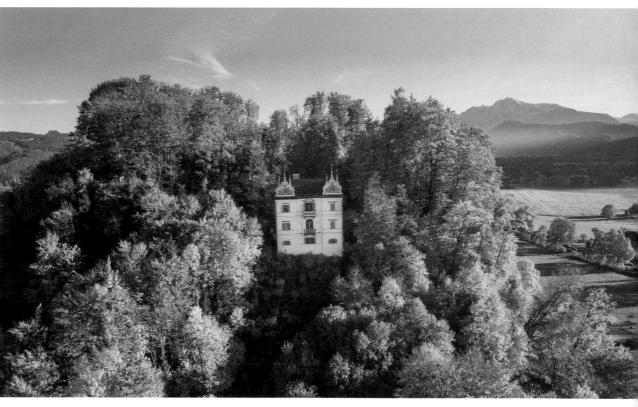

Salzburg, Austria
By Moritz Ott

 47.8095

⏲ 13.0550

↥ 35m (115ft)

Haute-Savoie, France
By tcoffy

◒ 46.3309

⏲ 6.4646

↥ 100m (328ft)

Elektrėnai, Lithuania
By Karolis Janulis

⊖ 54.7794
⏾ 24.6675
↑ 70m (229½ft)

The tiny blue speck in this image is a man
fishing in a frozen lagoon in Elektrėnai,
Lithuania. The photographer wanted to
capture the scene, which he has titled
Space Fishing, with his DJI Phantom 2
Vision, as it looked to him as though the
lake was a solar system, full of stars. Based
in Vilnius, the Lithuanian photographer
captures awe-inspiring scenes of his home
country, as well as places further afield.
See also pages 199, 232–34, 236–37 and 242.

Rattlesnake Mountain,
Reno, USA
By Tk art

⊖ 40.2524
⏾ -115.6064
↑ 19m (62ft)

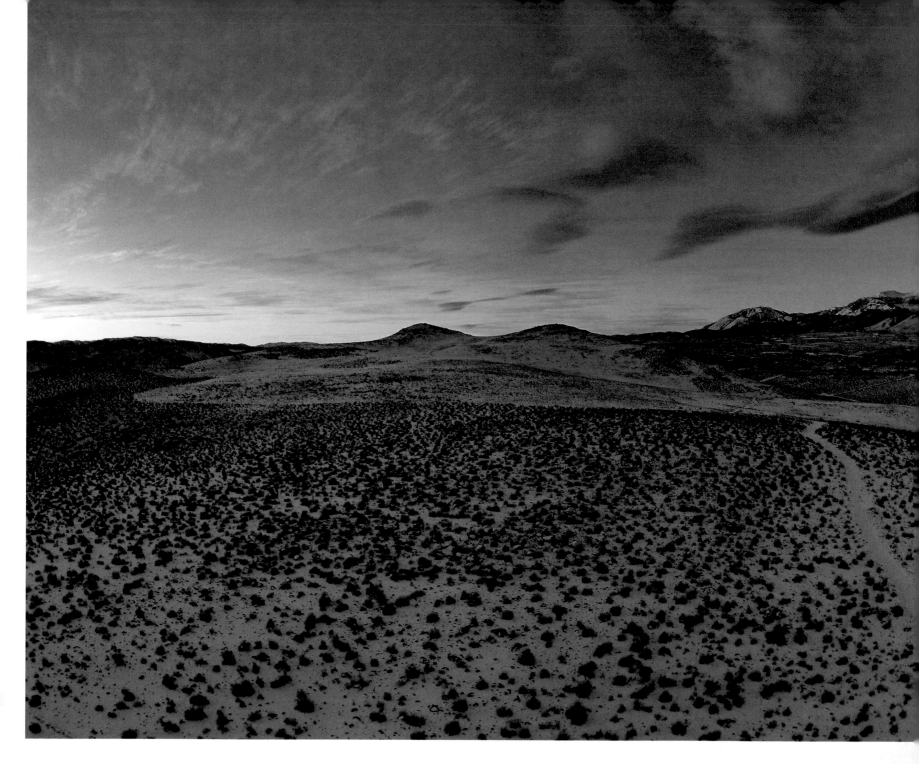

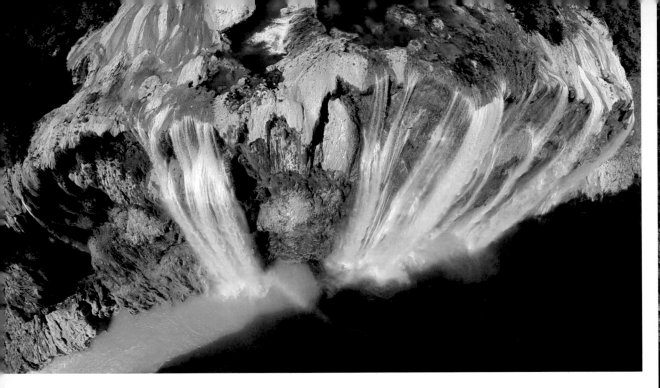

Aquismón, Mexico
By postandfly

⊖ 21.8014

① -99.1818

↑ 105m (344ft)

Taken with a DJI Phantom 1 and GoPro HERO3 Black, this photograph shows the 105m- (344ft)-high Tamul waterfall, the highest in the region of San Luis Potosí in Mexico.

The area has a special meaning to the photographer, since it was here that he flew his first drone, attempting to capture this very shot – the waterfall in all its glory. However, on its initial flight the drone malfunctioned, and it, the camera and all footage were lost to the waterfall. Undeterred, he returned two months later and finally achieved the photograph he was after, shown above.

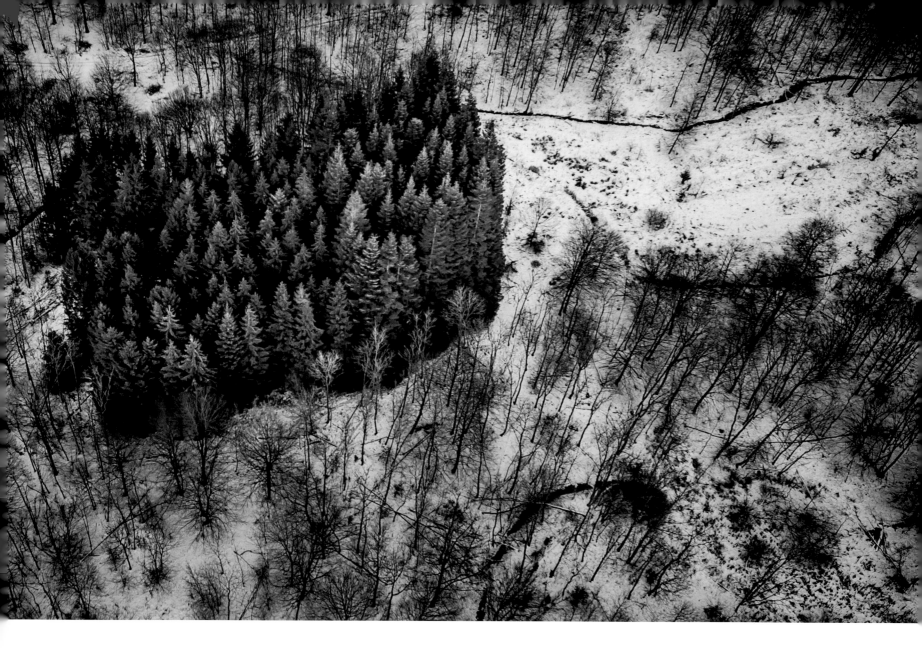

Næstved, Denmark
By mbernholdt

55.2289

11.8078

119.2m (391ft)

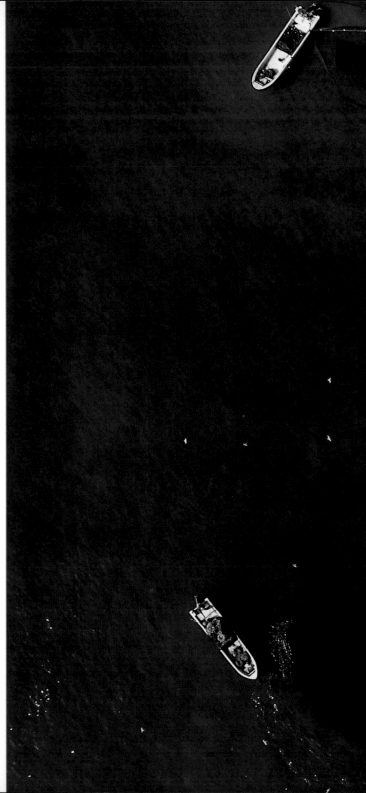

Fujairah, UAE
By Shoayb Khattab

25.1528	
56.3576	
65m (213ft)	

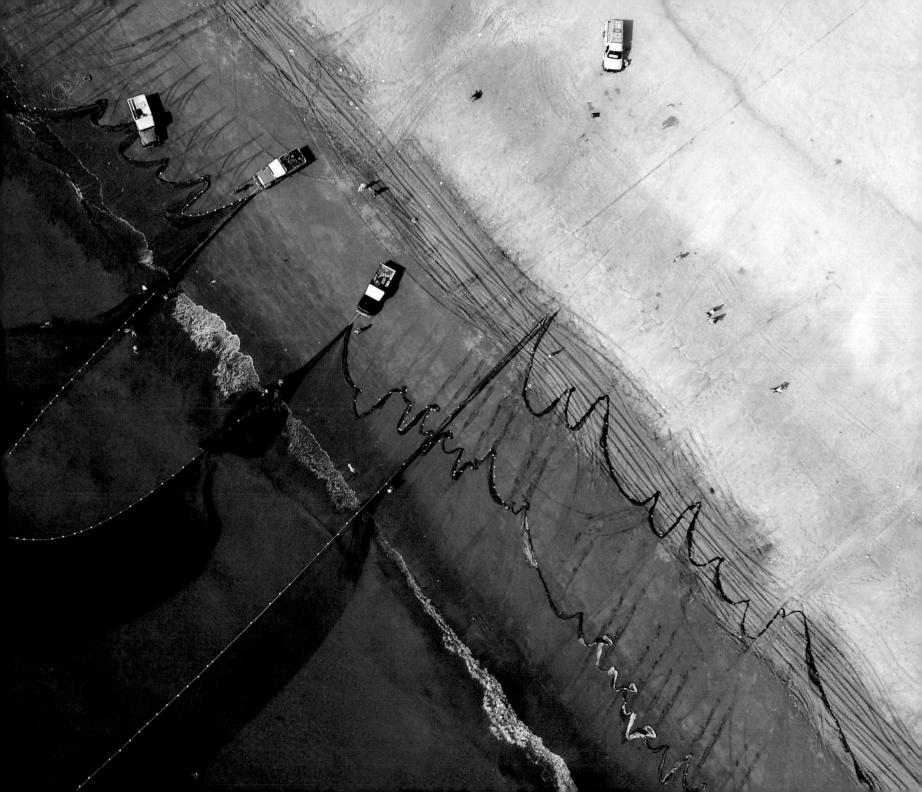

Romeo
Durscher

Son Doong, Vietnam

⊖ 17.4452
Ⓘ 106.2906
⊕ 37.6m (123ft)

AGE | 41
PROFESSION | Director of Education at DJI
NATIONALITY | Swiss
BASED IN | San Francisco, USA
USES DRONES SINCE | 2013
DRONE PIX TAKEN | 200,000+
EQUIPMENT | DJI Phantom 1, DJI Phantom 2 Vision, DJI Phantom 2 Vision+, DJI Phantom 3 Professional and DJI Inspire 1 / GoPro HERO3 Black and DJI Phantom 3 Professional

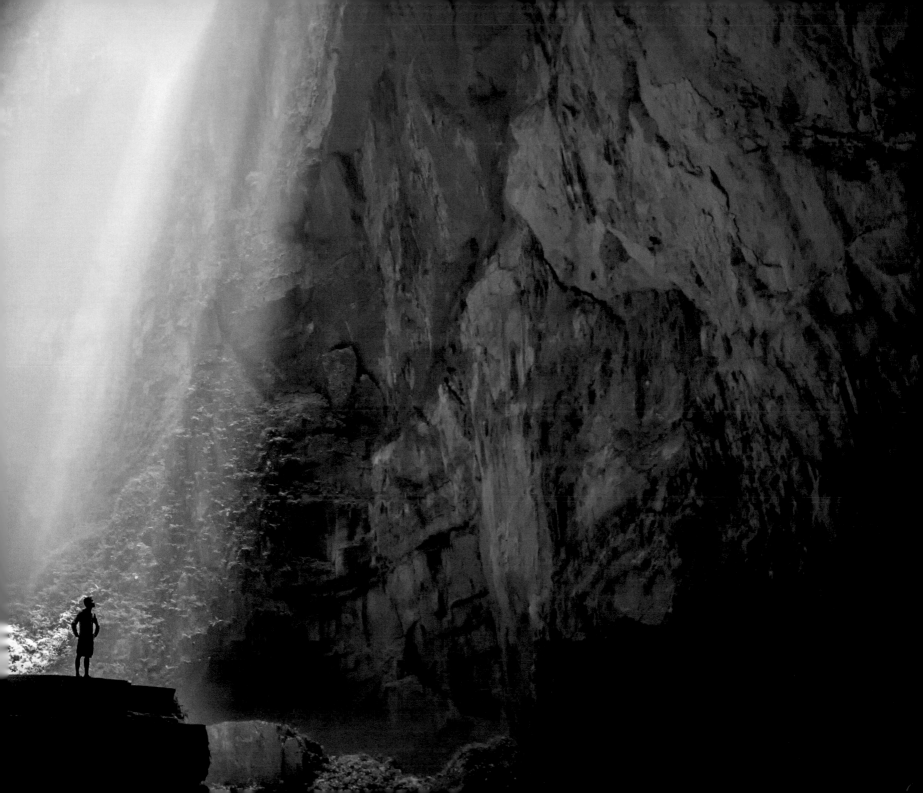

California-based Romeo Durscher, known on Dronestagram as romeoch (see also pages 27 and 87), has been flying drones since 2012. He is perhaps best known for his aerial panoramas and long-exposure shots, the appeal of which to the photographer are the unexpected vistas and landscape formations that emerge only once the drone is up in the air. This sense of discovery is fascinating to him: 'You see a pattern, a formation or something completely different to what you expected – that's what's so fun about using drones. Usually I like to fly in the same location more than once, so I know what to expect and can focus on taking the images that I want.'

When Durscher's interest in drones was first piqued drone technology was limited. The end results were difficult to predict and the views from up high that he wanted to capture were hard to achieve: 'the first platforms were clunky and didn't offer a camera or stabilization system. So an action camera had to be added but you were still shooting blind (there wasn't a live camera feed available).'

In spite of these challenges, seeing the results of photos taken from 50m (164ft) or more above ground, was thrilling for Durscher, and he began to modify his drone, 'tinkering and adding equipment until we had a live feed into a monitor or goggles', so that he could have more control over the final shot. 'Then camera stabilization systems (gimbals) came out. That was huge for videography.

From there things started to evolve very quickly and today we have integrated platforms not only with stabilized cameras but with HD live downlinks, allowing you to change camera settings during the flight.'

With drone technology constantly evolving, Durscher is impelled to produce even more technically difficult shots: 'You can now have a micro four third camera on a quadcopter (DJI Inspire 1 Professional with a Zenmuse X5 camera) and change lenses. This dramatically changes the way your images look and feel. A 12mm (actively 24mm) lens has a nice "wide" feel, while a 45mm (actively 90mm) lens really closes in on the subject. Now that it is possible to adjust the aperture and focus, you can really control the creativity and look for your work. It's truly amazing and allows for much more flexibility.'

For Durscher drones make any shot or view possible: 'Want to capture the sun from behind a satellite dish or create interesting views by pointing the camera straight down? Easy! The "God's-eye" view is one of my favourites. It's just something we are still not used to seeing. Even when using a helicopter it's difficult to achieve such results.'

Ultimately, as the drone photography revolution continues to advance, the possibilities for Durscher are limitless: 'As technology evolves, and with cameras and sensors on aerial platforms getting better and bigger, photographers can be more creative and have even more fun in the air.'

Pfeiffer Beach,
Big Sur, USA

36.2508
-121.7943
150m (492ft)

Pfeiffer Beach,
Big Sur, USA

36.2424
-121.8271
7.9m (26ft)

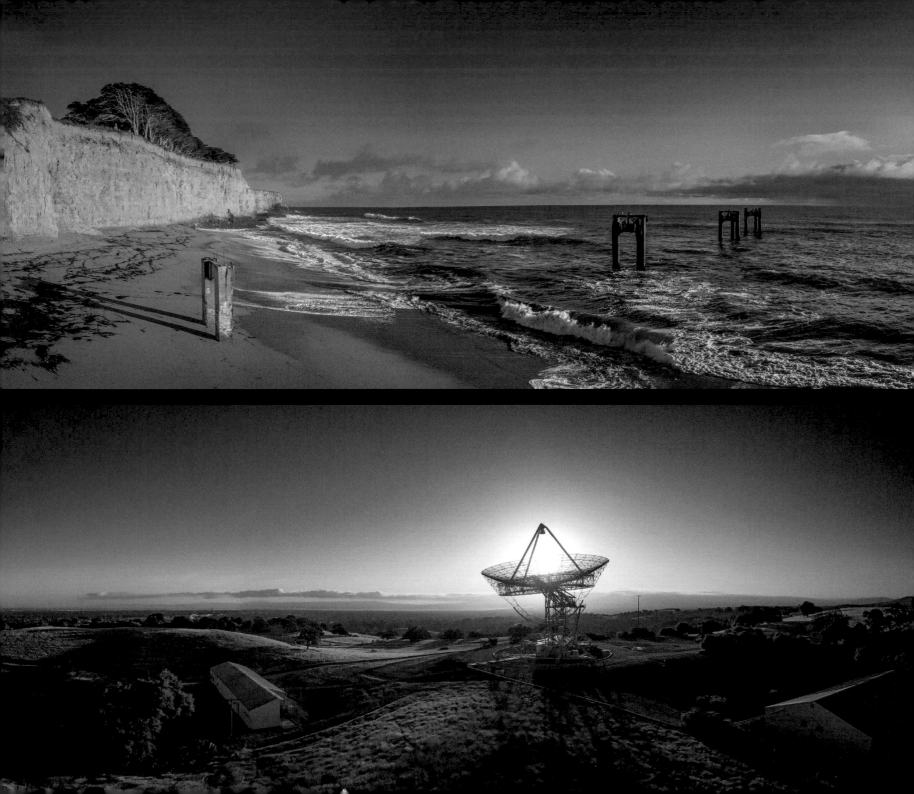

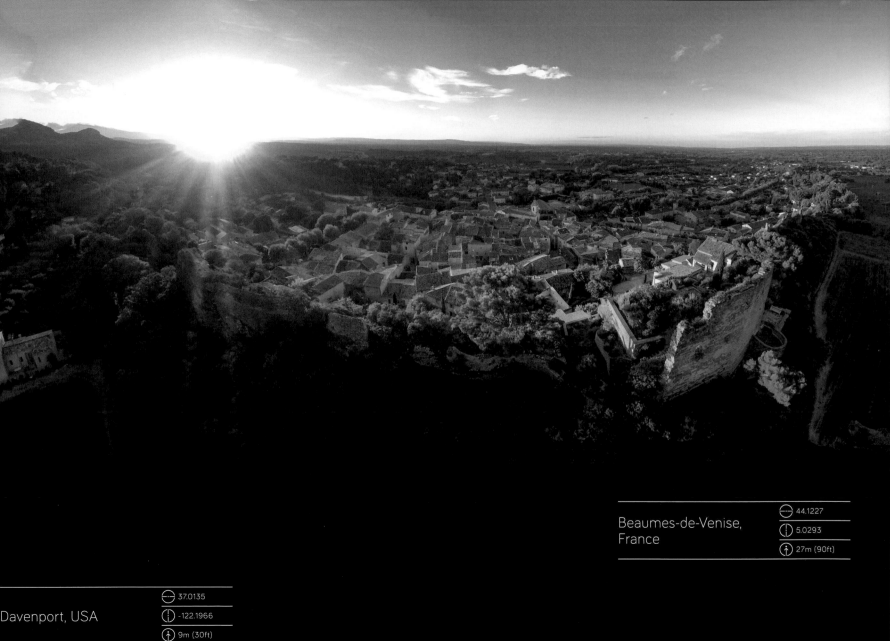

Beaumes-de-Venise,
France

44.1227

5.0293

27m (90ft)

Davenport, USA

37.0135

-122.1966

9m (30ft)

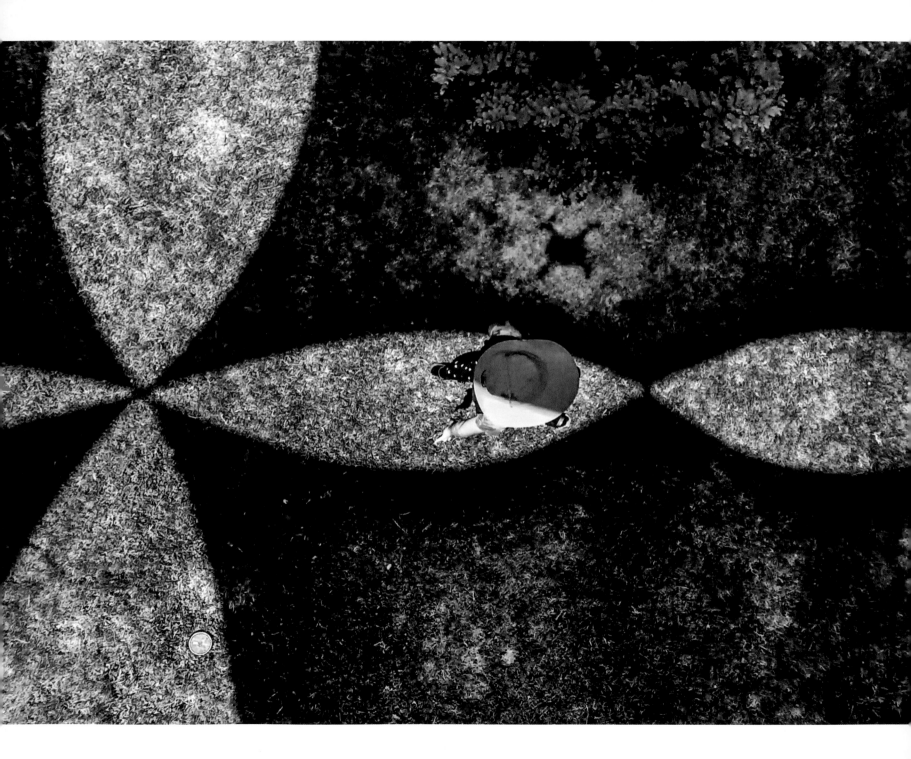

PATTERN/ SHADOW

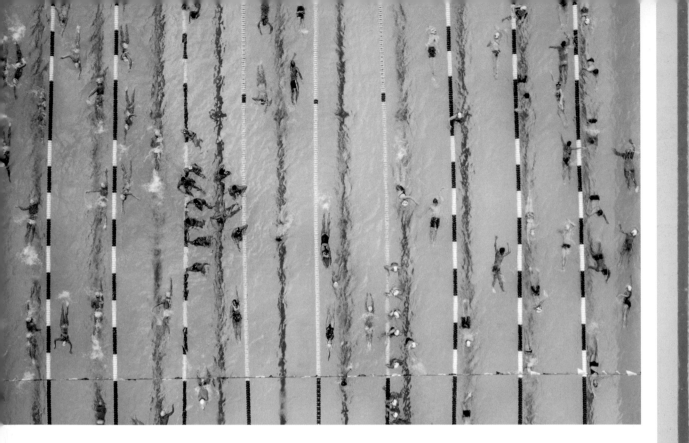

Cúcuta, Colombia
By losmanesdeldrone

⊖ 7.8897
⊘ -72.4969
⊙ 20m (65½ft)

Oskarström, Sweden
By anders@andersa.com

⊖ 56.7947
⊘ 12.9759
⊙ 12m (40ft)

This photo – shot with a Sony A7 and HAB Paparazzo v2 – won the overseas category in China's first UAV photo contest.

The photographer had the composition in mind for a while and, in his own words, 'needed to get it out'. It was taken in the community pool in the town of Oskarström. He asked his neighbour to pose for the shot, and they arrived just before the pool opened, and with the permission of the janitor, a drone hobbyist himself, achieved this award-winning image.

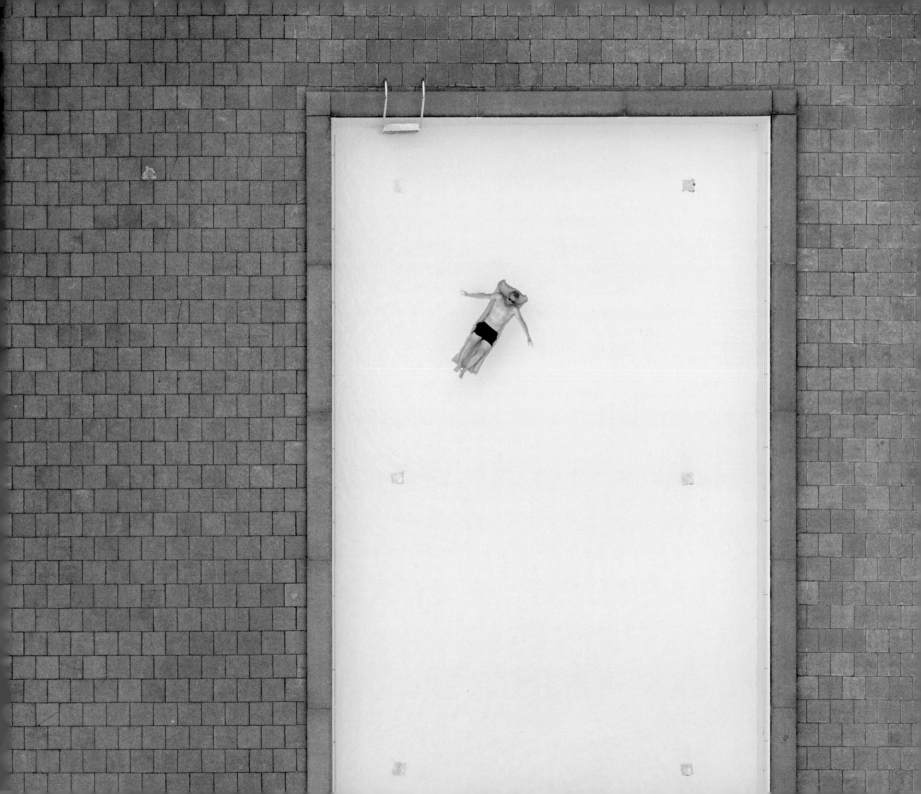

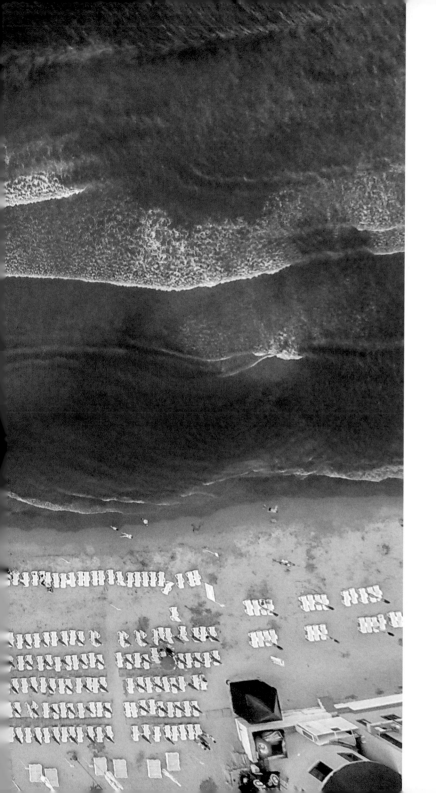

Mamaia, Romania
By thedon

44.2199
28.6362
100m (328ft)

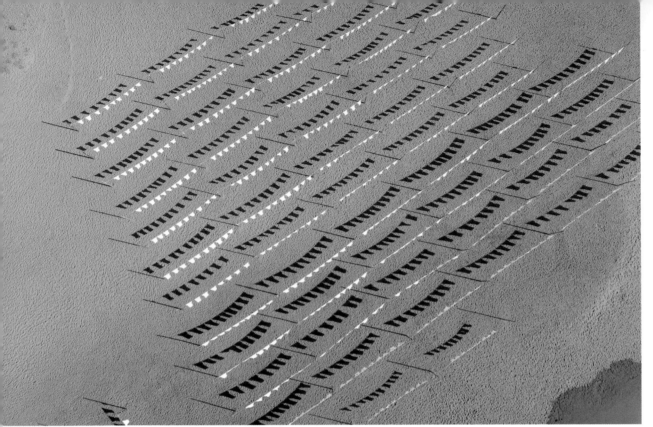

Kuroshio-cho, Japan
By K-max07

⊖ 33.0184
⊕ 133.0081
⬆ 120m (394ft)

Taken with a custom-made drone and
Sony NEX-5 camera this image shows
Kuroshio-cho's Irino Beach in which, every
year, the 'Seaside Gallery' emerges with
this installation of hanging T-shirts. As
the environment changes so too does the
installation, which is captured perfectly
by K-max07's aerial view depicting the
shadows that the T-shirts cast on the sand.
See also page 133.

Margherita di Savoia,
Italy. By Francesco
Gernone Photo

⊖ 41.3845
⊕ 16.0845
⬆ 459m (1,506ft)

Captured here, with a DJI Phantom 2
Vision+, is the 20km- (12½-mile-)long strip
of saltmarsh in Italy's Margherita di Savoia
region. Titled *The Sultan*, the image shows,
from a height of nearly 500m (1,640ft), how
the colours of the clay saltpan are reflected
in the water to kaleidoscopic effect. See
also page 59.

Vilnius, Lithuania
By Karolis Janulis >

⊖ 54.6712
⊕ 25.2836
⬆ 90.6m (297ft)

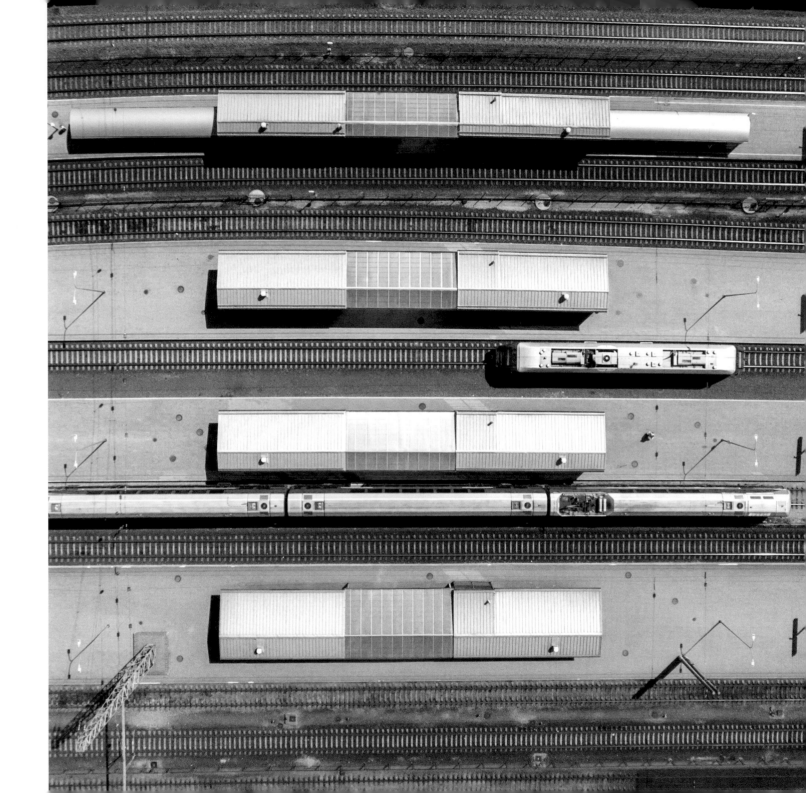

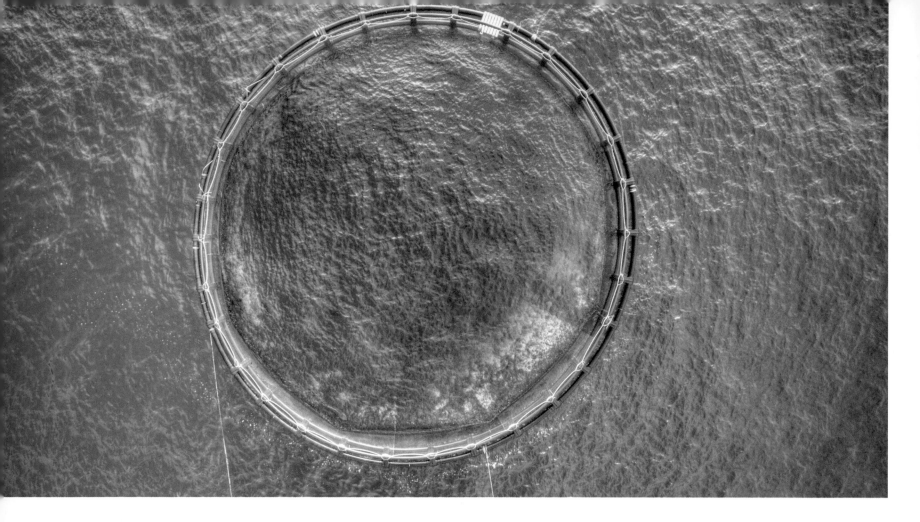

Ilha Grande, Brazil
By MAZZA_FPV

⊖ -23.1237
◐ -44.2737
↑ 253.3m (831ft)

Shot with a DJI Inspire 1 this picture shows
a mariculture of scallops and Bijupirá
fish. The photographer operated the drone
from his beachside home and had to fly
approximately 500m (1,640ft) out to sea to
achieve this image. See also pages 130–31.

Mallaram, India
By Aurobird

⊖ 17.2702

⊕ 80.9956

↥ 15.5m (51ft)

St Albans, UK
By CloudVisual

⊖ 51.7822
⊕ -0.4052
↑ 87m (285½ft)

Asan, Korea
By boy1004

⊖ 36.8497
⊕ 126.8612
↑ 102m (334½ft)

Lake Balaton, Hungary
By
FlyingEyesDroneMedia

46.7144
17.4765
40m (131ft)

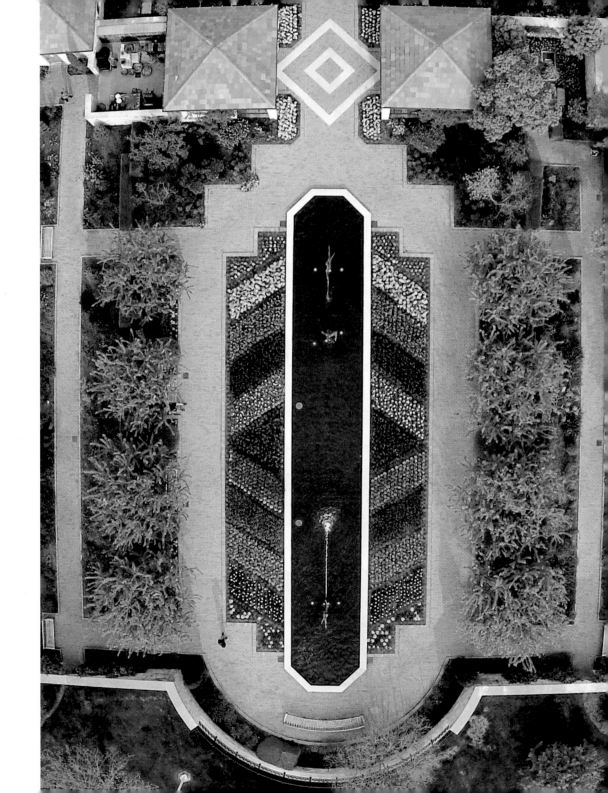

Kansas City, USA
By KC HoverCam

⊖ 39.0397

Ⓘ -94.5792

⌖ 60m (197ft)

Guntur, India
By Aurobird

⊖ 16.3475
⊘ 80.3713
↑ 8.1m (26½ft)

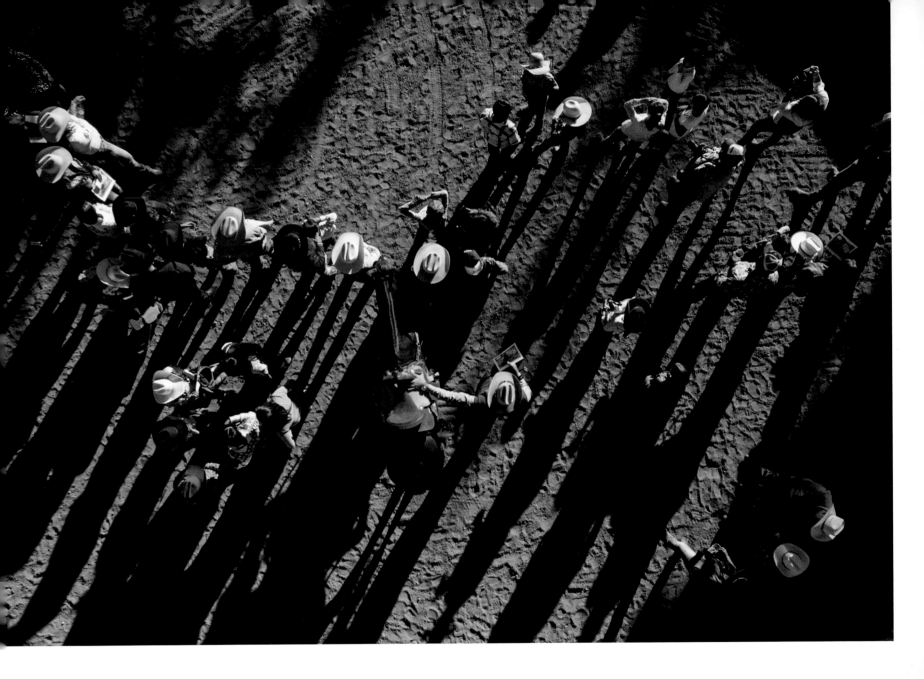

Lagos de Moreno,
Mexico
By dronesolutions

⊖ 21.4222

⊘ -101.8340

⬆ 10.6m (34½ft)

Salo, Finland
By vaihkonen

⊖ 60.3909

⊘ 23.1354

⬆ 8m (26ft)

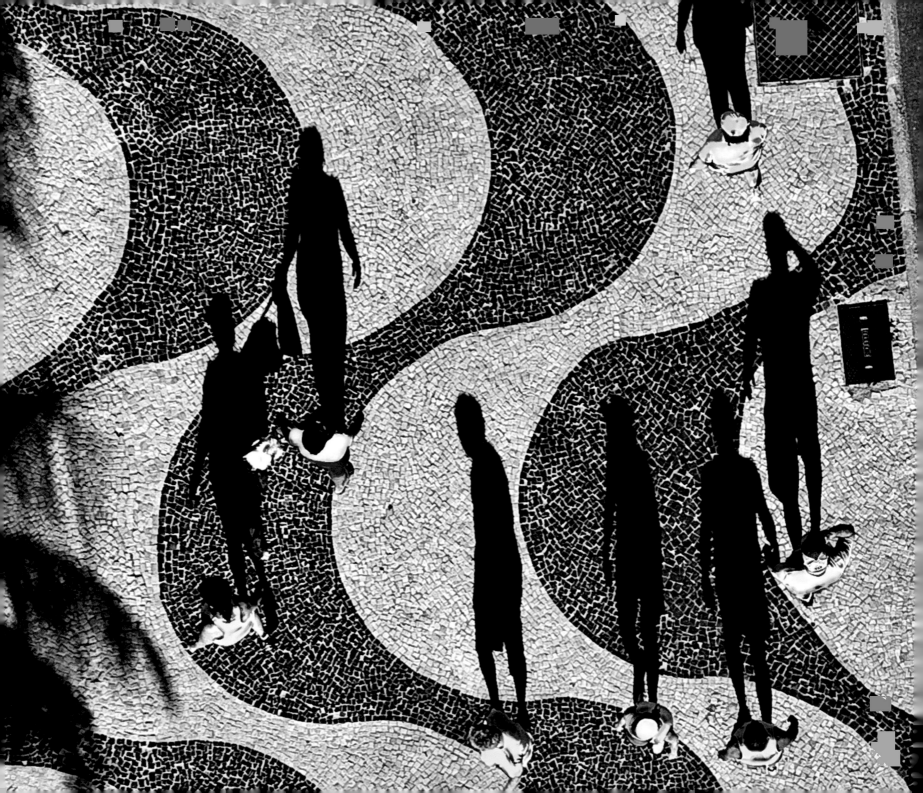

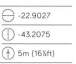

Rio de Janeiro, Brazil
By Francisco Lima

⊖ -22.9027
⊘ -43.2075
⊛ 5m (16½ft)

Amos, Canada
By Roger Caron

⊖ 48.5717
⊘ -78.1251
⊛ 60m (197ft)

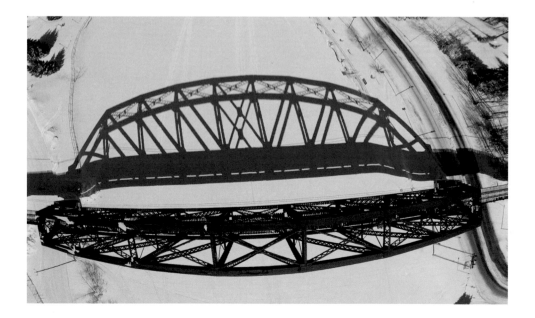

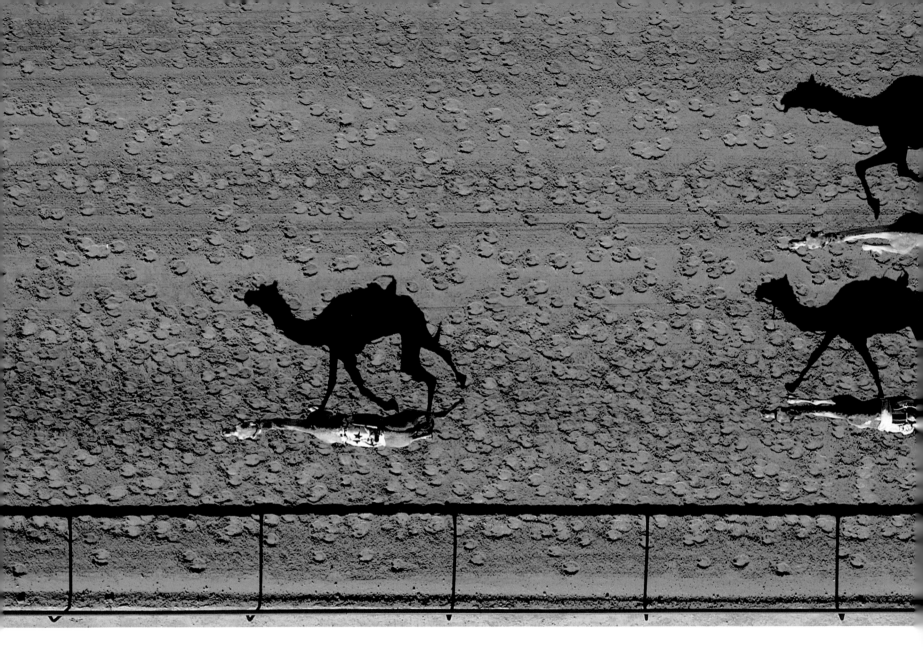

Dubai, UAE
By Shoayb Khattab

25.1528
56.3576
9m (30ft)

Titled *Vertical Racing* this image – shot using a DJI F550 – captures the annual camel race held at the Al Marmoum racetrack in Dubai.

To achieve this shot, which the photographer calls *A Story of Shadows*, he visited the site multiple times beforehand to work out the best vantage point and time at which to capture the shadows. Hi experience, he says, was also vital in taking this shot, since any mistakes could have potentially disrupted the entire event. See also pages 184–85.

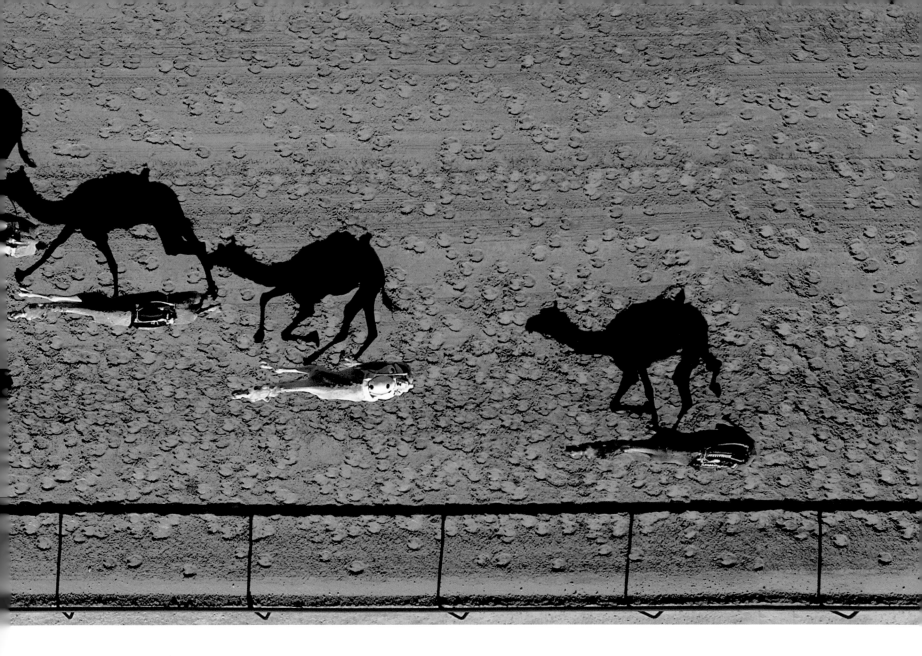

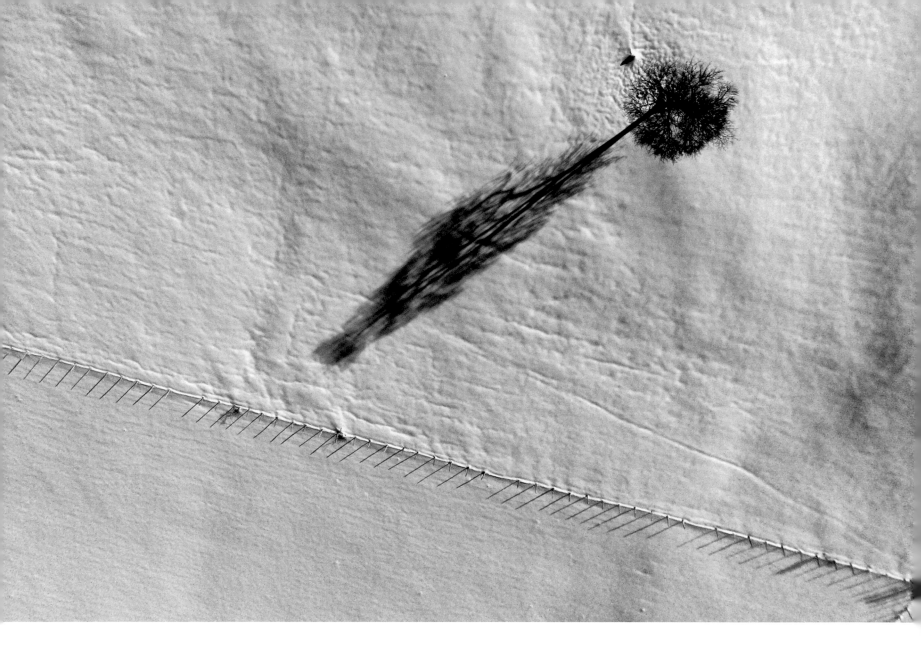

Vitoria-Gasteiz, Spain
By santiyaniz

⊖ 42.9872

⌀ -2.9736

↥ 85m (279ft)

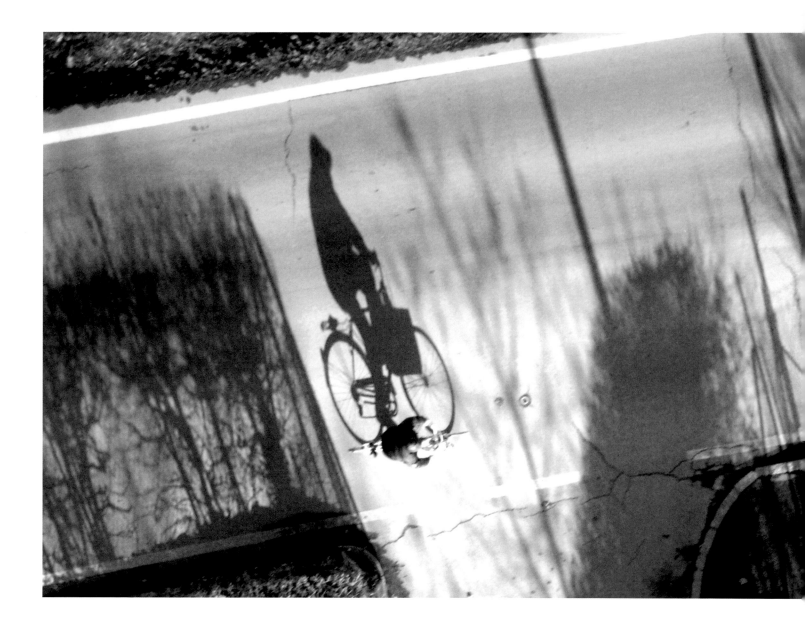

Bologna, Italy
By EYE-SKY

44.4964

11.3817

65m (213ft)

Jamesville, USA
By BobGates

⊖ 43.0275
⊘ -76.0803
↑ 197m (646ft)

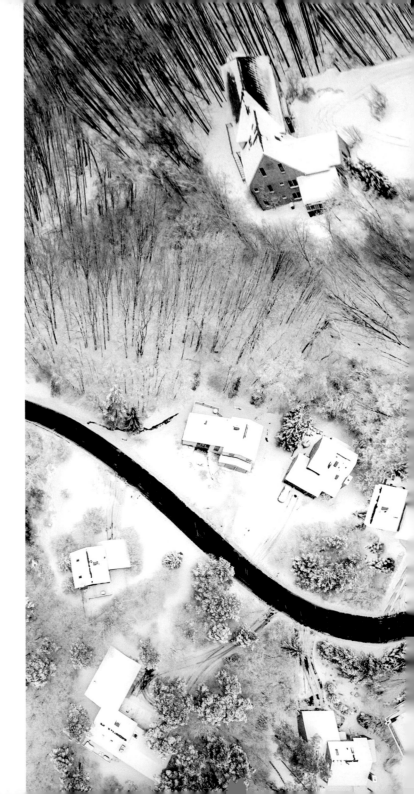

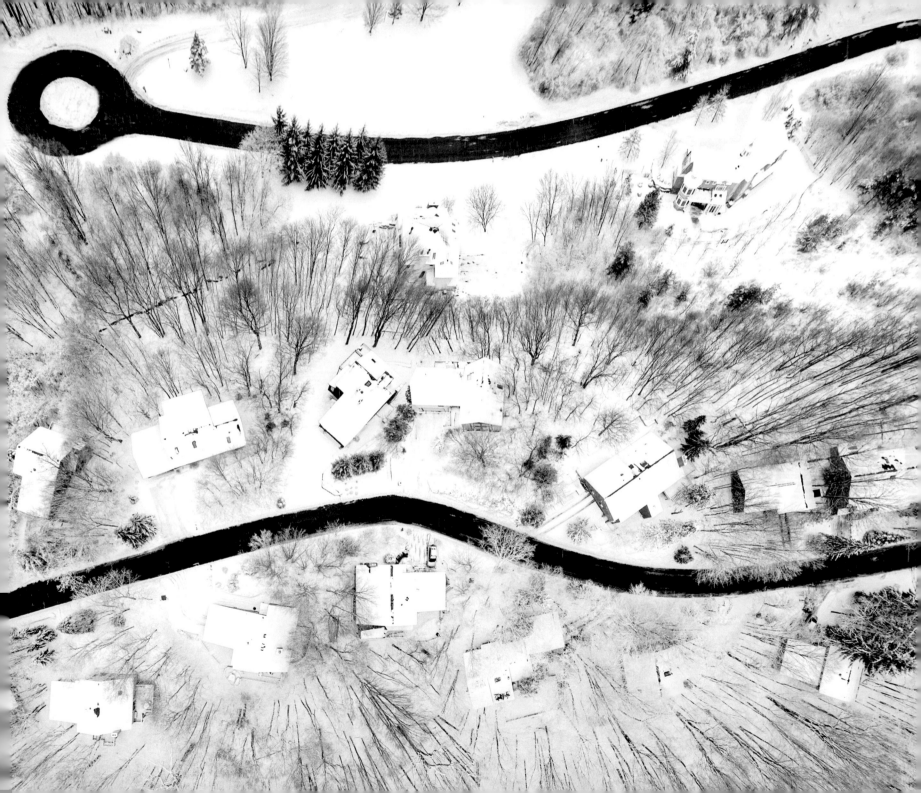

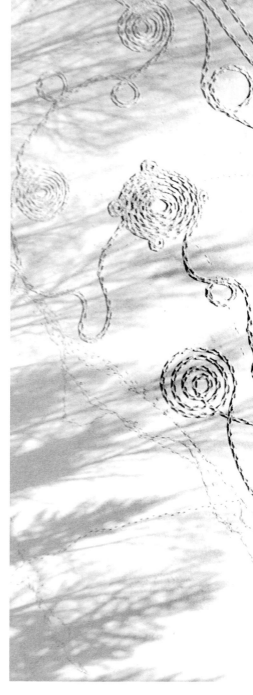

Cazenovia, USA
By BobGates

⊖ 42.9120
⊘ -75.8327
⊕ 476m (1,562ft)

Taken in January 2016 at Stone Quarry Hill
Art Park in Cazenovia, with a 3DR Solo and
GoPro HERO4 Black, this image captures
volunteers creating snow drawings under
the direction of the artist Sonja Hinrichsen.
See also pages 216–17 and 224–25.

Rouen, France
By alleyoops

⊖ 45.7149
⊘ -1.2375
⊕ 25m (82ft)

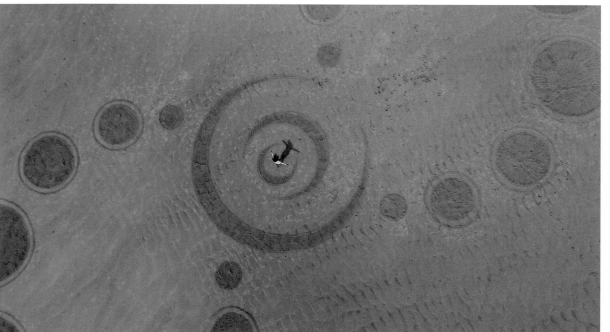

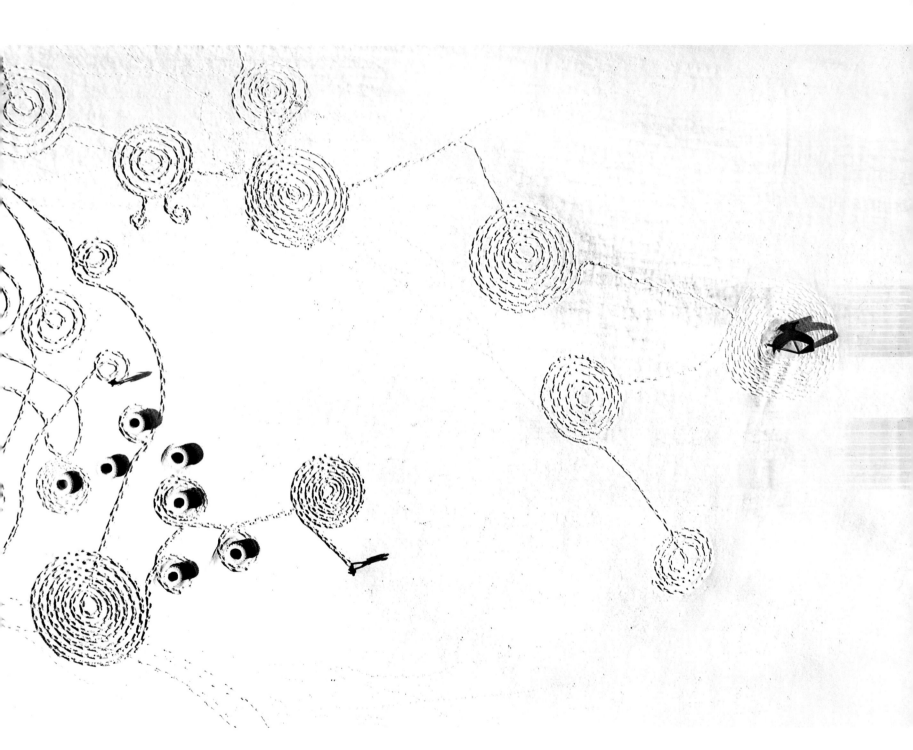

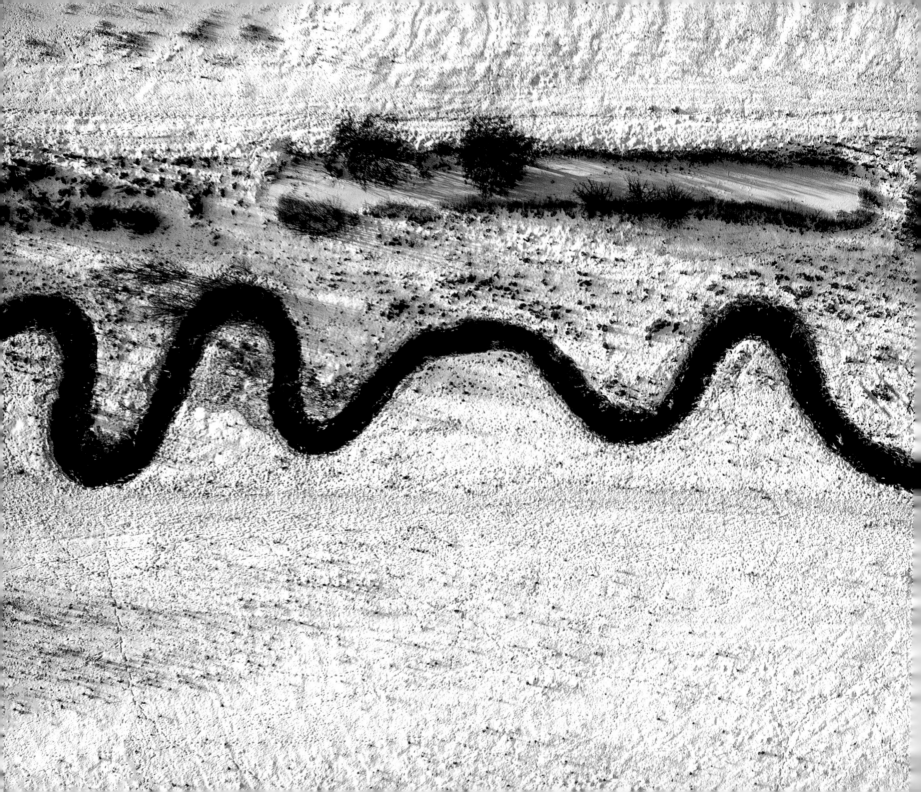

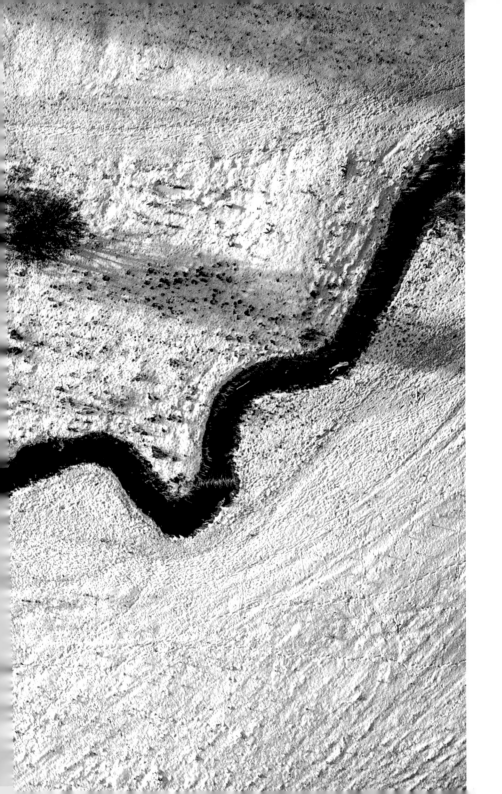

Næstved, Denmark
By mbernholdt

55.2205
11.7592
78.9m (259ft)

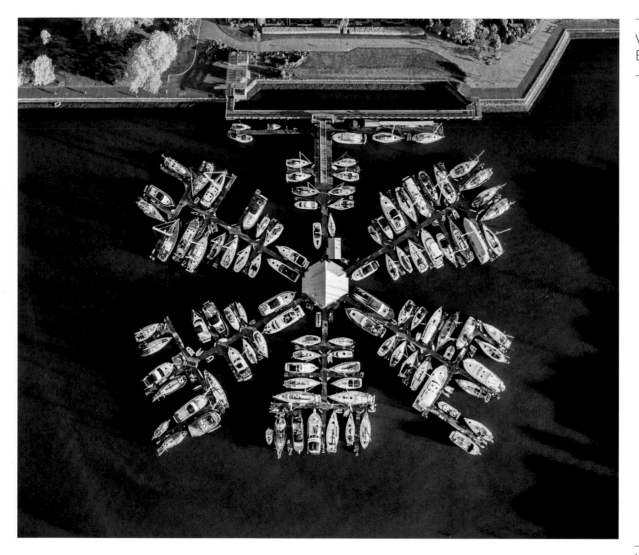

Vancouver, Canada
By eyecon

⊕ 49.2659

⊘ -123.1298

⬆ 28m (92ft)

Miass, Russian
Federation
By Maksim Tarasov

⊕ 55.1624

⊘ 60.1116

⬆ 26m (85ft)

This image shows the hole made by
a fisherman in the completely frozen
Morskaly Lake in Miass, Russia. It was
taken by Tarasov using a DJI Phantom 3.
See also pages 260–62 and 264–65.

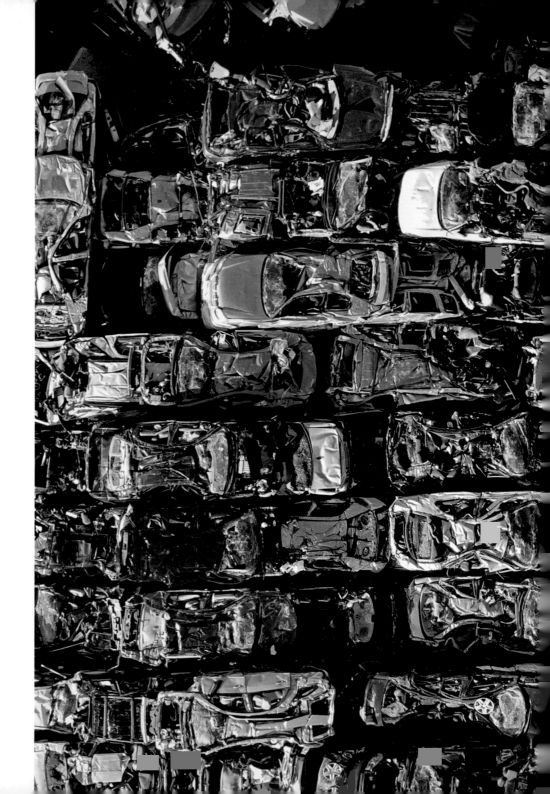

Cicero, USA
By BobGates

⊖	43.1847
⊕	-76.1219
↥	15m (49ft)

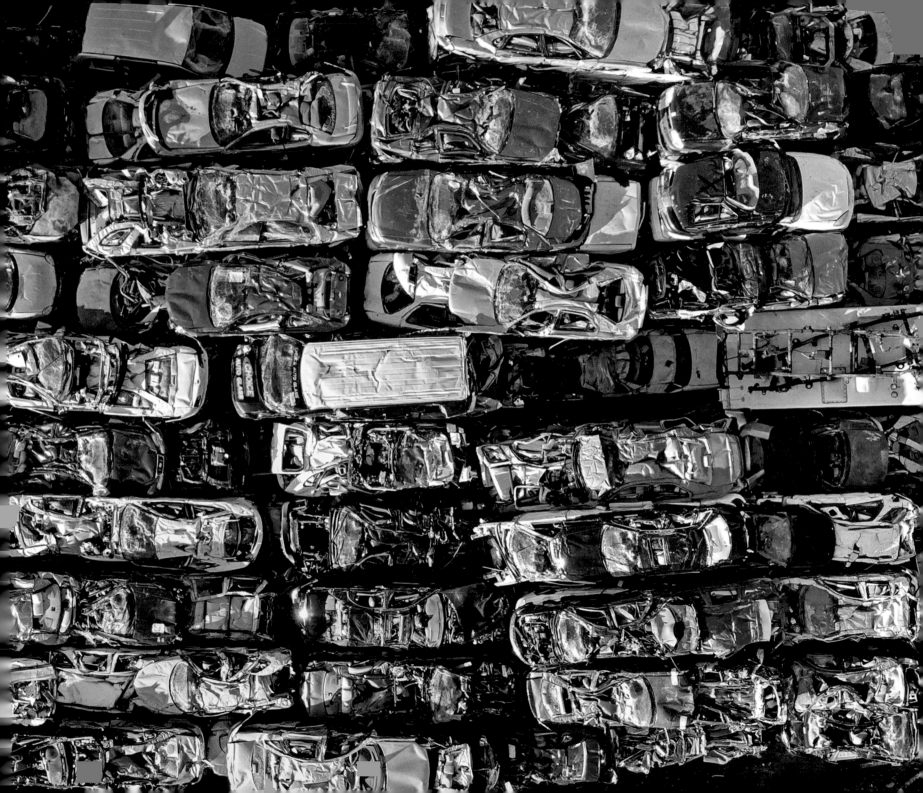

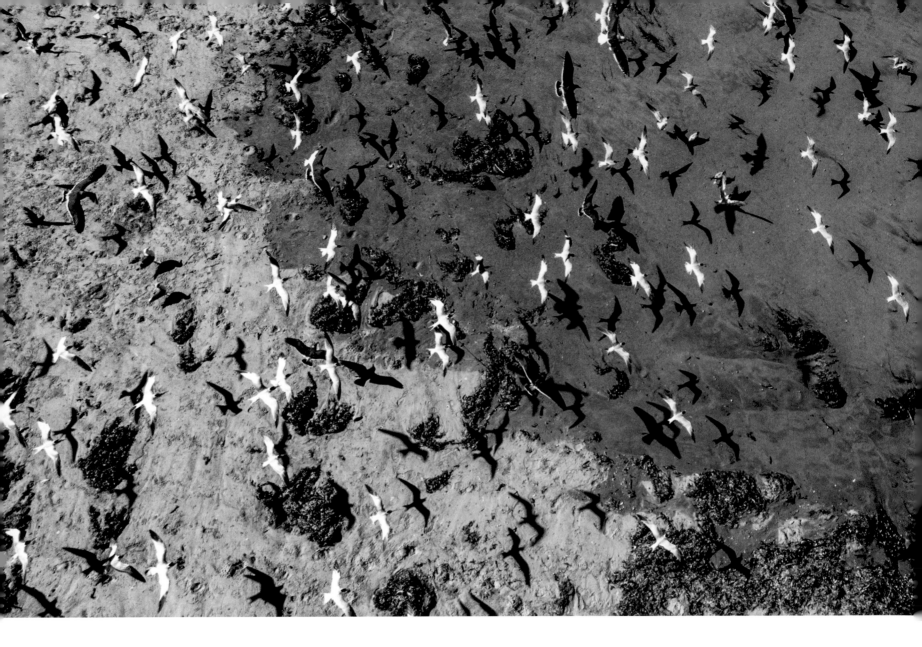

Seaside, California, USA
By GeorgeKrieger

36.6313

-121.8364

16m (53ft)

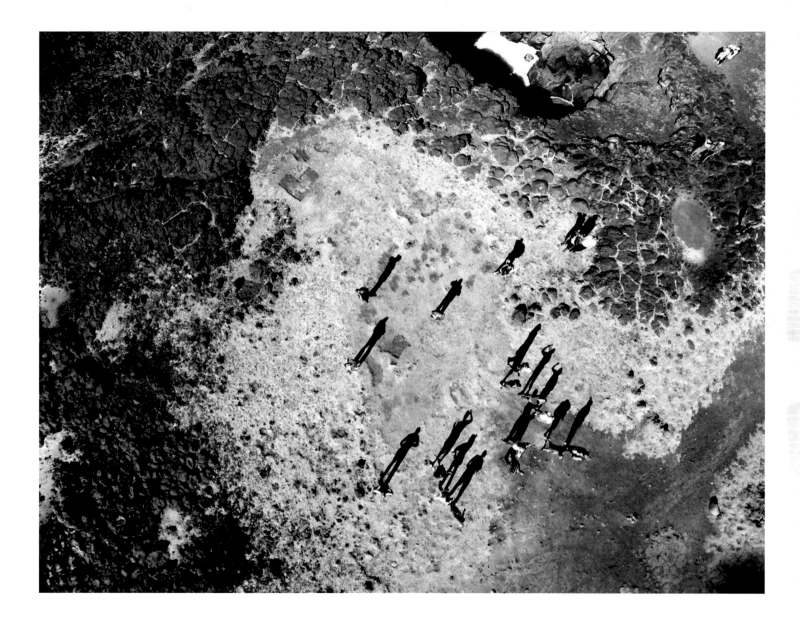

Grand Port, Mauritius
By Tariq

⊕ -20.4804

◐ 57.6693

⬆ 35m (115ft)

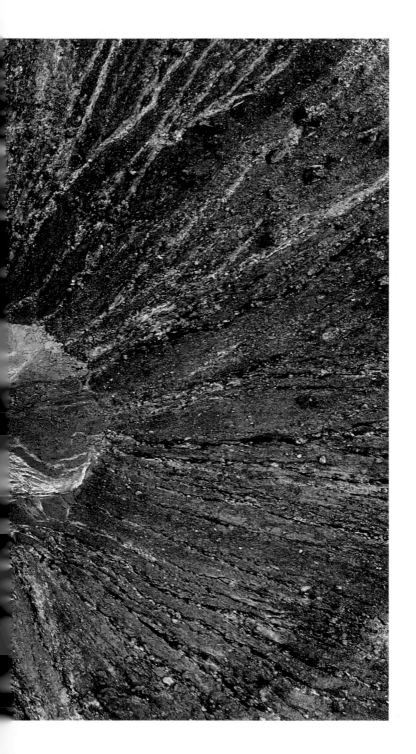

Vulcano Lipari, Italy
By kolibik-foto

⊖ 38.4810
① 14.9390
↑ 26m (85ft)

The Gran Cratere on the Italian island of
Vulcano, captured by the photographer
with a DJI Phantom 3.

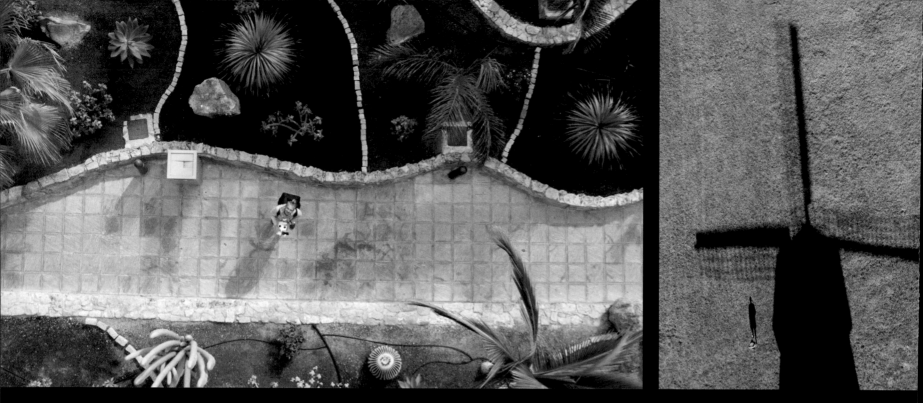

Karolis
Janulis

AGE	34
PROFESSION	Photographer
NATIONALITY	Lithuanian
BASED IN	Vilnius, Lithuania
USES DRONES SINCE	2015
DRONE PIX TAKEN	1,500
EQUIPMENT	DJI Phantom 2 Vision+

Rumšiškės, Lithuania
54.8740
24.1921
31.7m (104ft)

Rumšiškės, Lithuania
54.8766
24.1986
30.3m (99⅓ft)

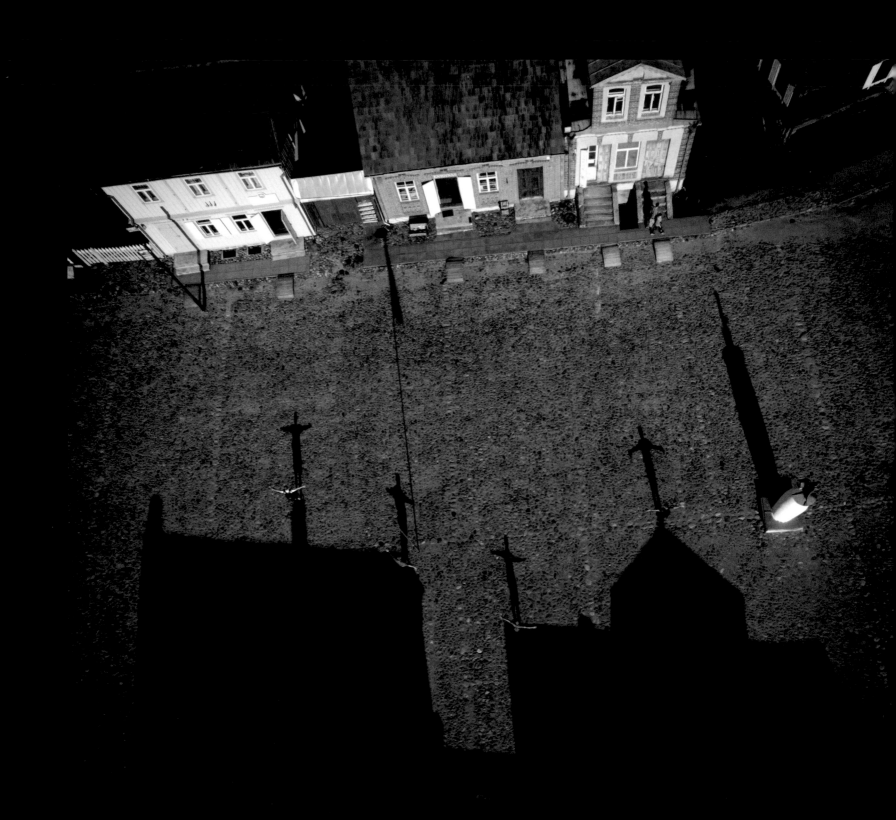

'Drone photography is still very complicated and risky. Flight time is limited; the gear needs to be constantly recharged, there is an increased risk of accident and loss of equipment and flying rules vary across different countries. It is not all quite as simple as it looks.'

Vilnius-based Karolis Janulis has been using drones since 2015, his model of choice being a DJI Phantom 2 Vision+. This he takes with him wherever he goes, and his collection of pictures and videos now amounts to more than 5,000 works.

Janulis has always been fascinated by perspectives from above: before acquiring his first drone he was flying hot-air balloons, motor gliders and using other means to capture the desired shot. But drones, he says, have allowed him unrivalled views: 'Mankind has always dreamt of flying and now it is possible to see the world from the bird's-eye view.'

Janulis has travelled the world over with his drone – to Bulgaria, Croatia, the Canary Islands and Mexico – and his unique views of the landscape and people of these areas have received much acclaim. It is, however, his photographs of his home country, Lithuania – its winter landscapes, urban scenes and people – in particular that seem to resonate. His beautiful and unusual compositions showing the patterns made by shadows are a hallmark. Some of these are almost abstract in their arrangement, while in others he allows in as much detail and space as possible. Drones, he suggests, are the perfect tools to capture such scenes, their unique viewpoint revealing 'the beauty of shadows, which in some cases can be even more detailed in information than the objects that make them.'

His landscapes, whether natural or urban, have an underlying human character. This is especially so of his city scenes, in which figures and shadows interplay to create unexpected, and playful, urban vistas.

Janulis plans his shoots carefully, first choosing a location and next identifying an activity that is taking place there that might look interesting from above. He usually sets up in the morning or late afternoon, finding that the light conditions at these times often wield the best results. Though sometimes, he acknowledges, when faced with an area of such outstanding beauty, all one needs to do is shoot, capturing the scene in all its simplicity.

Janulis is continuously evolving his practice: he is always on the move, shooting, watching others work and seeking to advance his ideas. It is also the sense of discovery and adventure offered by drone photography that propels him forward: 'Every work has a story. Shooting with drones can attract attention and involves finding oneself in various interesting and dangerous situations.' Challenges such as these, he explains, are often not apparent in the final picture: 'Drone photography is still very complicated and risky. Flight time is limited; the gear needs to be constantly recharged, there is an increased risk of accident and loss of equipment and flying rules vary across different countries. It is not all quite as simple as it looks.'

Janulis's works have been published in *The Telegraph*, *The Guardian*, *American Photo Mag* and RotorDrone.mag among others. He is also a Member of OFFSET.

See also pages 6, 180, 199 and 242.

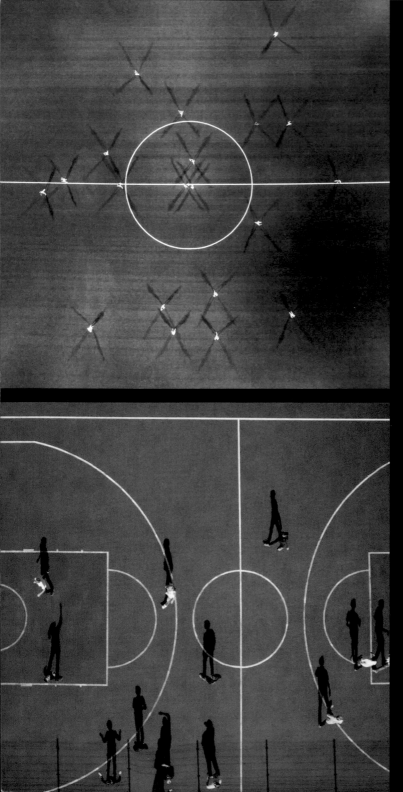

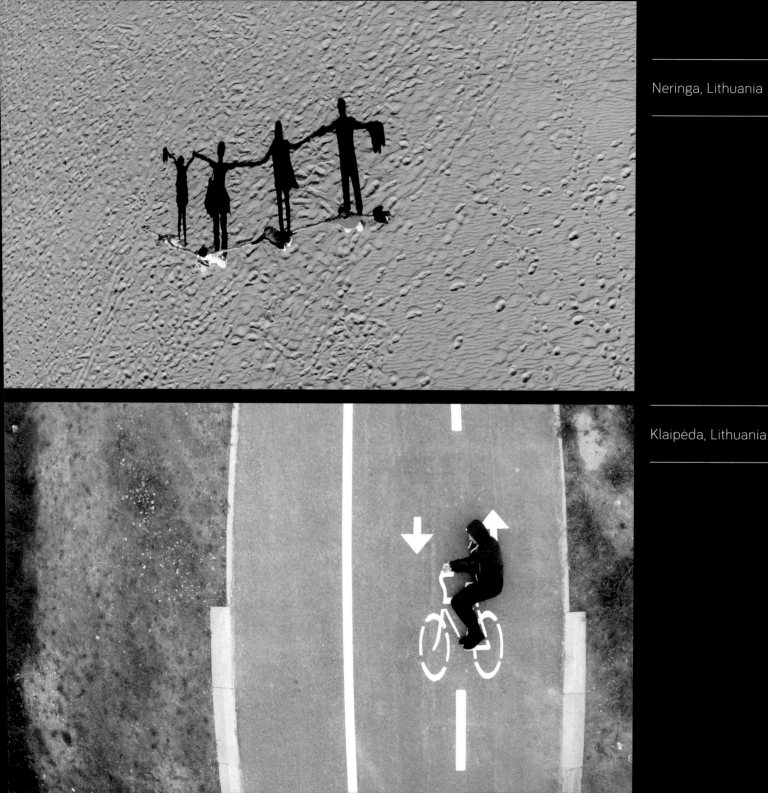

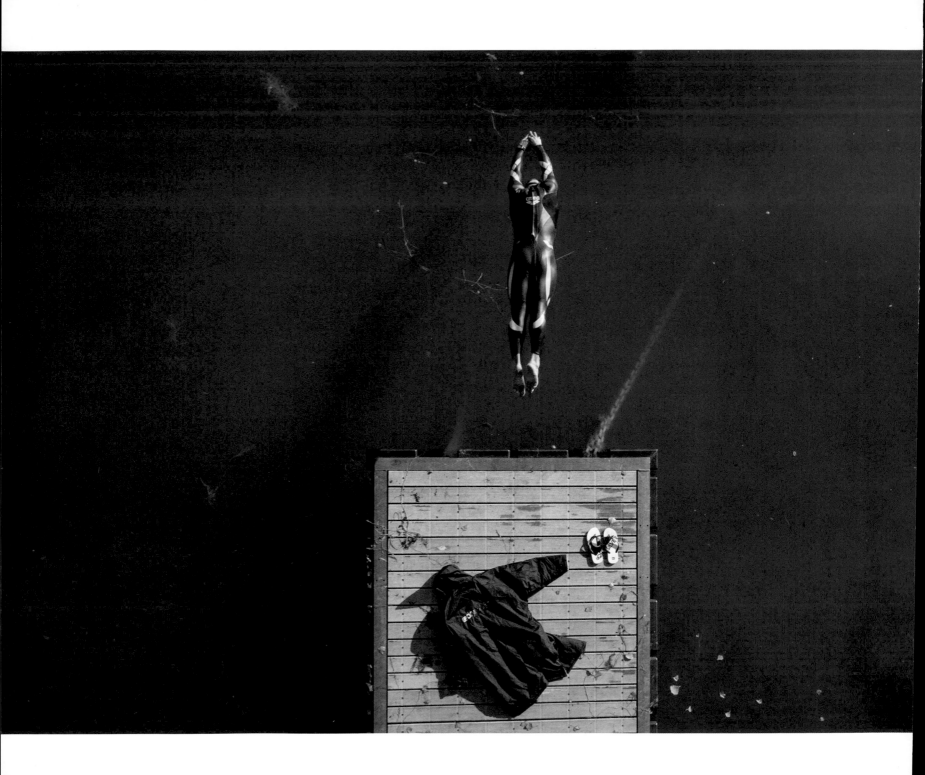

CHAPTER 8

MOVE

Barnesville,
Pennsylvania, USA
By fdnyfish

40.8096

-76.0712

9.8m (32ft)

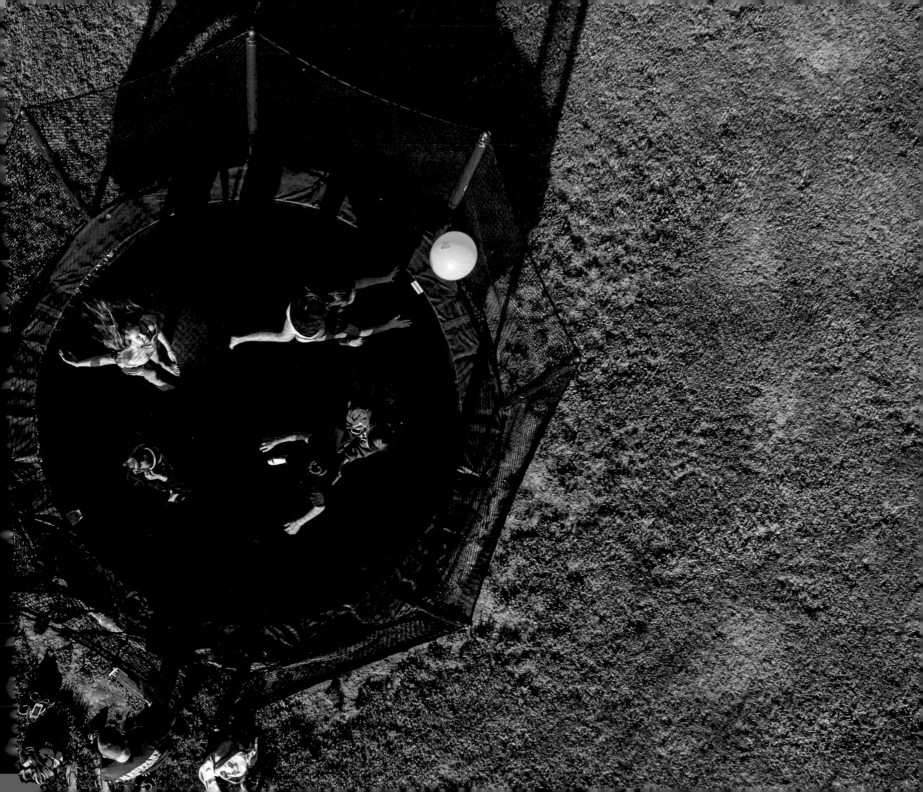

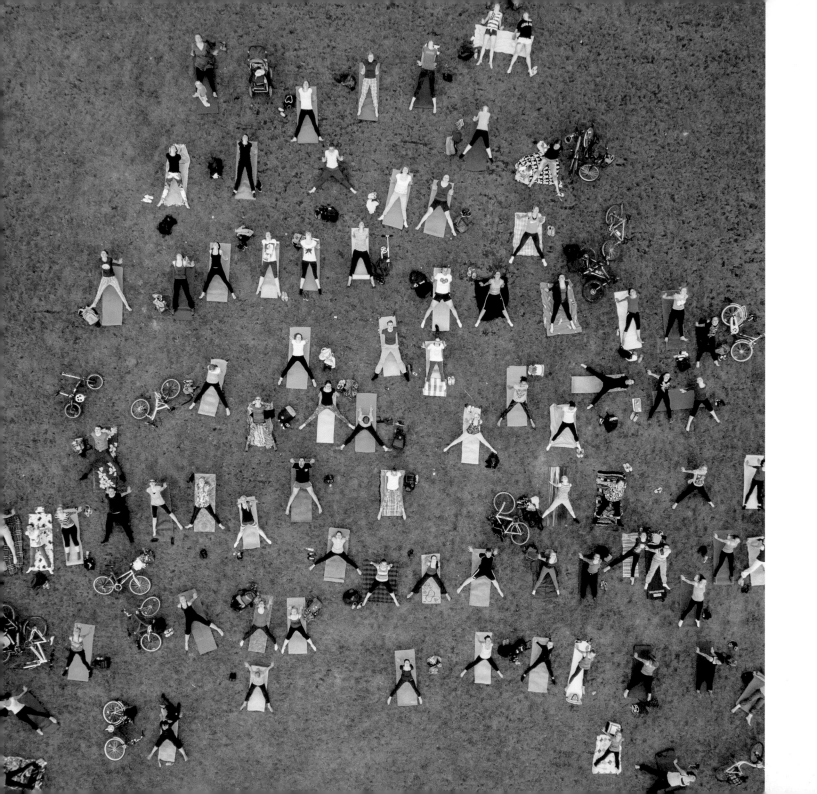

Vilnius, Lithuania
By Karolis Janulis

⊖ 54.6935
◔ 25.2393
↥ 29m (95ft)

Kaafu Atoll, Maldives
By allistairrod

⊖ 4.4559
◔ 73.5594
↥ 60m (197ft)

Oceanside, USA
By kdilliard

33.1931
-117.3885
48m (157½ft)

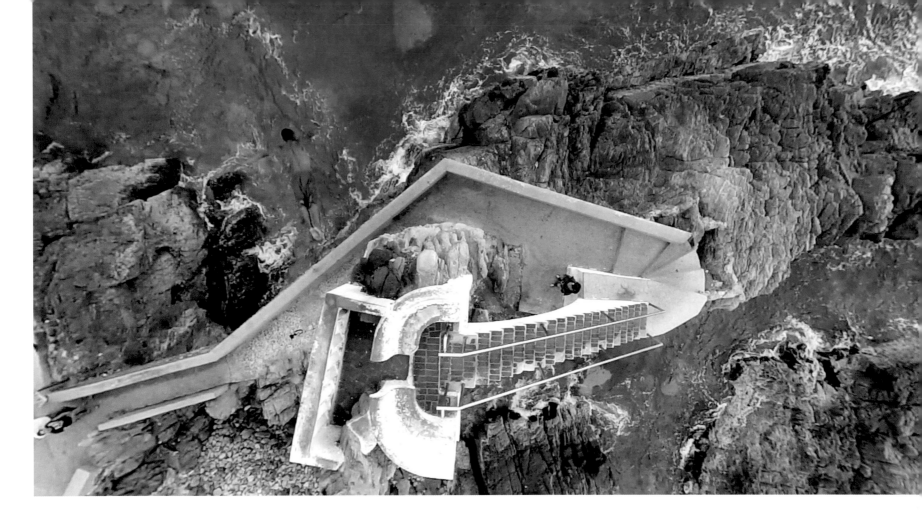

Mazatlán, Mexico
By w00tsor

⊖ 23.2469
⊕ -106.4922
↑ 5.5m (18ft)

'Every day at Plazuela Sánchez Taboada, in Mazatlán, Mexico, a cliff diver risks his life for some pesos and the cheer of the crowd', says the photographer. w00tsor has immortalized such scenes with his DJI Phantom 1 and GoPro HERO3 Silver.

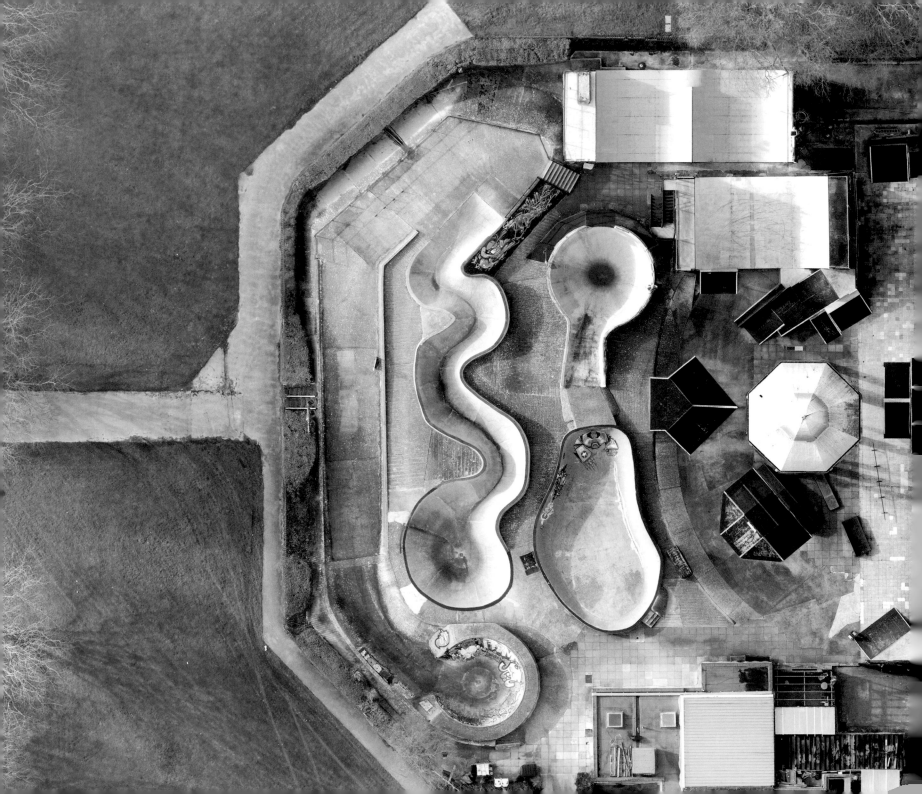

Southsea, UK
By droneexplorer

50.7802
-1.0926
25m (82ft)

Southsea Skatepark is one of the oldest skateparks in the world, with some parts dating back as far as the 1950s. This picture is made up of 104 separate images that have a 70 per cent overlap and are stitched together with software to achieve a very high-quality orthomosaic, which is also geo-referenced. The drone used was a DJI Inspire 1, and it took approximately 12 minutes at an altitude of 25m (82ft) to achieve this shot.

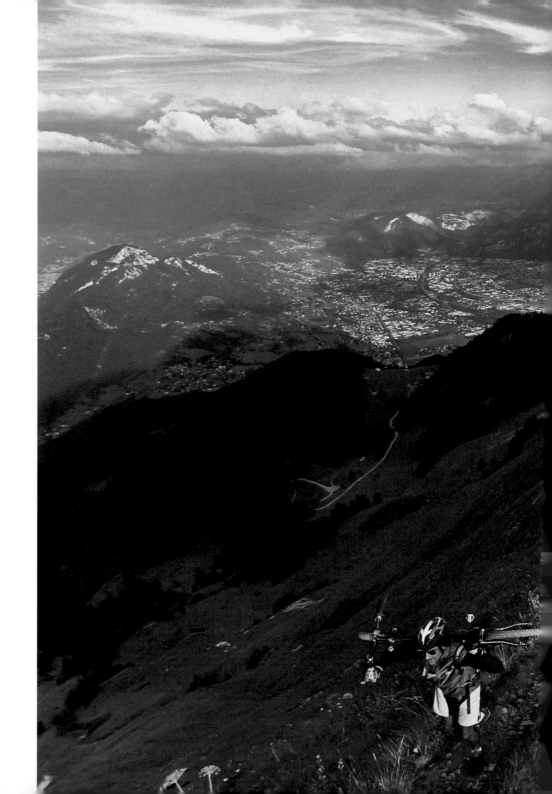

Le Môle, France
By ppelletdoyen

45.7856
6.6661
3.2m (10½ft)

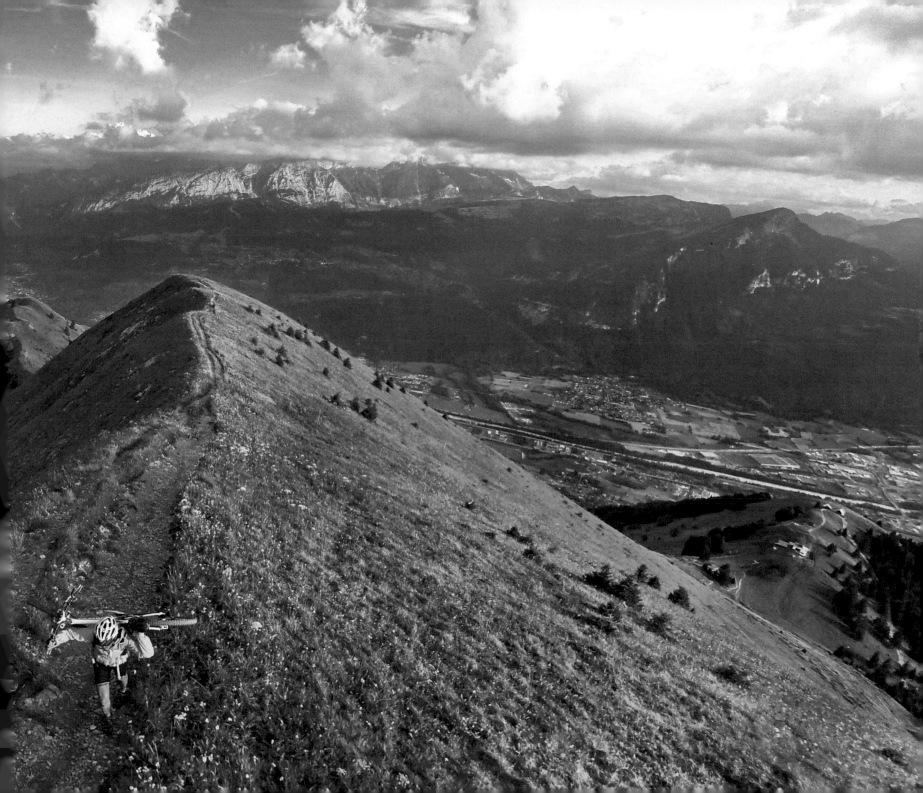

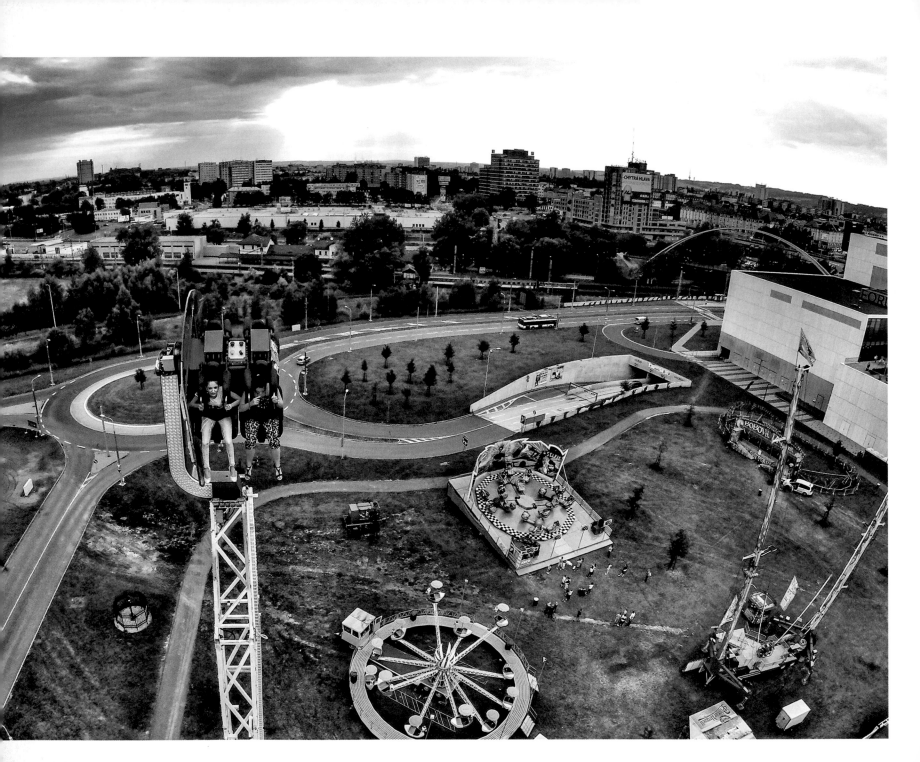

Ostrava, Czech
Republic
By kolibik-foto <

⊖ 49.8209
⊙ 18.2625
⊤ 22m (72ft)

Tatón, Argentina
By ignaciokantor

⊖ -27.3333
⊙ -67.5667
⊤ 12m (40ft)

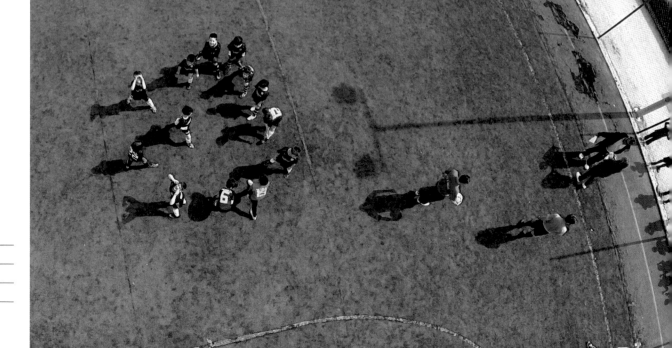

Athens, Greece
By Rizikianos

⊖ 38.0134
⊙ 23.8080
⊤ 8m (26½ft)

Tignes, France
By mountaindrone

⊖ 45.429
⌀ 6.905
↥ 30m (98ft)

Mereni, Romania
By thedon

46.0811

26.2339

3m (10ft)

Patterson,
California, USA
By mikebish

37.4591

-121.1891

6.5m (21½ft)

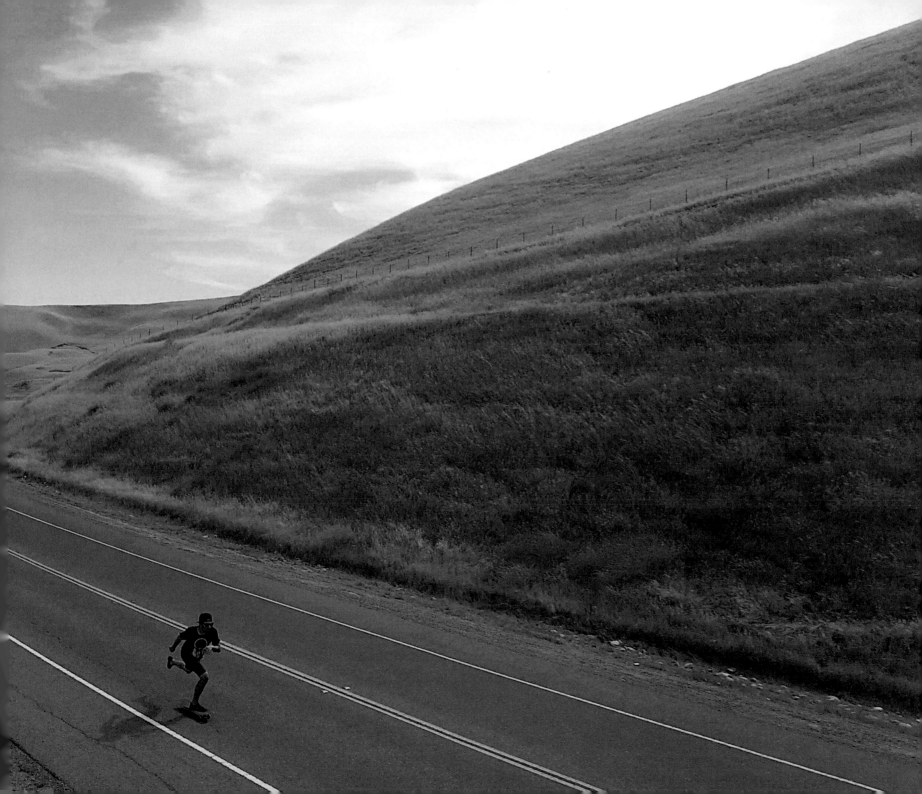

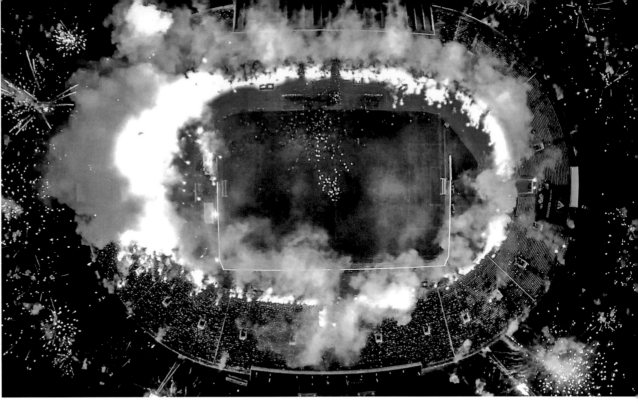

Sofia, Bulgaria
By IceFire

⊖ 42.6977
⊕ 23.3218
⊕ 250m (820ft)

La Noë-Blanche, France
By macareuxprod

⊖ 47.8055
⊕ -1.738722222
⊕ 20m (65½ft)

Also working for the drone production
company Panorapix, macareuxprod
(or Thibault Beguet as he is otherwise
known) shot this promotional image of
a newly constructed sports arena during
a rainy day in the small town of La Noë-
Blanche in Brittany.

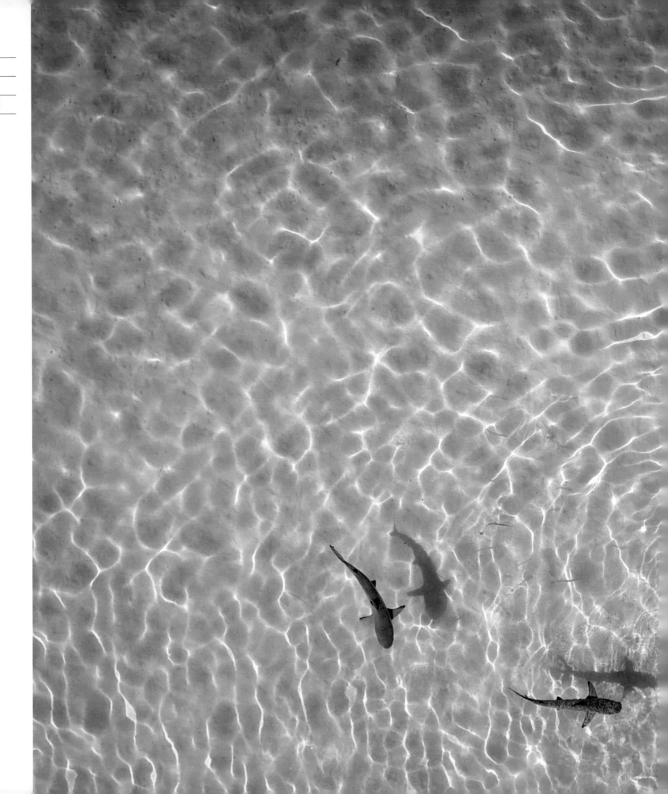

Papeete, French
Polynesia
By tahitiflyshoot

⊖ -17.5333
⊙ -149.8703
↑ 8m (26½ft)

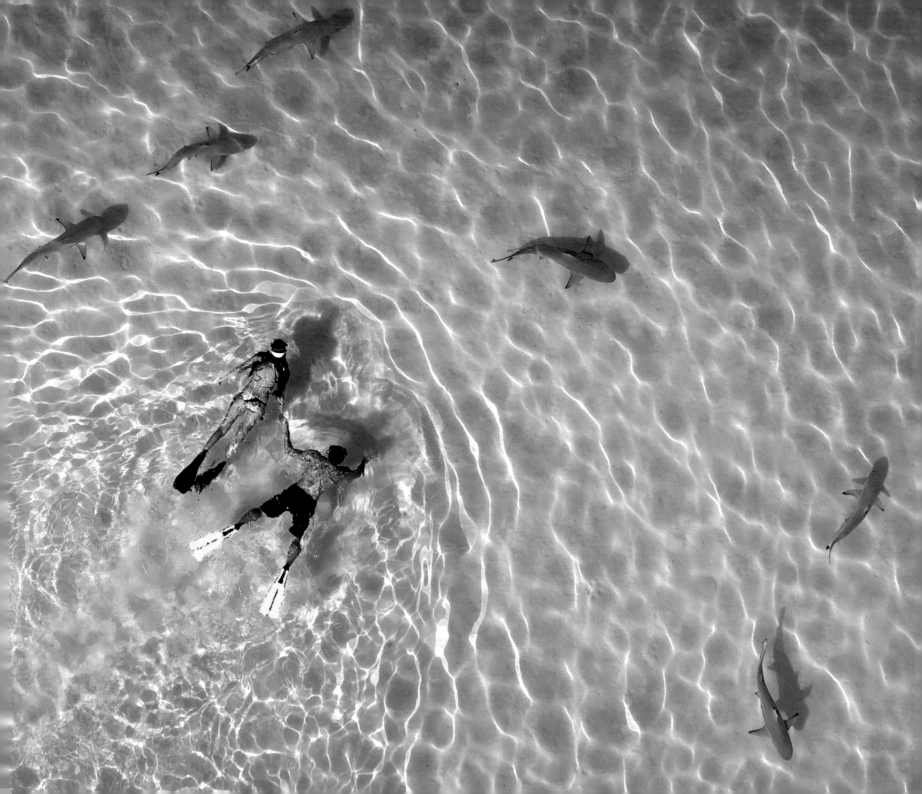

Maksim
Tarasov

Miass, Russian
Federation

⊕ 54.8800
⊘ 59.8094
⊕ 282.1m (925½ft)

AGE	30
PROFESSION	Photographer
NATIONALITY	Russian
BASED IN	Chelyabinsk, Russia
USES DRONES SINCE	2015
DRONE PIX TAKEN	1,000
EQUIPMENT	DJI Phantom 3 Professional / DJI Phantom 3 Professional and GoPro HERO3 Silver

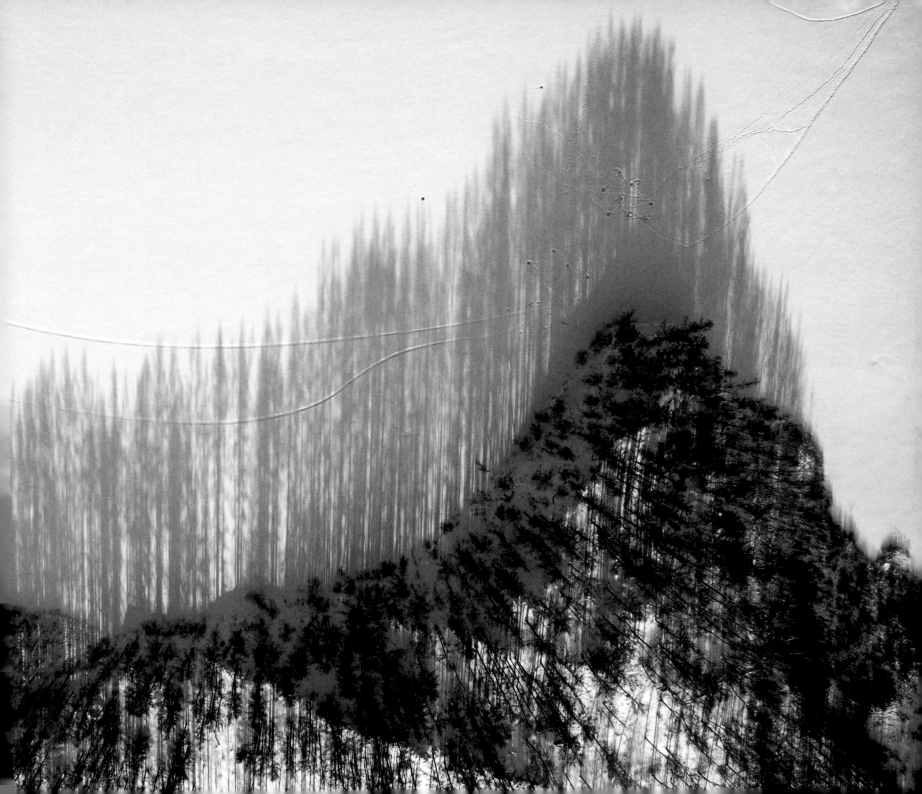

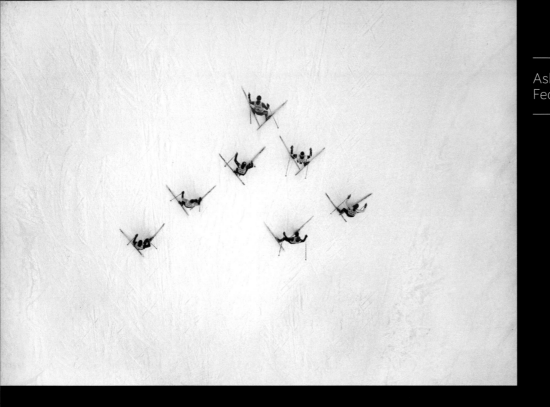

Asha, Russian
Federation

⊖ 54.8084
⌀ 55.7406
⊕ 6m (20ft)

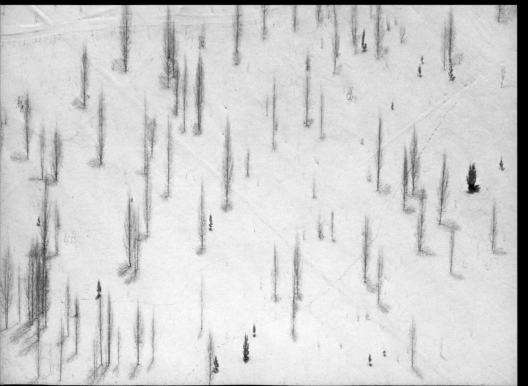

Chelyabinsk, Russian
Federation

⊖ 55.1327
⌀ 61.2913
⊕ 70.8m (232ft)

'I take my drone everywhere.... There are so many opportunities to take great photos of nature – I'm just trying not to miss them.'

Maksim Tarasov (see also page 223) has been using drones since 2015 to produce his spectacular aerial photographs. Born in the small town of Miass in Russia and now living and working in the city of Chelyabinsk, he is, in his own words, a 'traveller, photographer and explorer', taking his trusty companion, the DJI Phantom 3, with him wherever he goes. His collection of photographs, which now surpasses some 1,000 images, depict the rural landscapes of his homeland, as well as his adventures further afield, in places such as China.

'It was nature that was a first source of inspiration,' he says. 'The natural world is mysterious and multifaceted. Since childhood I've lived near forests and I still remember my first hiking trip in the mountains. My photography involves not only personally coming into contact with and appreciating the beauty of nature but a commitment to capturing this and sharing it with others.'

Tarasov's approach is two-fold. Most of his shots of the natural world are the result of careful planning, but some are purely accidental, photographs taken of the places that he has passed on the way to planned destinations. 'I travel a lot, and try to capture well-known places in a new light, as well as to discover new ones. I take my drone everywhere – if I see a place of interest on the way I immediately set up. There are so many opportunities to take great photos of nature – I'm just trying not to miss them.'

Tarasov's passion for his craft and keen eye for detail are fundamental to his ability to capture the unique in the everyday. He is not afraid to experiment or take risks, and is undeterred by elements such as poor weather or light conditions while he searches for the perfect shot. 'The camera of the DJI Phantom 3 is not able to make qualitative pictures in bad light', he explains of the fact that he most often works in the daytime, which of course is the point at which the most striking effects of light and shadow can be captured, as can be seen in his snow pictures. He also uses the application LightTrack to anticipate the best light conditions in specific locations.

In spite of these considerations, Tarasov rarely plans the position from which the camera itself will shoot, or indeed the depth of field, finding that this is best guided by the location, 'I just launch the drone into the sky and look around'. Whether or not the image should be abstract or show as much of the subject in its entirety as possible are factors that, with experience, he has been able to navigate more easily: 'I'm trying to spend more time outdoors, be inspired by nature, understand and feel it.'

Tarasov considers his best photographs to be the ones that uncover something never before seen, and it is this that motivates him to work. 'I continue searching. Nature creates incredible images hidden from the human eye. This secret world opens up to you when you are flying: an overgrown pond can appear as the Cosmos; a fishing hole, a human eye; and in dying soil, there can be seen life.' With his Phantom he has been able to make pictures that have changed his own sense of what photography is and does: 'Things that were hidden suddenly become available. Every new flight is wonderful and promises unexpected discoveries. All you need is to continue searching.'

'Nature creates incredible images.... This world opens up to you when you are flying: an overgrown pond can appear as the Cosmos; a fishing hole, a human eye; and in dying soil, there can be seen life.'

Kusa, Russia

⊖ 55.4305
⊘ 59.3991
⊛ 84.2m (276ft)

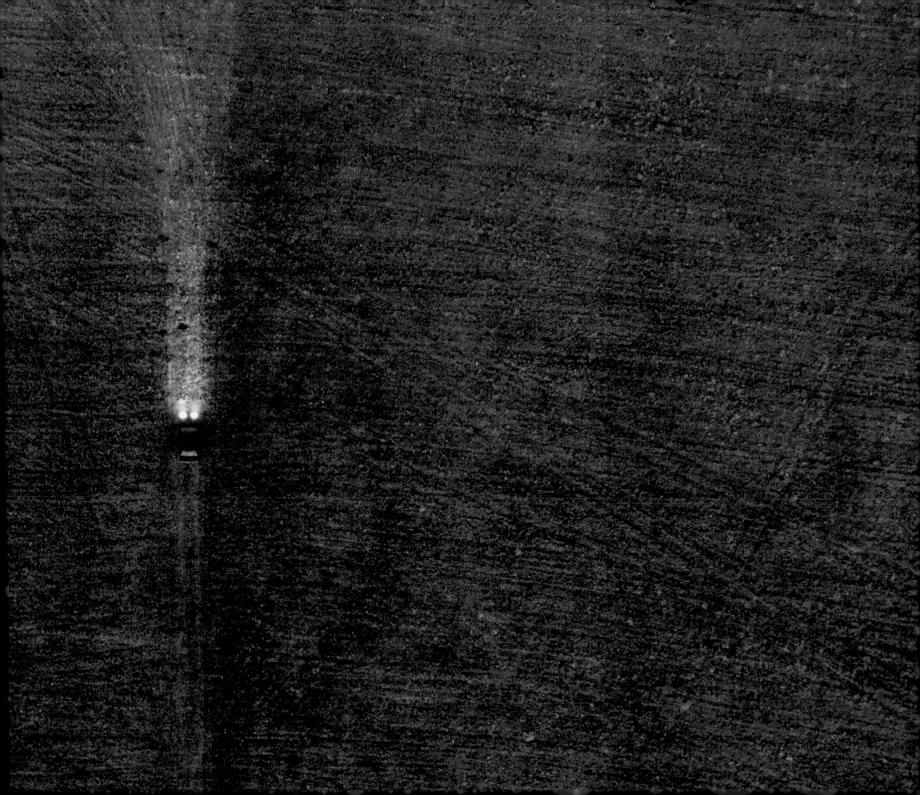

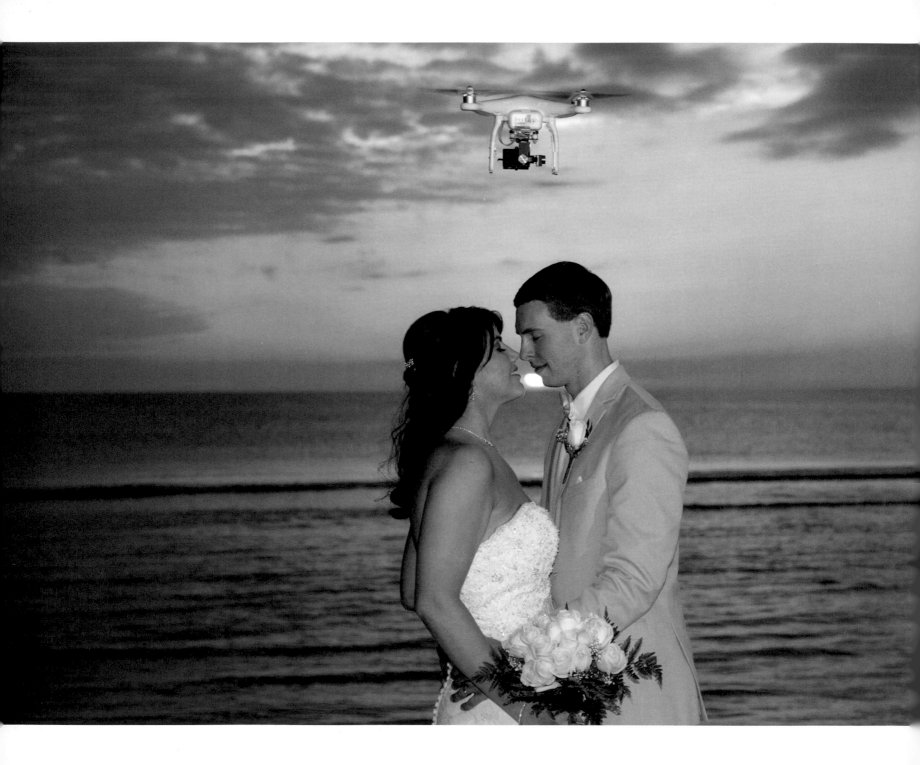

CHAPTER 9

I DO

Arcus, Romania By thedon	⊖ 45.8970
	⟨¦⟩ 25.7831
	⟨↑⟩ 20m (65½ft)

A photographer by trade, thedon, or
Szabolcs Ignacz as he is professionally
known, shot this secluded wedding scene
on the outskirts of the village of Arcus with
his DJI Inspire 1 and Sony camera. Based
in Romania, Ignacz has been a member of
Dronestagram since 2015. See also pages
196–97 and 253.

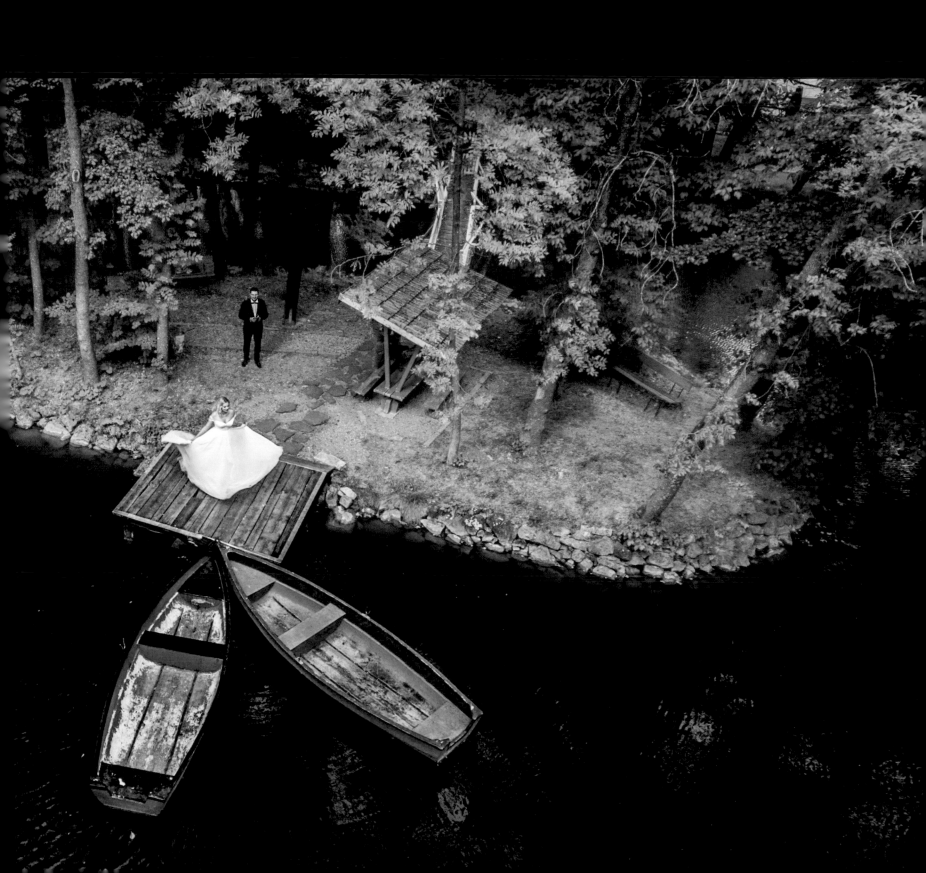

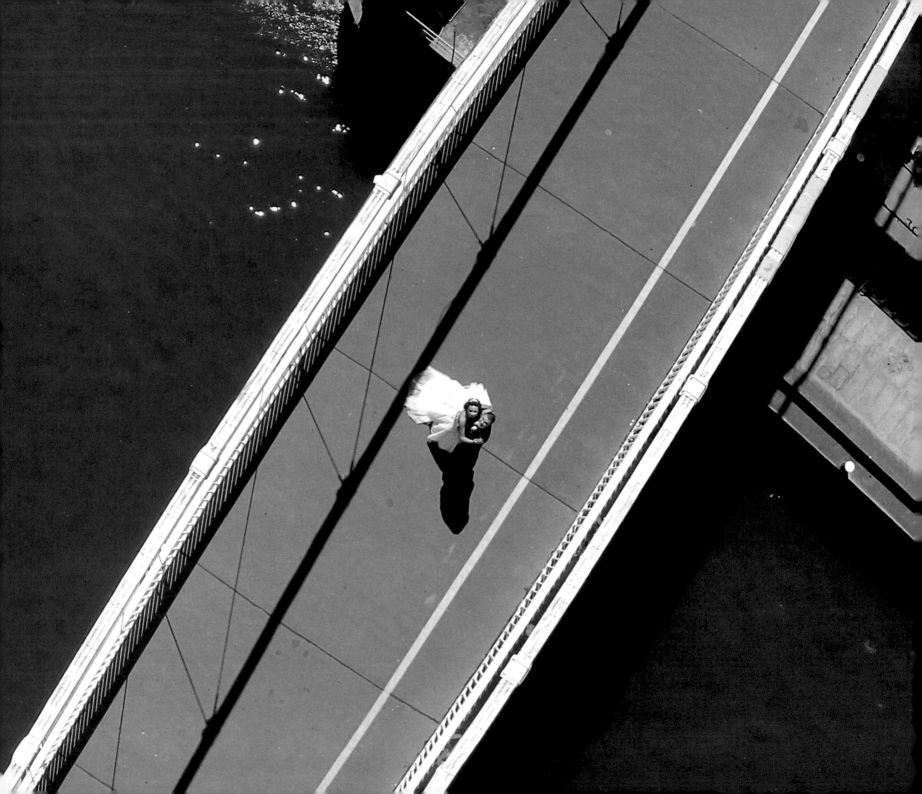

Osijek, Croatia
By zkon

⊖	45.5636
⊕	18.6852
⬆	9m (30ft)

Croatia-based zkon, or Zoran Kon, is a professional wedding photographer who likes to take unconventional shots, including this one, in which the geometric shadows on the bridge and the boats passing underneath become as important a part of the composition as the 'subjects' themselves. A member of Dronestagram since 2015, Kon's quadcopters of choice are a DJI Phantom 2 Vision+ and DJI Phantom 4. See also pages 274–75 and 277.

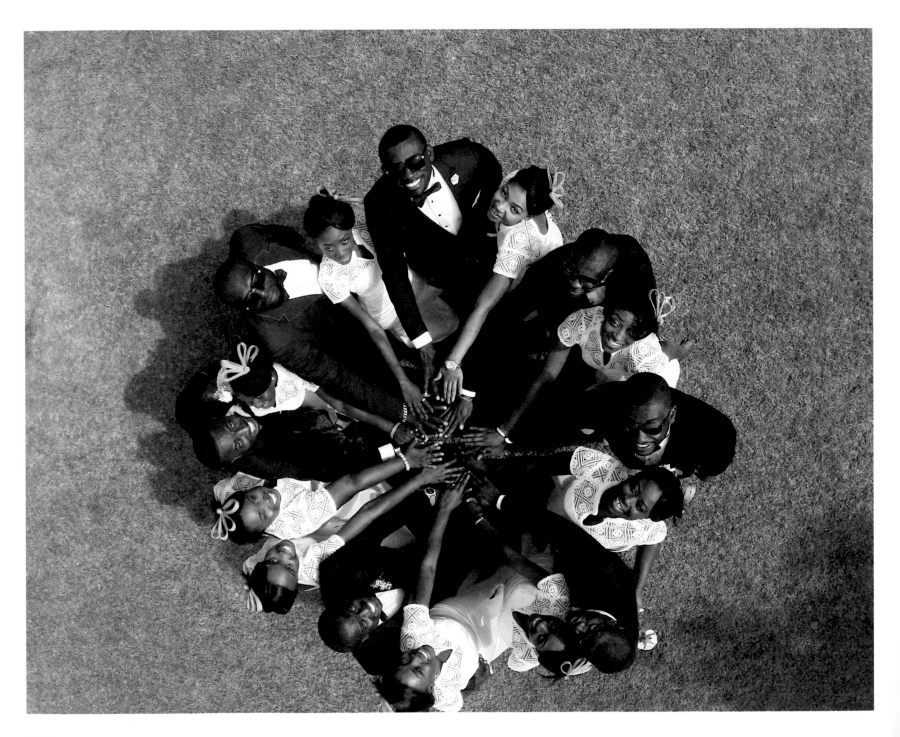

Aburi, Ghana
By aeroshutter

5.8275

-0.1861

4m (13ft)

Kondey, Maldives
By muhaphotos

0.5258

73.5471

18.2m (60ft)

Mohamed Muha used a DJI Phantom 3 to take this unique shot in an unparalleled location – a tiny strip of sand on a beach on the small island of Kondey in the Maldives.

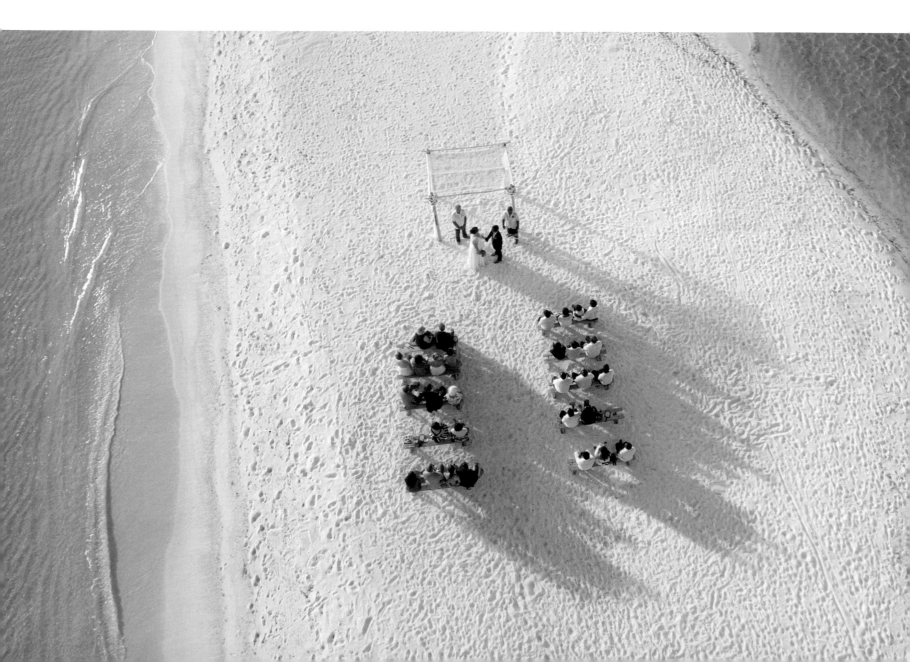

Našice, Croatia
By zkon

⊖ 45.4905
① 18.0936
↑ 11m (36ft)

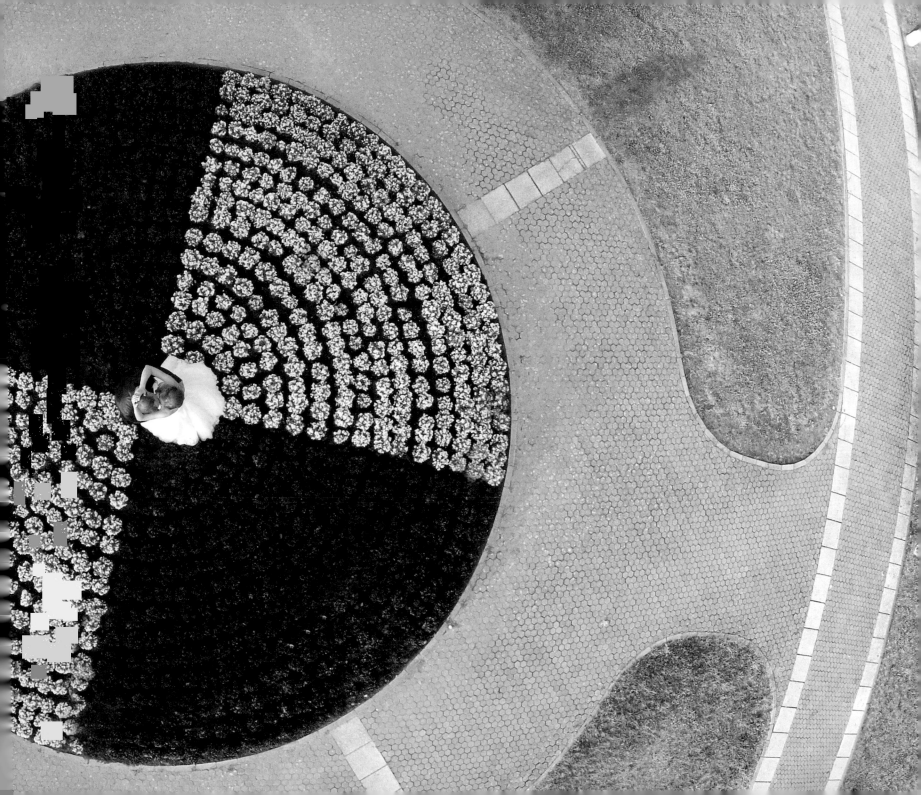

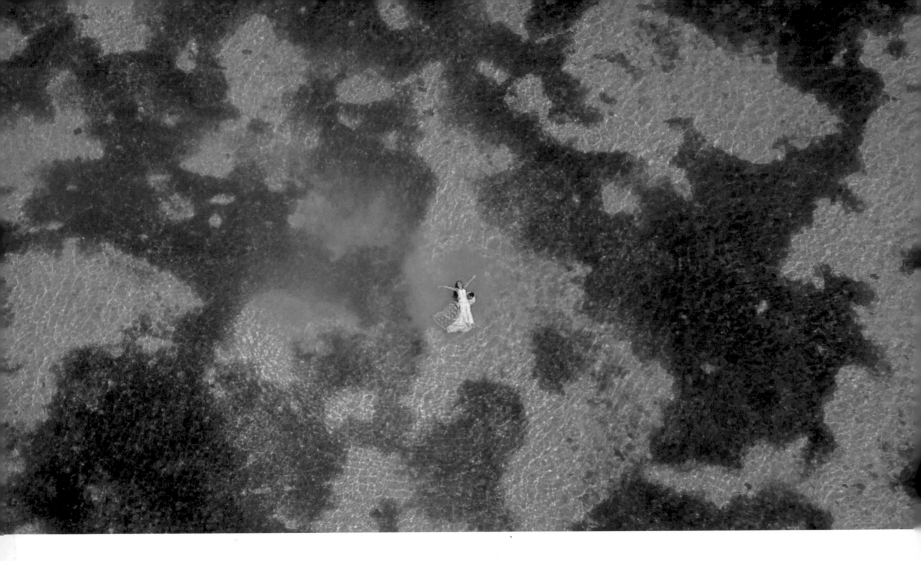

Vacoas-Phoenix,
Mauritius
By Christopher_Barry

⊖ -20.0205

⊙ 57.9788

⬆ 35m (115ft)

Našice, Croatia
By zkon

⊖ 45.4905
⊖ 18.0933
⚲ 3.5m (11½ft)

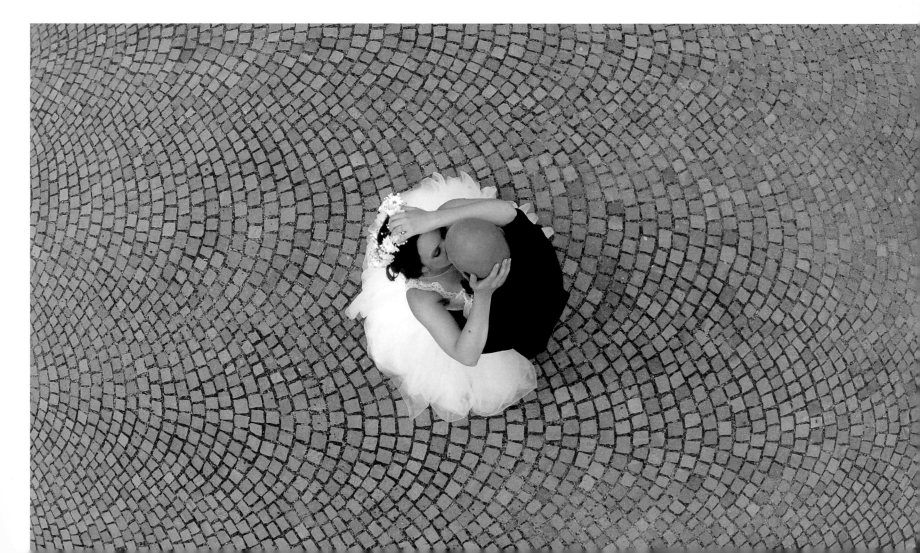

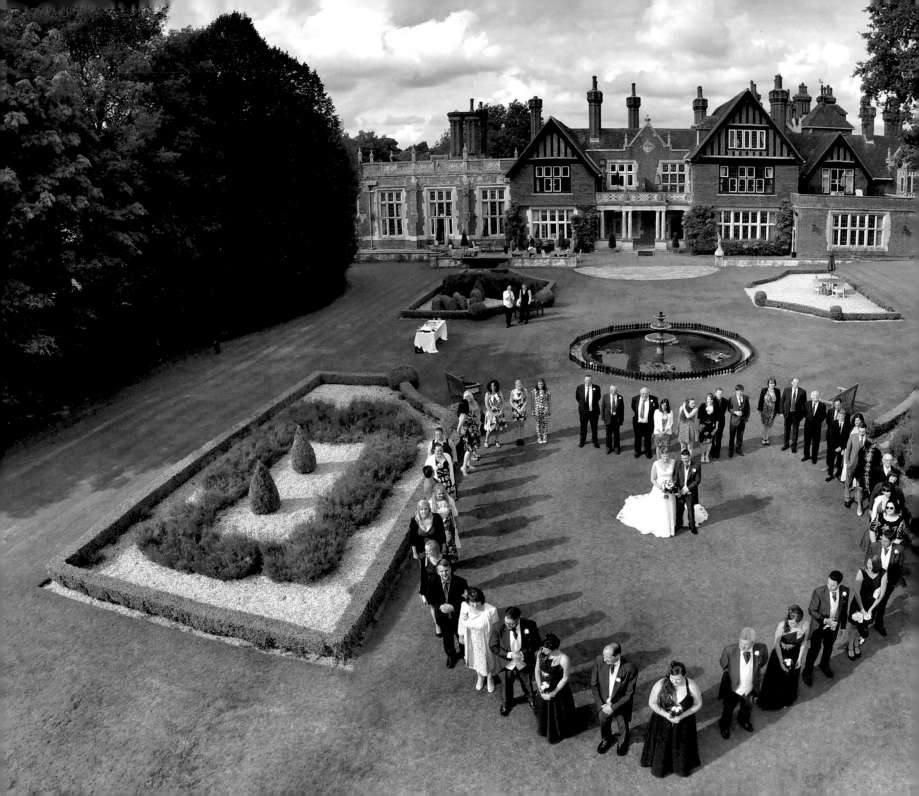

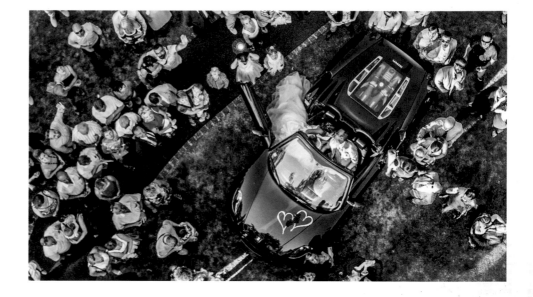

Sermamagny, France
By Drone Capture
System

⊖ 47.6396
⌖ 6.8638
↥ 4.5m (15ft)

Lymington, UK
By mark baker

⊖ 50.7575
⌖ -1.5244
↥ 21m (70ft)

⊖ -27.0910
⊘ -48.9592
↥ 6m (20ft)

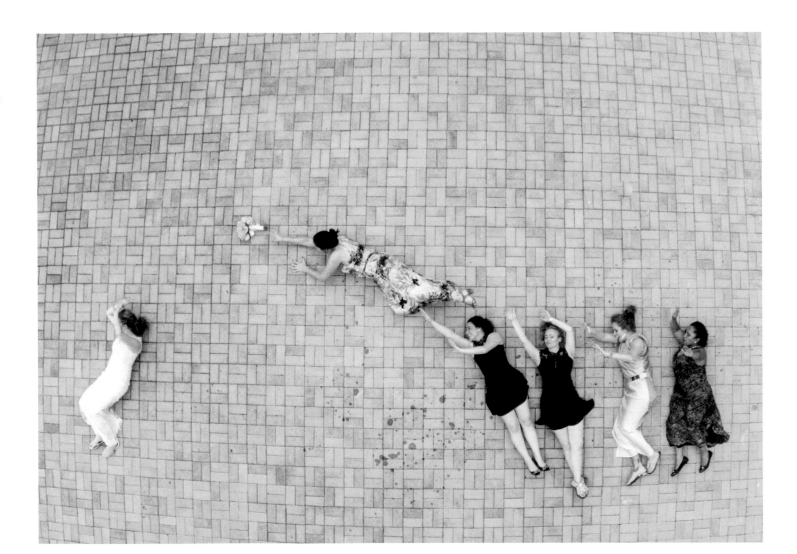

Atlixco, Mexico
By zeckua

18.9131
-98.4294
40m (131ft)

Gabriel Chavez Zeckua usually operates his
DJI Phantom 2 Vision, the quadcopter used
for this shot, in areas near the Mexican–US
border, close to his home of San Antonio.

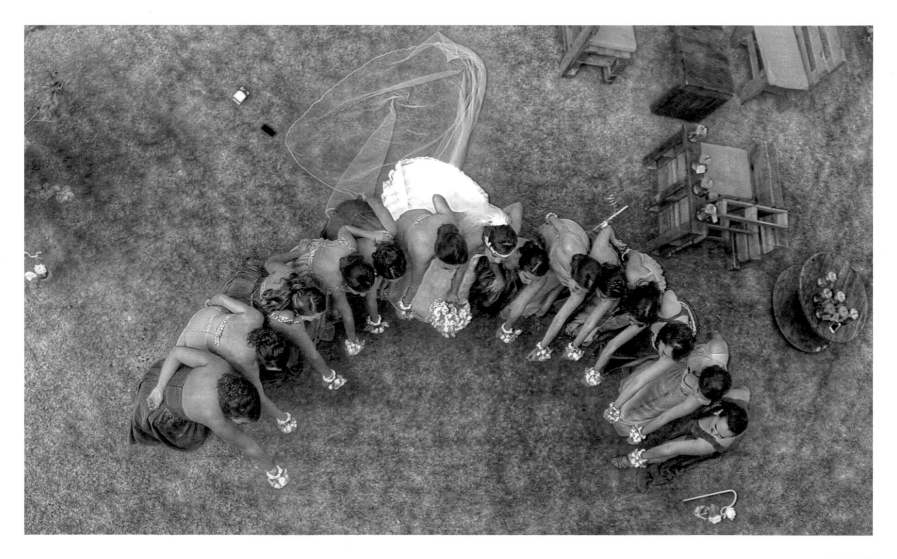

USER GUIDE

If you are considering buying/using a drone, here are some key points to remember:

• Register your drone. If your model weighs more than 0.55lb and you are going to use it outdoors you will need to register it through your national aviation association.

• Know the rules and regulations. The rules for recreational use differ to those for commercial use, but in both cases they dictate the maximum height at which you can fly your drone, and how close to airports and other aircraft. Check your national aviation association's website for more information.

• Familiarize yourself with your drone. Know how it should be operated and handled before take off to avoid breakage. Most drone manufacturers publish user guides online, so check the Internet for manuals specific to your model. Before flying always inspect your drone and ensure that the batteries in your remote controller and craft are fully charged. Check that all propellers are secure and free of damage and calibrate your compass too. Once in the air, maintain your line of sight for ease of navigation. Fly in open spaces to avoid collision with nearby objects, and be mindful of people and animals during flight.

• Enrol on a training course. Being trained by professionals will not only help you to strengthen your flying skills, it will increase your confidence, bring you into contact with other drone enthusiasts and introduce you to a range of different drone models.

• Research the best drone apps for your model. B4UFLY is a good starting point, as it informs users about flying restrictions in specific areas, provides updates in relation to regulatory changes as well as other useful information. 3DR Solo is another, allowing you to fly and control your drone using your smartphone.

• Join drone communities. Dronestagram is of course the leading online community but find out about local events for drone enthusiasts too, so that you can come into direct contact with like-minded photographers, expand your knowledge and exchange notes.

• Keep updated. Always stay informed of changes in flight regulations as well as drone 'trends' and technological developments, all of which can be found online.

AUTHOR BIOGRAPHIES

Ayperi Karabuda Ecer

Ayperi Karabuda Ecer is a photo editor with extensive experience in the world of documentary photography. She has been Vice President of Pictures at Reuters, Editor in Chief at Magnum Photos Paris, NY Bureau Chief for SIPA PRESS and chair of the World Press Photo Jury. While assigning, editing and launching innovative multimedia productions, teaching, chairing juries and nominating awards, she has worked closely with generations of renowned photographers worldwide. She also headed the world's largest photo community project shot on a single day, ADAY.org. Ayperi is of Turkish/Swedish origin, and is based in Paris.

Eric Dupin

Eric Dupin is a French entrepreneur, blogger and geek. He is the founder, CEO and Chief Editor of Presse-citron, a website that features news and information about the latest developments in web technology and gadgets. He launched Dronestagram in 2013.

Guillaume Jarret

Guillaume Jarret is a French entrepreneur, born in Annecy-le-Vieux, France, in 1984. He is the co-founder of Dronestagram.

SUPPLEMENTARY IMAGE REFERENCES

Page 2
Cable Beach, Broome, Australia
By Todd Kennedy
-17.9319
122.2081
75m (246ft)

Page 6 (clockwise from top left)
Sète, France
By rjean
43.3905
3.6570
15m (49ft)

Luz, Portugal
By MAZZA_FPV
37.0842
-8.738
19m (62ft)

Ribeirão Preto, Brazil
By Raf Willems
-1.2627
-47.8213
12m (39ft)

Near La Paz, Mexico
By Roberto Hurko
24.1870
-110.4189
42m (138ft)

Kansas City, USA
By skeyephoto
39.0964
94.5878
28m (92ft)

Mexico City, Mexico
By Karolis Janulis
23.6345
-102.5528
43m (141ft)

Altipiani di Arcinazzo, Italy
By ARCIERE
41.8580
13.3472
12m (39ft)

Bogra, Bangladesh
By zayedh
24.8510
89.3697
300m (984ft)

La Roca del Vallés, Spain
By dronieproductions
41.5942
2.3762
357m (1,171ft)

Habsheim, France
By Tristan68
47.7284
7.4159
50m (164ft)

Maringá, Brazil
By Ricardo Matiello
-23.4262
-51.9382
550m (1,804ft)

Zahara, Spain
By kolibik-foto
36.8420
-5.3959
92m (302ft)

Salt Lake City, USA
By Freeway Drone
40.6250
-111.6156
42m (138ft)

Milan, Italy
By tosky
45.4640
9.1888
20m (65½ft)

Krabi, Thailand
By EricHanscom
8.0863
98.9063
200m (656ft)

Page 7 (clockwise from top left)
Alqueva Dam, Portugal
By MAZZA_FPV
41.7693
-8.2222
103m (338ft)

Austin, USA
By 1138 Studios
30.27
-97.7557
32m (105ft)

Barnesville, USA
By fdnyfish
40.8096
-76.0712
10m (33ft)

Yedigöller National Park, Turkey
By ertugbilgin
40.9414
31.7460
900m (2,953ft)

Tatón, Argentina
By ignaciokantor
-27.3333
-67.5667
12m (39ft)

Yasawa Island, Fiji
By Droneworks New Zealand
-16.682143
177.217815
8m (26ft)

Le Havre, France
By Freeway Drone
49.4910
0.1012
66m (216½ft)

Columbia, USA
By Photoworx
35.6630337
-87.1653465
15m (49ft)

Le Caule-Sainte-Beuve, France
By TechniVue
49.7648
1.5913
100m (328ft)

Dent de Crolles, France
By Mountaindrone
45.308
5.856
10m (33ft)

Huraa, Maldives
By allistairrod
4.3384
73.6031
84m (275ft)

Araçatuba, Brazil
By Marcio Ogura
-21.2029
-50.4537
100m (328ft)

Istanbul, Turkey
By cagkanyuksel
40.9493
29.1009
90m (295ft)

Roodepoort, South Africa
By Cloud 9 Photography.SA
-26.1201
27.9014
1,522m (4,993ft)

Næstved, Denmark
By mbernholdt
55.2246
11.7592
150m (492ft)

Page 8
Rio de Janeiro, Brazil
By hanower
-22.9673
-43.1968
20.3m (66ft)

Pages 18–19
Jakarta, Indonesia
By Tuntungan2
-6.1745
106.8227
1m (3ft)

Pages 38–39
Paris, France
By Freeway Drone
48.8566
2.3522
25m (82ft)

Pages 52–53
Paris, France
By Freeway Drone
48.8598
2.2842
7m (23ft)

Pages 92–93
Jędrzejów, Poland
By Myszon
50.5426
20.2937
16m (52½ft)

Pages 112–13
Geneva, Switzerland
By Drone Capture System
46.2044
6.1432
2m (6½ft)

Pages 144–45
Akron, USA
By jrudick
41.0814
-81.5190
2m (6½ft)

Pages 192–93
Angels Camp, USA
By GeorgeKrieger
38.0678
-120.5385
10m (33ft)

Pages 238–39
Milan, Italy
By Olivier Morin
45.4654
9.1859
10m (33ft)

Pages 206–07
Guntur, India
By Aurobird
16.3475
80.3713
8m (26ft)

Page 288
Anza-Borrego State Park, USA
By EricHanscom
33.2559
116.3750
25m (82ft)

On the cover (front)
Hong Kong, China
By iP
22.2738
114.1519
448m (1,470ft)

On the back (clockwise from top left)
Sofia, Bulgaria
By IceFire
42.6977
23.3218
250m (820ft)

Neringa, Lithuania
By Karolis Janulis
55.3074
21.0058
19m (62ft)

Le Havre, France
By Freeway Drone
49.4910
0.1012
66m (216½ft)

Altipiani di Arcinazzo, Italy
By ARCIERE
41.8580
13.3472
12m (39ft)

Klaipėda, Lithuania
By Karolis Janulis
55.7412
21.1518
8.4m (28ft)

Arcuri, Romania
By thedon
45.8970
25.7831
20m (66ft)

Le Caule-Sainte-Beuve, France
By TechniVue
49.7648
1.5913
100m (328ft)

Frankfurt, Germany
By mleissl
50.2038
8.7008
92m (302ft)

Athens, Greece
By Rizikianos
38.0361
23.7875
5.5m (18ft)

Habsheim, France
By Tristan68
47.7284
7.4159
50m (164ft)

Našice, Croatia
By zkon
45.4905
18.0936
11m (36ft)

Maringá, Brazil
By Ricardo Matiello
23.4262
51.9382
550m (1,804ft)

INDEX OF PHOTOGRAPHERS/WEBSITES